Cultural Studies

Theorizing Politics, Politicizing Theory

VOLUME 12 NUMBER 2 APRIL 1998

Editorial Statement

Cultural Studies continues to expand and flourish, in large part because the field keeps changing. Cultural studies scholars are addressing new questions and discourses, continuing to debate long-standing issues, and reinventing critical traditions. More and more universities have some formal cultural studies presence; the number of books and journals in the field is rapidly increasing. *Cultural Studies* welcomes these developments. We understand the expansion, reflexivity and internal critique of cultural studies to be both signs of its vitality and signature components of its status as a field. At the same time, cultural studies has been – and will no doubt continue to be – the subject of numerous attacks, launched from various perspectives and sites. These have to be taken seriously and answered, intellectually, institutionally and publicly. *Cultural Studies* hopes to provide a forum for response and strategic discussion.

Cultural Studies assumes that the knowledge formations that make up the field are as historically and geographically contingent as are the determinations of any cultural practice or configuration and that the work produced within or at its permeable boundaries will be diverse. We hope not only to represent but to enhance this diversity. Consequently, we encourage submissions from various disciplinary, theoretical and geographical perspectives, and hoep to reflect the wide-ranging articulations, both global and local, among historical, political, economic, cultural and everyday discourses. At the heart of these articulations are questions of community, identity, agency and change.

We expect to publish work that is politically and strategically driven, empirically grounded, theoretically sophisticated, contextually defined and reflexive about its status, however critical, within the range of cultural studies. *Cultural Studies* is about theorizing politics and politicizing theory. How this is to be accomplished in any context remains, however, open to rigorous enquiry. As we look towards the future of the field and the journal, it is this enquiry that we especially hope to support.

Lawrence Grossberg
Della Pollock *January 1998*

Transferred to Digital Printing 2004

Advertisements: Enquiries to Routledge Journals,
2 Park Square, Milton Park, Abingdon, Oxon, OX14 4RN

Subscription Rates (calendar year only):
UK/EC individuals £30; institutions £108
North America: individuals $46; institutions $150
Rest of the world: individuals £30; institutions £108;
All rates include postage. Subscriptions to: Subscriptions Department,
Routledge, Cheriton House, North Way, Andover, Hants SP10 5BE, UK.
Tel: +44 (0)1264 343062; Fax: +44 (0)1264 343005

Periodicals postage paid at Rahway

Single copies available on request.

ISSN 0950-2386

Typeset by Type Study, Scarborough

Contents

VOLUME 12 NUMBER 2 APRIL 1998

Articles

Commentary

Book reviews

Lisa Cartwright

COMMUNITY AND THE PUBLIC BODY IN BREAST CANCER MEDIA ACTIVISM

Abstract

In this article, I consider how communities form around health care advocacy and activism. My concern is the place of visual media in the politics of breast cancer. Art photography and film are considered against mainstream images and media campaigns focusing on breast cancer. The primary work considered is the self-portrait photography of the artist Matuschka and the film *The Body Beautiful* by Ngozi Onwurah. I argue that these alternative texts help us to think about the ways in which issues such as race, age and beauty are key aspects in the experience of breast cancer, and not tangential cultural issues or 'appearance-related side effects', as one breast cancer support programme puts it.

Keywords breast cancer; community; body; media; mastectomy; photography

IT WOULD BE impossible to understand health cultures in the US without acknowledging the crucial role of media in their formation. Television, print media, cinema, online discussion groups and medical educational computer programs are important, if underconsidered means through which health issues are taught, communicated and lived. This article considers a few examples of breast cancer media produced by women who identify as activists, alternative media producers and members of the community of women affected by breast cancer. First, though, I want to address some of the problems that have made it difficult to think through questions of identity and community around health culture without also considering the role of media (film, print media, photography, video and digital technologies) in the incorporation of illness and survival as aspects of identity and community. In the discussion that follows, I try to demonstrate the importance of focusing on 'local' or 'minor' media productions – work by independent or alternative media producers, personal video and art photography – rather than mainstream media. As I will try to demonstrate below, the concepts

of *community* and *media* function in highly specific ways within health cultures, demanding analytic strategies that take into account the specificity of media users and audiences.

Health and community

Arenas of political action devoted to health care, illness and disability historically have formed on the basis of collective responses to experiences with illness and the health care system. Advocacy and activist groups, self-help and support groups, and more loosely based networks of individuals organized on the basis of shared experiences which might include having a particular illness and/or treatment, protesting lack of access to medical treatment, advocating for research, managing pain, needing emotional support, negotiating loss of bodily functions, identifying as a survivor, confronting iatrogenic illness, facing ongoing disability, or doing support work or caregiving. Whereas broad social networks have formed around breast cancer generally (for example, the National Breast Cancer Coalition (NBCC)), groups have also organized themselves on the basis of these more delimited issues as well as on the basis of identity or region (the Chicago Lesbian Community Cancer Project, or the Atlanta-based National Black Women's Health Project). What are the implications of using the terms *identity* and *community* to refer to groups that coalesce around illness and/or disability? There are important discontinuities between health status as a category of identity or community and the more familiar identity categories of ethnicity, race, nationality, gender, class and sexuality. Akhil Gupta and James Ferguson present a version of current thinking on community formation that helps me to access this issue. They state:

> something like a transnational public sphere has rendered any strictly bounded sense of community or locality obsolete. At the same time, it has enabled the creation of forms of solidarity and identity that do not rest on an appropriation of space where contiguity and face-to-face contact are paramount.
>
> (Ferguson and Gupta, 1992: 9)

In the fragmented world of postmodernity, Gupta and Ferguson argue, space has been reorganized in a way that forces us fundamentally to rethink the politics of community, solidarity and cultural difference. They make this point with regard to an issue wherein space – its occupation and its ownership – is essential in a particular way: they are concerned with the establishment of groups such as displaced and stateless peoples, ethnic groups, exiles, refugees and migrants. But what are the implications of this idea of the obsolescence of bounded community and locality when we consider collective identity as it

forms, provisionally, on the basis of illness, disability and the fight for access to treatment? Do reterritorialized space and transcultural formations become metaphors, or is there a parallel reconfiguration and dispersal of collective identity in the postmodern experience of breast cancer? For example, would it be accurate to describe survivors of breast cancer as a transcultural or transnational community because breast cancer strikes women of all classes, ethnicities and nationalities?

'Community' formation on the basis of health and illness is always highly provisional and unstable, in part because group formation takes place on the basis of a condition or experience that is always strongly determined by more conventional identity categories. Illness is not necessarily attached to, but must always be lived through, other categories of identity and community – categories that come into play at every level of the construction of publics and cultures around disease. In short, illness may take on the trappings of an identity category; it may be the basis for the formation of a (highly conditional) community, and it may be the grounds for the formation of a public sphere. But the experiences and cultures of illnesses none the less are always lived through identity positions and arenas of public and professional discourse that exceed the frameworks and cultures of disease. This is further complicated by the fact that 'illness communities' are comprised of people whose respective identities as ill or disabled shift throughout the course of a disease. Within breast cancer communities, one might occupy the position of caregiver, patient and survivor at different points in time, or even simultaneously.

While distinctions among these positions are fairly well acknowledged within groups formed around health issues, differentials of class, cultural identity, ethnicity and sexuality are quite often bracketed in order to underscore the unifying factor of disease. The online breast cancer listserv, for example, is comprised of women with breast cancer, survivors and their caregivers (doctors, health professionals, hospice workers, friends and family). The individuals who participate in this forum forge conditional bonds on the basis of their day-to-day experiences. But this kind of transcultural alliance sometimes problematically fulfils the conditions of Habermas's concept of a liberal public sphere, rather than becoming an increasingly more interactive, less rigidly class-, race- and nation-based model of a public. In broad-based groups like the breast cancer listserv or the NBCC, participants from disparate backgrounds bracket cultural differences on the basis of a common experience with breast cancer. This approach is to be lauded for its emphasis on the pervasive scope of the disease, but it provides limited means for addressing the class and cultural specificity of the experience, diagnosis and treatment of breast cancer among women of different ages, economic groups, regions and designated races. Following the model of white middle-class women's organizations in the 1970s and earlier, broad-based support groups tacitly uphold the liberal fantasy of a quasi-universal discourse among women.

What I am arguing against here is the idea that disease is the great leveller, or that coalition politics can or should smooth over differences as they impact on experiences of disease and disability. Much of mainstream breast cancer media so far has elided these differences. For this reason, I have chosen to focus on media texts that emphasize the specificity of different women's experiences with breast cancer. The work I have singled out for attention falls into the categories of alternative or activist media. Rather than looking at material like public service advertisements, *Primetime* feature stories and Lifetime television specials, I will be considering activist and art photography and video. Before turning to this work, however, I want to look more closely at some presuppositions that often accompany the analysis of non-mainstream media.

Health care and alternative media

The analysis of activist media often relies on a binary model that sets off local, oppositional, community-based groups against the globalizing force of mainstream medicine and media institutions. Much recent health care activism, however, crosses the boundaries between these two spheres. Groups like ACT UP (AIDS Coalition to Unleash Power) and the NBCC include among their members media and medical professionals with entrenched institutional practices as well as patients and lay advocates. In many areas of political organizing, alliances, however uneasy, have been forged across genders, classes, professions and cultures. What is new here is not what counts as community or coalition, but the fact that the crisis of illness, and not an aspect of shared identity in the conventional sense, is the basis for alliance. In the past decade we have seen an unprecedented degree of influence over medical policy brought to bear by medical countercultures composed of patients, activists and nonprofessional caregivers. The very idea of a counterculture as an extra-institutional force becomes complicated when we consider this traffic between the medical professions and activist groups and the role of laypersons in policy making.

Some of the more significant media activity shaping US health culture is taking place through advocacy, activist and community health groups using visual media as a prime form of public intervention. It is essential to consider how agents within these arenas gain a public voice; how they acquire access to decision making at the level of the institution or the state; and what the relationship is between media productions that originate from a position of activism or community politics (AIDS videos, breast cancer awareness pamphlets) and those that originate within 'minor' public spheres whose position at the margins of public culture does not necessarily stem from oppression, or from a stance of opposition. Progressive work in medicine is not necessarily coming only from practices identified as countercultural or as oppositional, as I will try to demonstrate below in the case of the work of photographer Matuschka. When we look

at the interaction among various media forms (political cinema, mainstream pho-
tojournalism) and various public constituencies, it becomes difficult to theorize
'media activism' as a unitary sphere situated outside institutional medicine, or
outside a mass public culture.

Viewed in this light, the binaries of a public and a counterpublic, mainstream
and activist politics become less than productive analytic models. These formu-
lations parallel the media studies binaries of broadcasting and narrowcasting,
mainstream media and alternative media. The terms *counterpublic* or *countercul-*
tures suggest oppositionality, when in fact many alternative publics are forged
around the increasingly fragmented special interests that constitute the global
market. Likewise, the term *narrowcast* implies marginality of those cultures tar-
geted (ethnic groups, special interest groups, exilic cultures, language groups,
and so on), when in fact these groups are often comprised of financially and
politically powerful, if numerically small, sectors of the viewing public.[1]

Within media studies, the concept of the local more often appears in writ-
ings about alternative media production, decentralized community-based pro-
gramming, and activist media. The term carries connotations of appropriation
and resistance to mainstream media politics and institutionally sanctioned uses
of technology. If much of the literature on media assumes a singular monolithic
form, failing to account for the specific conditions of discrete media forms and
uses, writings about alternative media often construct the flip side of that image
– what Coco Fusco (1988) has dubbed 'fantasies of oppositionality', totalizing
accounts of resistant media strategies that do not take into account the partial
and specific constituencies, locations and effects of particular media interven-
tions.

In the case of the breast cancer media texts I consider below, gender, class
and cultural identity become key factors in the formation of distinct public cul-
tures around breast cancer. Moreover, I argue, within these cultures, there is no
unitary concept of breast cancer. The disease is represented and lived through
issues such as class, beauty, fashion and ageing. Emotions such as anger, pain and
fear are tied to the correlated effects of disease and ageing, hair loss through
chemotherapy, and the physical, visible transformation of that iconic and
fetishized body part, the breast. Audre Lorde emphasized this cultural aspect of
breast cancer in *The Cancer Journals* (1980) when she criticized 'other one-
breasted women' for 'hiding behind the mask of prosthesis or the dangerous
fantasy of reconstruction' promulgated by groups like Reach to Recovery, the
American Cancer Society's signature programme for women with breast cancer
(Lorde, 1980: 16). R2R, developed by breast cancer patient Therese Lasser in
1952 (when the Halsted radical mastectomy was the conventional treatment),
was based on the then radically new idea that laywomen who had experienced
breast cancer could provide a unique kind of emotional support for other women
in recovery. In officially adopting this programme in 1969, the ACS placed certain
topics off limits for discussion, such as family relationships, doctors and the scar

itself, emphasizing instead the goal of convincing women with mastectomies that they do not have a handicap but a condition from which they can recover – given the right attitude, clothes and prosthesis. Lorde cautioned that this sort of 'cosmetic sham' would undermine the sense of community and solidarity necessary for women with breast cancer to organize effectively (Lorde, 1980: 16).[2]

The circumstances that Lorde described in 1980 – the depoliticizing cosmetic cover-up of not just the (missing or altered) breast but the cultural and personal difficulties surrounding the disease and its aftermath – have taken on new proportions. In 1988, the ACS launched 'Look Good, Feel Better', an initiative conducted jointly with a charitable foundation set up by cosmetic manufacturers in which women receiving breast cancer treatment are invited to their hospitals for LGFB programmes, essentially group makeover workshops in which they get tips on such things as devising stylish head coverings and applying makeup. Anthropologist Janelle Taylor, in a critique of the marketing of beauty products to women under the guise of charity, describes an LGFB advertisement that appeared in *Mirabella* concerning 'appearance-related side effects of breast cancer'. The advertisement argues that 'When you give yourself an original Oscar de la Renta design, you're not the only one who gets something beautiful . . . you're helping in the fight against breast cancer. . . . So give. And get' (quoted in Taylor, 1994: 30). Often marketed in the conjuncture of breast cancer and fashion are particular items which take on status as fetish and icon (the scarf as a means of concealment and adornment, standing in for lost hair; the shoe as a fetish object *par excellence*). A similar message is conveyed in an ad for Larry Stuart shoes, part of a spread promoting the autumn 1994 three-day charitable event of the Fashion Footwear Association of New York (or FFANY, an acronym that suggests displaced attention from the breast to the buttocks). The event, sponsored by 800 companies, was a shoe sale held at the Plaza Hotel in New York. The advertisement presents a photograph of mud-covered hiking boots with the caption 'these are for war'. Below this is a second image of shoes – classy black suede T-strap pumps with a matching evening bag. These shoes, the advertisement tells us, 'are for the war on breast cancer'.

If these are part of the uniform for the war on breast cancer, we might ask the question: Where is the battleground? Apparently 'the foot that comes down against breast cancer', to borrow a line from the Larry Stuart advertisement, is shod in the signifiers of conservative femininity. My issue with this advertisement is not that it suggests that activists might wear heels, or that I think corporate America is not a viable battleground for cancer activism (it most certainly is). Rather, it is part of a broader trend in which liberal and right-wing campaigns appropriate the strategies and language of more progressive campaigns and movements, changing their constituencies and goals in the process. It has been widely acknowledged that AIDS activism of the 1980s and early 1990s was a model for the development of a broad-based campaign against breast cancer in the 1990s. But whereas in the 1980s AIDS activism was hardly a mainstream

campaign, by 1996 breast cancer has emerged, in the words of journalist Lisa Belkin (1996), as the year's hot charity.

Lorde (1980) argued that 'the socially sanctioned prosthesis is merely another way of keeping women with breast cancer silent and separate from each other.' The advertisement and programmes of the 1990s described above, all of which promote beauty aids as prosthetic means of recovery, suggest instead that the media cultures of fashion and beauty technologies do provide a resource for community building. However, this process appears to be occurring predominantly among those women concerned about breast cancer who are invested in conventional notions of gender, body and beauty. The problem we face is not that women are depoliticized, silent or separate, but that the media-savvy breast cancer activism that has emerged in the late 1990s constructs the breast cancer community around a set of signifiers that includes white, straight, middle and upper class, urban, educated, professional and conservative. In addition to marginalizing women who are poor or working class and/or less well educated (and who are less likely to have access to information and treatment), this concept of community also fails to acknowledge the lifestyles and concerns of women who do not share the politics, fashion preferences or sexual orientation of the collective profile tacitly generated by this media campaign.

In the texts I consider below, alternative media producers take up breast cancer via beauty and fashion in reflective and innovative ways to provide new, non-normative ways of constructing the post-operative body. The formation of communities and public cultures on the basis of breast cancer politics entails a reconfiguration of the post-operative female body in public space. Breast cancer culture becomes a crucial site for the re-evaluation of what counts as a beautiful body, and what meaning age, race and cultural identity have in a culture where disease and health technologies are reconstructing what a healthy body is, and what particular body parts mean.

Activist photography

Alisa Solomon's important essay chronicling breast cancer activism, 'The politics of breast cancer', appeared in the *Village Voice* in May 1991.[3] Significantly, the article begins with an ironic anecdote about a post-op breast surgery patient named Miriam who is visited by a R2R volunteer – a woman with big hair and nails and a body-hugging Lana Turner-style sweater. To Miriam's consternation, the volunteer's main agenda is the prosthetic recovery of Miriam's breast – that is, her body's public return to normative standards of female bodily form. Until the early 1990s, the typical media image of a woman with breast cancer was the smiling, middle-aged white woman, identified as a survivor – a woman whose clothed body and perfectly symmetrical bustline belied the impact of breast cancer. A 1995 episode of *Chicago Hope* typifies this public fantasy of survival as

physical restoration. The episode features a teenage girl. She is African-Ameri-
can and beautiful – and, tragically, she has breast cancer. This perfect young body
loses a breast to mastectomy. However, by the end of the episode a skilful plastic
surgeon returns the girl's body to its near-perfect state. We are given a view of
the young woman's reconstructed body as her mother exclaims to the doctor:
'How do you do what you do?' Here the body of the woman with breast cancer
is finally made public. However, the body which this episode makes available for
public display is a black woman's body, a move that replicates the medical tra-
dition of using the bodies of black women for teaching demonstrations and text-
book examples. The privacy of white women's experience with breast cancer is
thus maintained. Moreover, this episode culminates by displaying the body of the
woman with breast cancer at a moment when all signs of disease and its treat-
ments are erased. Elided is not only the scar of the unreconstructed breast, but
the fact that the great majority of women with breast cancer are far from young.
Like many print advertisements promoting mammograms, the *Chicago Hope*
episode makes invisible the factors of age and associated issues of beauty that are
relevant to the majority of women with breast cancer, while including black
bodies only to replicate a centuries-old problem in Western medical represen-
tation.

The repression of the image of scar tissue, hair loss and ageing is not limited
to the popular media. Two years after the publication of Solomon's essay, her
title, 'The politics of breast cancer' was given to a flurry of feature articles pub-
lished in the scientific, liberal feminist and mainstream presses. In 1993, *Science*
(Marshal *et al.*, 1993) and *Ms* (Rennie *et al.*, 1993) both published special sec-
tions with the same title. Interestingly, neither series features the female body in
any significant way. *Ms* used a typeface graphic design on its cover and illustrated
the personal vignettes that were scattered throughout the essays with small, flat-
tering portraits of smiling 'survivors' with symmetrical bustlines. *Science* opted
for what the editors described as 'a statistical portrait of breast cancer' (a display
of graphs and charts) along with the great men of science approach (the only
actual portraits in the piece were head shots of scientists credited with research
breakthroughs).

Surprisingly, it was the *New York Times Magazine*'s variation on Solomon's title
theme that provided a radical twist on the mainstream tendency to disembody
breast cancer. To illustrate 'The anguished politics of breast cancer' by Susan
Ferraro, the cover story for 15 August 1993, the *New York Times Magazine* editors
chose for the cover a photograph of a stylishly thin woman wearing a high-fashion
white sheath and headscarf, her dress cut low on the diagonal to reveal the
woman's mastectomy scar (Figure 1). The prominently placed publication of this
image, a self-portrait by the artist Matuschka titled 'Beauty out of damage',
marked a watershed in media representations of breast cancer. Matuschka, an ex-
fashion model and photographer, not only exposes her scar to public view, but
artfully frames and lights it for optimal display. As she puts it, 'If I'm going to

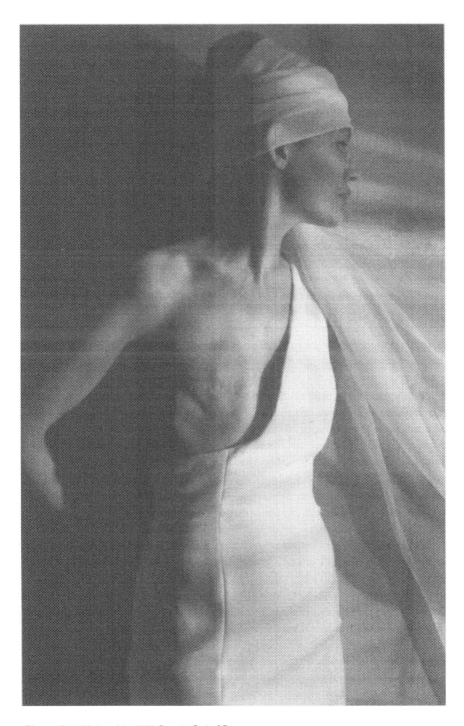

Figure 1 © Matuschka 1993 *Beauty Out of Damage*

bother putting anything on my chest, why not install a camera?' (Matuschka, 1992: 33). The scar occupies the space closest to the centre of the page, a locus towards which the eye is drawn by angles cut by Matuschka's arm and the shadows created by her prominent bone structure and the gown's neckline. Matuschka's head is in profile, turned away from the camera, as if to dramatize the large caption that fills a portion of the page to pronounce: 'You Can't Look Away Anymore.'

The publication of 'Beauty out of damage' was a watershed in the public representation of breast cancer because it rendered public an image previously familiar only to medical students and doctors, and women and their caregivers, families and close friends. The image stunned the *New York Times* public because it exposed physical evidence of breast cancer surgery that previously had been subject to repression in the mainstream press, with its images of smiling survivors and charts. It generated a vast outpouring of commentary by readers both in support of and in opposition to the paper's editorial decision to use this image on its magazine cover. While some readers saw in the photograph the message that women who have undergone mastectomy are not victims to be pitied and feared, and the altered or missing breast as something not to be prosthetically and journalistically covered over and restored, others saw the image as an inappropriate display of private parts and private matters. The issues that concern me most, though, are the photograph's representation of age, beauty and agency, and its apparent evocation of the natural and the technological as they pertain to these issues.

Solomon, in her account of Miriam and the Reach to Recovery volunteer, suggests that the volunteer projects an outmoded politics of the body onto the post-operative Miriam. She relates that Miriam is offended by the volunteer's assumption that prosthetic simulation or restoration is the first step to recovery. Solomon seems to advocate, along with Lorde, a public body that bears its scar as a natural and perhaps even healthy condition. This body is represented in a photograph used to illustrate her *Village Voice* essay of 1991, photographer Hella Hammid's 1977 portrait of Deena Metzger, titled 'The warrior'.

Metzger was 41 years old when she was diagnosed with breast cancer in 1977. In a recent interview she recalls that after her mastectomy 'When I went to a health club – even a women's health club – I noticed that I was the only one in the place with a mastectomy. I began to understand that women who had mastectomies were not showing their bodies.' A poet and novelist who had been fired from her tenured professorship for reciting a poem she had written about censorship (she eventually won an appeal in the Supreme Court), Metzger was not one to comply with the times and hide her body. Instead, she adorned her scar with a tattoo to better display it. 'If I were sitting in a sauna or I would be swimming or something, because my chest was tattooed, it was implicit that someone could look at my body,' she explains. 'In this intimate setting, women would turn to me and say, "Thank you," and they felt relief. They saw having a mastectomy was not the end of the world.'[4]

Wishing to document the scar and tattoo, Metzger contacted Hammid, whose previous work included child photography shown in *The Family of Man* exhibition curated by Edward Steichen for the Museum of Modern Art in the 1950s. 'The warrior' features the nude torso of Metzger, her white skin, naturally curly hair and exuberant expression framed against a backdrop of clouds. Her arms reach out in a gesture of openness to nature and the cosmos – a gesture that also exposes fully her single breast and her scar and tattoo, itself an image evoking nature (a tree branch). Like the image of Matuschka, this photograph puts a positive and politicized spin on the scar and the one-breasted female body, evoking Lorde's fantasy of an army of one-breasted women confronting the medical establishment. But the two images differ in an important way: Metzger's curly hair, unclothed torso and setting evoke an aesthetic of natural beauty and health. She is shot against the sky, as if euphorically reaching to recovery without the aid of technology. As journalist Delaynie Rudner has remarked, the image 'draws you in with a touch of innocent hippie celebration' (1995: 15). Rudner describes Hammid's photograph of Metzger as the perfect 'first' in the non-medical imaging of a mastectomy scar. Whether or not this is true, the image certainly presented a stunning alternative to the ongoing medical tradition of representing mastectomies, wherein women's faces are blacked out or their heads cropped off to maintain anonymity. 'The warrior' sends a clear invitation to look and to acknowledge that a mastectomy can be healthy and happy without being physically 'restored'.

Matuschka's self-portrait is a far cry from this upbeat late 1970s depiction of pleasure in the post-operative body in its 'natural' state. Matuschka occupies a stark environment suggesting both clinic and urban art studio – sites where bodies and body images are technologically transformed. Like Metzger, she looks away from the camera; however, her expression is serious if not severe. She is clothed in a form-hugging sheath that suggests both a hospital gown and formal evening wear, a garment that suggests the body's discipline and restriction within the terms of high fashion. Her headscarf, covering short dark hair, is reminiscent of the turbans preferred by some women to conceal the fact of their hair loss as a result of chemotherapy treatments. Matuschka's public image of breast cancer clearly advocates pushing the envelope of cultural expectations about the body within the fashion industry: she 'looks forward to the day *Vogue* magazine would consider devoting an entire issue to the dozens of beautiful one-breasted women who live all over the world' (Matuschka, 1992: 33). While Metzger's scar is displayed in a manner that seems to promote its joyous revelation, Matuschka's is artfully lit and framed to emphasize the role of concealment and display in its disclosure. And whereas 'The warrior' puts forth the post-operative woman as a naturally beautiful figure, 'Beauty out of damage' suggests a concept of beauty whose aesthetic involves an appreciation of the fashioning of the body. The photograph seems to suggest that far from destroying beauty, mastectomy can be appropriated for a politicized display of high-tech beauty. In a new twist on techno-aesthetics, mas-

tectomy joins the repertoire of body-altering surgical techniques that have gained currency in 1990s mainstream fashion, techniques that include breast prosthetics, implants and reconstruction; liposuction; face lifts; tummy tucks; eyelid reconstruction, and body piercing. While some of these techniques are associated with the impetus to render the body closer to cultural norms, others appeal to cultural constructions of the exotic or the unique.

While the association of one-breastedness with disease makes it unlikely that this condition will ever be incorporated into mainstream beauty culture, Matuschka's photograph goes a long way towards placing the fact – and the look – of this bodily state into public consciousness. I am not arguing that Matuschka's self-portrait critiques the technological alteration of the body offered in processes like breast reconstruction or the use of prostheses. Rather, my point is that this portrait foregrounds the scar as a physical and aesthetic transformation of the body that is as significant to the experience of breast cancer as these other techniques and their more conventional (and familiar) results. In this image, Matuschka has opted to reclaim the scar as an object of aesthetic and political significance and, more profoundly, as an object of fascination, if not beauty.

Despite its appearance in such a well-respected public site, Matuschka and her photograph, 'Beauty out of damage', were not embraced by the breast cancer community as universal signifiers of the current state of breast cancer politics. The magazine cover image was nominated for a Pulitzer prize in 1994, but this moment did not necessarily mark a shift in the public politics of breast cancer. The photograph, like previous and subsequent work produced by Matuschka, was not received with universal enthusiasm. That some readers were dismayed by this editorial decision is clear from some of the many letters to the editor which followed the story's publication. Indeed, author Susan Ferraro forewarned readers of the controversial nature of Matuschka's work: 'Her poster-size self-portraits have shocked even some of her mainstream sisters,' she writes. This is not surprising, since Matuschka's work circulated primarily in activist and art venues such as demonstrations and exhibitions including the Women's Health Show, a multi-site show mounted in gallery spaces around New York City in the winter of 1994.

Despite this public perception of Matuschka as too controversial or radical a figure, her identity as an activist and member of a health care counterculture is far from secure. Originally a photographer's model, Matuschka's transition into breast cancer activism was, in her own words, by chance. Although a member of the Women's Health Action Mobilization (WHAM!), an activist group close to ACT UP in its tactics and structure, Matuschka's relationship to health activism seems to have been largely through the group's embrace of her work. As she explained in an interview,

> WHAM! discovered me. I didn't even know what WHAM! was. I was at a
> talk-out on breast cancer in Washington, D.C., in front of the legislature

and various other politicians back in 1991. I was on chemotherapy. I was wearing a blonde wig, and I had already made a bunch of posters. . . . Evidently, when I got up and spoke I moved a lot of the audience. There were two or three WHAM! members there, and they had just started a breast cancer department. They said that they would like to use one of my images, and asked me to come to one of their meetings. So I went to their meetings. That's how it began.[5]

Conventions like the DC talk-out provided Matuschka with a venue to market her photographs in the form of postcards and posters. It was at the Breast Cancer Coalition Convention in California in May of 1993 that Susan Ferraro encountered Matuschka by chance, displaying her posters on her own body, sandwichboard style (she had been barred from selling them). Andrew Moss, the editor of the *New York Times Magazine*, explained that Matuschka was called when the magazine decided to run Ferraro's story, which included material on Matuschka, at the eleventh hour, and they had only a few days to locate a cover image. According to Matuschka, the magazine specified that they wanted an image with a face but no breast. Moss's account suggests that the photo struck the editorial team 'like a hammer', leaving them unanimously committed to using it for the cover.[6]

Matuschka's ambiguous status as, on the one hand, conventional model and art photographer and, on the other, activist-by-default, allowed her to emerge as a public icon of breast cancer activism in a mainstream media venue like the *New York Times*. Likewise, her ambiguous status as both youthful/beautiful and 'damaged' (to quote the term she chose for her photograph's title) allowed her image to play a particular role for a particular set of readers. For the photograph in question was undoubtedly targeted to a very specific readership, those who get the *New York Times* – those women whom Ferraro identifies as the 'mainstream sisters' who might be offended by Matuschka's more daring work (Figure 2). Presumably these women might be willing to participate in 'activism' in the form of liberal political pressure groups and advocacy organizations – FFANY, for example. *The Times* tacitly marketed Matuschka the activist as an evocative but acceptable symbol of white, urban, middle-class, professional women's breast cancer activism. Ferraro's article documents and constructs an activist countersphere whose ties to nineteenth-century liberal counterspheres of women-only voluntary associations are strikingly apparent, if not stated outright. Breast cancer, in this formulation, is a disease with its own class aesthetic, culture and constituency.

In sum, this image that apparently functioned as a mass public icon was in fact identified with a relatively elite sector of women. The public image of breast cancer which it puts forth tacitly incorporates whiteness, youth, thinness and urban chic as core elements of the collective body for which the activist feminist body collectively speaks. Yet very rarely do we see public representations of

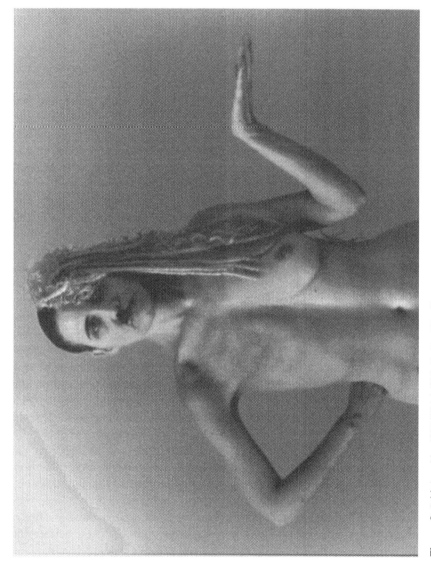

Figure 2 © Matuschka 1994 *Which Side Do You Want?*

older women (in their fifties and sixties, say), who constitute the greater majority of breast cancer cases in this country and who certainly comprise a large percentage of the *New York Times Magazine* readership. Photographs like the self-portrait of artist Hannah Wilke and her mother, from a series produced between 1978 and 1981, are much less likely to circulate in public venues. This image documents Wilke's mother's breast cancer. Wilke, like Matuschka, built her career on self-portraits, many of which featured her nude and youthful, slender body. In the early 1990s, Wilke ended her career with 'Intra-Venous', a series of nude self-portraits of her own ageing and cancer-ridden body. Not surprisingly, this series, which documents her treatment for lymphoma (the disease from which she died in 1993), received far less attention than her earlier work.

These points about the factor of age in representations of breast cancer lead me dangerously close to making an argument in favour of some sort of media realism: 'breast cancer campaigns should depict older women' and so forth. This is hardly my goal. Rather, I am in favour of representations that take up the complexities of age and beauty as they pertain to specific groups of women for whom breast cancer is most immediately a concern (women in their fifties and sixties) as well as those women categorically left out of discussions about breast cancer media (for example, black women). It is worth recounting here a well-known tenet of feminist film theory: audience members do not always or necessarily recognize themselves in images of 'their own kind' – that is, older women may not necessarily identify any more with images of other older women than they will with images of, say, younger women. (If this were not the case, Matuschka's image would not have received the broad-based response it got.) Perhaps the inordinate number of representations of youthful, slender bodies in mainstream breast cancer media campaigns is not an error on the part of media producers, but an effective use of the mechanisms of identification and fantasy that invite viewers to look at and identify with particular bodily ideals and particular cultural norms, regardless of their own age and appearance.

To elaborate on this possibility, I will turn to a second media text, Ngozi Onwurah's *The Body Beautiful*, a 1991 experimental documentary film about the relationship between a young woman – a teenage bi-racial fashion model – and her mother, a white woman in her fifties who is disabled by rheumatoid arthritis and who bears the memories and the scars of breast cancer surgery. This loosely autobiographical film foregrounds the cultural aspects of breast cancer that are repressed not only in the erasure of the post-operative body, but in the elision of cultural difference among women impacted by the disease.

The Body Beautiful

In the United States, Onwurah has been represented as a black British film-maker, a documentary film-maker whose work circulates in the women's film

festival circuit. These designated categories of race, nationality and genre inform the reception of her three best-known films currently in circulation in this country (*Coffee-Colored Children*, 1988; *The Body Beautiful*, 1991, and *Welcome to the Terror Dome*, 1994). However, what is less than clear from the promotion of her work in the US is that Onwurah is not only British but also Nigerian. Whereas in the US she is most often identified as a black film-maker, in England she is recognized (and identifies herself) as mixed-race. Her films are also difficult to categorize within the limited terms of US film criticism: they combine techniques of conventional and experimental documentary and narrative, resisting categorization within any of the groups of 'black British cinema' familiar to US independent film audiences.

By introducing Onwurah in this manner, I mean to highlight the fact that race is as provisional and circumstantial a category as illness or disability. As *The Body Beautiful* aptly demonstrates, cultural identity and disability can also be interconstitutive categories. While Onwurah shares a history, a national identity and representational politics with many black British film-makers, her work is structured through a discontinuity that also shapes cultural identity and representational strategies in highly particular ways – that is, in ways that, for Onwurah, have to do not only with having been raised in Nigeria and exiled to England at the age of 9, but with her subsequent experience as an exoticized beauty, a professional model whose commodity is her light-skinned body and her ambiguously African-Anglo features. Both *The Body Beautiful* and Onwurah's earlier film *Coffee-Colored Children* demonstrate that race is a historical category that can be structured through experiences such as exile, loss of a father, a mother's disability, and a general loss of the unity and stability of such basic categories as family and body. Onwurah's identity is deeply informed by her status as the daughter of a white, disabled and scarred mother – a woman with whose body she strongly identifies, and a woman whose erotic and identificatory investment in the beauty, youth and colour of her daughter's body is also profoundly deep. *The Body Beautiful* is primarily about Madge and Ngozi Onwurah's relationship to public perceptions of ageing, disfigurement and disability. But, as in the print media breast cancer coverage discussed above, questions of identity (nationality, race, class, sexuality and gender) and related issues (health, beauty, ageing) are the fundamental terms through which this film engages with public views about breast cancer.

In the central scene of the thirty-minute film, Ngozi convinces her mother to accompany her to a sauna (coincidentally also the site of Metzger's enlightenment about the public repression of the scar). Inside the sauna, women lounge bare to the waist. Madge keeps her towel wrapped up high, covering her mastectomy scar. But she dozes off and the towel slips, exposing her scar. While Madge sleeps, Ngozi witnesses the stares of the women in the sauna as they look and turn away from her mother's scar. Madge wakes up, almost instantly feeling for her towel and pulling it up over her chest, looking around in shame to see if anyone has noticed.

This scene performs a function not unlike that of Matuschka's photograph: the taboo mastectomy scar is placed on display, shocking a public audience, while the performer of this scene averts her gaze from the eyes of the viewer. But there are crucial differences between these texts. Whereas Matuschka's youthful and fashionably thin body is framed by a high-fashion sheath, Madge's plump, ageing torso is haphazardly draped with a towel. Moreover, while Matuschka clearly poses for her photograph, we gaze on Madge while she sleeps, ostensibly unaware of her position as spectacle. And while Matuschka as photographer actively proffers her body as both icon and model of what breast cancer can mean (albeit for women of a particular age, culture and class), Madge (who, significantly, plays herself in the film) performs at the direction of her daughter, who is behind the camera (and is played by an actor). If Matuschka's image is a performance of defiant pride and an assertion of the agency of the woman with breast cancer, Madge's is a staging of public embarrassment for the benefit of Ngozi's (and the viewer's) enlightenment. Ngozi (we) learns compassion and awareness of the meaning of Madge's difference through Madge's humiliation.

Matuschka's distinction, due in part to her status as media icon, buffers her availability as an identificatory figure for women viewers. Her function as a highly symbolic image precludes the shock of recognition available in the representation of Madge. In the scene in which Madge's body is exposed to the gaze of other women, the camera provides us with subjective shots taken from the point of view of the various women in the sauna, intercut with shots of these women from Ngozi's line of sight. The organization of shots invites the viewer to see Madge through the eyes of her daughter. We see Madge being seen by those women who clearly are made uncomfortable at the sight of Madge's body. It might be argued that Madge's body represents not only the unimaginable, unimage-able fear that any woman might one day be disfigured by breast cancer, but that age itself inevitably will generate bodily changes (sagging, weight gain, loss of muscle tone) – aspects of female bodily transformation held in general public contempt and denial. In a sense, the missing breast is just one signifier of Madge's bodily ageing; but the scene also represents Ngozi's shift from a strong identification with the body of the mother to her ability to see that body from a distanced, public eye. By shifting the emphasis from the scarred body as iconic (as in the case of Matuschka's photograph) to that body as a locus in the shifting politics of looking, *The Body Beautiful* is able to direct its viewers to work self-consciously through complex responses like recognition, identification and denial of bodily signs of disease and ageing.

The theme of the negotiation of the public eye and the iconic status of the marked body carries over from Onwurah's earlier film, *Coffee-Colored Children*, an experimental documentary devoted to recounting mixed-race Ngozi and her brother Simon's experience of growing up in Britain. In *Coffee-Colored Children*, we see the siblings as children being taunted with racial slurs, attempting to wash off their skin colour, and eventually coming to terms with the complex public

meanings of their bodies. *The Body Beautiful*, then, functions, like the earlier film, as a means of coming to terms with the body of the mother as a white body, but as a body that is also marked by a complex of other cultural identities and conditions. This is not to say that physical disability and racial identity are alike, but that disability is a process implicated in the construction of cultural identity along with race, class and gender; and that historically there has been continual slippage between the classification and ranking of bodies according to racial typologies and according to categories of health, disability and illness.

I want to consider this point more fully through one of the more controversial scenes in *The Body Beautiful*: a fantasy/memory scene featuring Madge. Leaving the sauna, Madge and Ngozi stop for a cup of tea. Madge spies a young black man playing pool and exchanging sexist banter with his friends, a conversation in which a woman's breasts are referred to as 'fried eggs'. As Madge looks on, the man catches Ngozi's disapproving narrowing of the eyes, and he returns her look with interest. This exchange of looks prompts Madge to recall a memory of her Nigerian husband. Madge states in voice-over, 'I saw the look in his eyes and remembered it from somewhere in the past. A single caress from him would smooth out the deformities, give me the right to be desired for my body and not in spite of it.' The shots that follow demonstrate the strength of the identificatory bond that exists between mother and daughter on the basis of one another's bodies. As Madge and the young man make love, the sound-track gives us Madge's subjective memories of the young Ngozi and her brother arguing. Intercut with this scene are shots of Ngozi the model, her lips and breasts being made up for a photo shoot, and Madge looking on and directing the love scene from an ambiguously situated off-screen space. Just as the mother lives through her daughter's public body, as if it were a prosthetic extension of the sexuality and youth she feels she has lost, so Ngozi imagines herself in control of the enlivening of her mother's sexual desires. Above all, Ngozi wants to return to her mother the sexual life she feels she has lost with the loss of her breast and (subsequently) her youth. However, rather than visually restoring her mother's body to some prior state of completion for the purpose of the fantasy, Ngozi demands that the scar itself must be rendered a site of sexual pleasure for both her mother and the young man. The shots of love-making between Madge and the young man are intercut with shots of Ngozi being made up and shot by a fashion photographer who commands, 'pump it up, give me some passion'. Like the photographer who directs her performance from off-screen space, the character Ngozi directs her mother's love-making scene from extradiegetic space. As the young man moves down Madge's torso with caresses and kisses, he hesitates at the scar. 'Touch it', Ngozi commands from her directorial position in off-screen space, 'touch it, you bastard'.

Without question, *The Body Beautiful* is about constructing a public image of breast cancer that goes beyond generalized notions of illness, disability and cultural identity. As Onwurah explains,

It wasn't simply just a mother–daughter thing. [The film] had all of the obvious stuff about the body and beauty, but it had quite a lot about race in it, too, almost by accident – things that I hadn't really thought about. For example, her fantasy sequence would need to be with a black man, and I wanted to try to get out of that. This sequence involved black–white, young–old, disabled–nondisabled. Just for this fantasy sequence, the film was going to take on all of these missions. At one point I was going to try to have a white guy in there, but mom was really insistent that her fantasies weren't just abstract fantasies. They were fantasies to do with her, and she wanted this black guy.[7]

The Body Beautiful demonstrates that public discourse on disability is always about issues such as desire and pleasure, race and age. But how does this film function within public cultures of health specifically? Who is the audience for this film? In the US, *The Body Beautiful* circulates through independent film venues. It has been shown at women's and experimental film festivals, academic conferences, and in university film and women's studies classrooms. In the United States, it is not a 'movement' film in the sense that it is not often screened among groups formed on the basis of health issues. However, the film has a very different set of venues in Britain. Onwurah explains:

In England, we have something called the WI [Women's Institute]. It's the kind of organization that Miss Marple would have belonged to in the rural areas. They have the largest women's health support network in the U.K. Their groups have actually used *The Body Beautiful*. And they're the most right-wing, the most conservative, that you can get. But I think that here [in the US] you actually have more restrictions or self-censorship on things to do with nudity, sex, or violence. I'm just beginning to realize this.

And

The Body Beautiful wasn't meant to be an educational film. It isn't a film for women who have just learned that they have breast cancer. You have to be a little bit down the journey to see the film. But still, it's used widely. Quite often my mom goes out with it, and its a completely different experience then. It's still mainly a filmmakers' film, a women's festival film. Its just too blunt. If someone diagnosed me with breast cancer and I saw the film the next day I think I'd go out and kill myself the day after, its so confrontational.[8]

The contradictions here are striking. In England the film is used in the most conservative sector of women's advocacy groups, yet it is too confrontational for even its own producer to tolerate if she were to watch it as a woman with breast

cancer. Here we see the same contradictions evident in the appropriation of acti-
vist Matuschka's demonstration posters for the *New York Times Magazine* story.
This suggests that perhaps in England as in the US we are seeing a blurring of
boundaries between institutional health cultures and countercultures, and
between mainstream and alternative media venues and audiences. Onwurah
herself emphasizes the importance of recognizing local conditions of use and
context:

> In Britain there is a burgeoning disabilities movement, and I definitely saw
> [the film] in the context of that. It had a place within the issues surround-
> ing the rights and disabilities movements. I've gotten involved because my
> mother's always been disabled and my grandmother was deaf since the age
> of two, so we used to sign with her.[9]

Earlier I posed the questions: What are the implications of this idea of the obso-
lescence of bounded community and locality when we consider collective iden-
tity as it forms, provisionally, on the basis of illness, disability, and the fight for
access to treatment? Do reterritorialized space and transcultural formations
become metaphors, or is there a parallel reconfiguration and dispersal of col-
lective identity in the postmodern experience of breast cancer? *The Body Beauti-
ful* speaks to these questions insofar as it addresses viewers across the bounded
communities of health educators, the British and American independent film
communities and disabilities movements, while also addressing issues of iden-
tity and its relationship to race, age, illness and disability. But while the film
addresses with great complexity the specific cultural issues framing experiences
of breast cancer, it none the less fails to generate a sense of community among
its diverse audiences. Most immediately, the film's display of an intergenera-
tional and interracial sexual fantasy and a physically close mixed-race
mother–daughter relationship place its message beyond the interests of many
mainstream viewers. Onwurah's own admission that she would not want to see
the film if she herself were facing breast cancer has been echoed by numerous
women who have been in audiences where I showed the film and spoke about
it. These points leave me facing a troubling contradiction: How are these issues
to be raised and worked through, if not by women to whom they are of the most
concern? Would it be better to bracket differentials of class, cultural identity,
ethnicity and sexuality in order to underscore the shared experiences of disease?
Are the effective media texts those that provide easy answers (for example,
prosthetic recovery) and false closure (a return to some ideal of a normal life)?
I would argue that work like Matuschka's and Onwurah's, 'difficult' as it may
be, performs the crucial task of widening the pool of collective images, expand-
ing the possibilities of what can be seen beyond outmoded norms and altering
historical concepts of the body beautiful to incorporate the effects of breast
cancer's limited treatment options.

Notes

1 See, for example, Hamid Naficy's study of the Iranian exilic community in southern California that both produces and views Persian-language programming – narrowcast cable shows that more often than not embrace family values and political views which would be regarded as conservative within Euro-American cultural standards (Naficy, 1993).

2 For a brief discussion of R2R and similar groups see Batt (1994: 221–37).

3 This essay, titled 'The politics of breast cancer', was republished in *Camera Obscura*, 28 (1992).

4 Quoted in Rudner (1995: 14–15). I am indebted to Rudner's essay for the information regarding the Hammid/Metzger photograph. He notes that the photograph was originally the inspiration for a book of poetry by Metzger titled *Tree*. When the publisher refused to use the image for the book's cover, Metzger used it to accompany a poem she wrote for a poster that became a cult item in feminist circles around the country. In 1992, in the third of its four printings, *Tree* was finally published with 'The woman warrior' on its cover (by Wingbow Press). Hammid died the same year of breast cancer (Rudner, 1995: 15–16).

5 From an unpublished interview with Matuschka by the author.

6 Moss and Matuschka are quoted in Rudner (1995: 24–6).

7 In Cartwright, 1994.

8 In Cartwright, 1994.

9 In Cartwright, 1994.

References

Batt, Sharon (1994) *Patient No More: The Politics of Breast Cancer*, Charlottetown, Canada: Gynergy Books.

Belkin, Lisa (1996) 'How breast cancer became this year's hot charity', *New York Times Magazine*, 22 December: 40–6, 52, 55–6.

The Body Beautiful (1991) Director Ngozi Onwurah. Distributed by Women Make Movies, New York City.

Cartwright, Lisa (1994) Interview with Matuschka. Unpublished.

Coffee-Colored Children (1988) Director Ngozi Onwurah. Distributed by Women Make Movies, New York City.

Ferguson, James and Gupta, Akhil (1992) 'Beyond "culture": space, identity, and the politics of difference', *Cultural Anthropology*, 7 (1): 6–23.

Fusco, Coco (1988) 'Fantasies of oppositionality: reflections on recent conferences in New York and Boston', *Screen*, 29(4): 80–93.

Lorde, Audre (1980) *The Cancer Journals*, San Francisco: Spinsters Ink.

Marshal, Eliot (1993) 'The politics of breast cancer', *Science*, 259, 22 January.

Matuschka (1992) 'The body positive: got to get this off my chest', *On the Issues*, winter: 30–7.

Naficy, Hamid (1993) *The Making of Exile Cultures*, Minneapolis and London: University of Minnesota Press.

Rennie, Susan, National Black Women's Health Network, Liane Clarfene-Casten and Carolyn Faulder (1993) 'The politics of breast cancer', *Ms*, 3 (6): 37–69.

Rudner, Delaynie (1995) 'The censored scar', *Gauntlet*, 9: 13–27.

Solomon, Alisa (1992) 'The politics of breast cancer', *Camera Obscura*, 28: 157–77. Also published in Paula A. Treichler, Lisa Cartwright and Constance Penley (eds) (1998) *The Visible Woman: Imaging Technologies, Science, and Gender*, New York: NYU Press.

Taylor, Janelle S. (1994) 'Consuming cancer charity', *Z Magazine*, 7(2): 30–3.

Michelle A. Stephens

BABYLON'S 'NATURAL MYSTIC':
THE NORTH AMERICAN MUSIC
INDUSTRY, THE LEGEND OF BOB
MARLEY, AND THE
INCORPORATION OF
TRANSNATIONALISM

Abstract

Bob Marley's significance as a popular cultural icon, both during his initial emergence in North America in the 1970s and after his death in 1981, has been a constantly evolving phenomenon. As American society and culture has adapted to the presence of new, racialized, West Indian immigrants, so too has Marley's legend been adapted to fit the changing moods of the past three decades. This article identifies and examines three aspects of Marley's changing image in the United States. From the Rastafarian outlaw of the 1970s through the natural family man of the 1980s to the natural mystic in the 1990s, Marley has represented ideologies of national liberation and black power, multiculturalism, universal pluralism and, most recently, transnationalism.

In this article, I show how the construction of Marley as the 'natural mystic' reflects the growth of the multinational corporation and mass media industries in this era of postmodernism and late capitalism. The resources and networks available to American record labels have been central to the wide-scale promotion of Marley's message across the world. However, in addition, Marley's life and work also profoundly benefited from a rich, century-long tradition of black internationalist movements and ideologies, which I term 'black transnationalism'. This black transnational legacy tells a larger story, one which contests the more mainstream

versions of Marley which have made him more palatable to a white liberal audience in America. He therefore stands as an interesting case study of the impact of black transnational cultural production on American popular culture.

Keywords black transnationalism; Bob Marley; music; reggae

> Rasta no abide amputation . . . I and I . . .
> don't allow a mon ta be *dismantled* . . .
> no scalpel shall crease me flesh!
> Dem cyan't kill Jah, cyan't kill Rasta.
> Rastamon live out.
>
> <div align="right">(Bob Marley)</div>

> Bob will come again. Like Christ he shall come in a new name.
>
> <div align="right">(Rita Marley)</div>

AMERICAN FANS OF JAMAICAN reggae music will have noticed over the past ten years an explosion of new musical and textual material on the life of Bob Marley, the Third World superstar who made reggae music an international phenomenon in the 1970s. In 1995, in celebration of the fiftieth anniversary of Marley's birth, Viking Penguin published the coffee table book *Bob Marley: Songs of Freedom*, and the Tuff Gong/Island label issued the CD compilation *Natural Mystic. The Legend Lives On: Bob Marley and the Wailers*. Both were follow-ups to previously released material. The book draws heavily from the layout, music and text of the 1992 CD boxed set of the same title, *Songs of Freedom*. The *Natural Mystic* CD compilation (1995) was conceived as the companion to *Legend: The Best of Bob Marley and the Wailers*, the LP collection first issued in 1984. Other recent paraphernalia and events have included a rock exhibit celebrating Marley's music that toured the United States throughout 1990, a number of documentaries, the most popular being *Time Will Tell* that was released on the home video market and remained in the top forty in video sales for up to a year and a half after its release in 1992, and various tributes, reissues and reggae covers which abound, including *The Family Album* (1994) and *Tribute to Bob Marley* (1994). The most recent and spectacular Marley monument is the three-dimensional exhibit at the Universal Studios theme park in Orlando. Florida.

The fact that Marley's 'legend' has lived on through the 1990s should come as no surprise. Bob was many things to many different people, at once revolutionary and spiritual, Third World and international, secular and mystical. In addition, Marley's revival as an object of consumer desire for the 1990s reflects market-driven considerations such as the lucrative cataloguing business of reissuing the work of dead rock stars. The 1984 *Legend* collection which initiated Marley's revival in the United Kingdom and the United States has been the

top-selling catalogue album since the catalogue chart's creation in 1991 (*Vibe*, August 1995: 138).

Bob Marley carries such cultural and commercial weight in North America because he embodies black *transnational* cultural production in the late twentieth century. Marley's life and career, his 'legend' as it were, reflects the two main features of contemporary transnationalism: the growth of international capital and the rise of the multinational corporation, particularly in the mass media industries, in this era of postmodernism and late capitalism (Jameson, 1991), and the increased back-and-forth migration of Third World citizens between core and periphery, First World and Third World, since decolonization.

The North American music industry has become a key site for exploring both the economic and cultural impact of transnationalism on American society. On the one hand, new Third World immigrants, 'new ethnicities' to quote Stuart Hall (1989), are key producers of much of the popular music of the United States. On the other hand, their music is controlled, sold and distributed worldwide by the North American record industry. In this article, I explore some of the features of transnationalism in the United States through the figure of Bob Marley.

Marley's popularity while he was alive and his legacy since his death on 11 May 1981 lay bare a common dilemma of the subaltern cultural producer: his or her battle against the monopolizing control of the culture industries over the production, distribution and profit to be made from their work. One of Marley's 1970s contemporaries, the group Parliament-Funkadelic, ceaselessly waged a battle with North American record labels on precisely these grounds. The band demonstrated their contempt for the industry by signing competing record conglomerates under a variety of different names. For Funkadelic, as for Marley, the chaos of the ensuing legal tangle was part of their subversion of the industry. In a recent interview George Clinton stated, 'My main thing is I don't want to happen to us what happened to James Brown, Bob Marley and Jimi Hendrix. Somebody [else] owns their music' (*Washington Times*, 25 October 1992). But Bob Marley's construction as the 'natural mystic' in 1990s American culture reflects not only the incorporation of his music but also the incorporation of his image and message. Here I use the term 'incorporation' both literally and figuratively, to refer to the increased corporate control over, and commercialization of, Marley's work, and to the specific way in which this has been accomplished symbolically.

According to *Webster's* (1968), the term 'incorporate' can have three possible meanings. First and foremost, 'to incorporate' can mean 'to unite with another body, forming a new unit, as in business'. Here the term refers to the financial activities of corporate mergers and conglomerations. Similarly, Marley's financial estate has been the source of much wrangling over the past ten to fifteen years as various parties attempt to claim, and therefore profit, from his prodigious recordings. In addition however, Marley's *cultural* capital in North America has increased the more 'incorporate' – 'without body or material substance' – he has become. The figure of the 'natural mystic' is a deliberately ethereal icon, one removed from

the very specific social and political context of reggae production in the 1970s. Marley's cultural value lies precisely in his status as the 'almost mythical ghost [that] still stands at the centre of the music' (*Maclean's*, 27 October 1986). But conversely, this article argues, both Marley's financial incorporation and his cultural incorporeality are determined by a prior cultural politics that emphasized his very corporeality. A third meaning of 'incorporation' is to be 'united in one body'. Marley's incorporation into North American popular culture has depended on the fetishization of his 'black body'. On the one hand his black body represents everything concerned with reggae and a primitive Caribbean. On the other, Marley's 'natural blackness' unites in one body a vision of racial harmony built on simple universalist ideals mystically removed from the history of race relations in the United States, Marley offers an image of blackness that has helped to preserve a *North American* identity built on the integration of racial differences into one unified national body politic.

Music critic Stuart Cosgrove (1989) summed up Marley's legacy in these terms: 'for American audiences, particularly white, Marley is the body of reggae, the figure at the center, the ghost haunting the beat.' In the first section of this article I explore the ways Marley's image and corpus have changed in the United States over time. The figure of the 'natural mystic' is the culmination of a posthumous ten-year process which first humanized Marley in the 1980s in order to immortalize him in the 1990s. The 1980s were an important transitional moment in the production of the 'natural mystic'. During much of this decade, the memory of an edgier Marley from the 1970s was much too close to be immediately incorporated into a universal and transcendental narrative. The Marley of the 1970s, rude boy, revolutionary, Rastafarian, needed to be exorcised for the singer to appeal to a more mainstream white audience. This was accomplished by more intimate portrayals of Marley as the family man (Gilroy, 1993), the lover of both women and children. This process of 'humanizing' Marley helped set the stage for his more mythic status in the 1990s. The 1980s took both Marley and his fans from the man to the myth, the body to the ghost, the natural man to the natural mystic.

The narrative of Marley's legend in the United States is also a story of the relationship between black musics, transnational forces and American national identity in the late twentieth century. The second half of this article examines how Marley's potential heirs, cultural producers within the United States, multinational corporations and black audiences are using his legacy to understand our current situation of economic and cultural globalization.

From 'legend' to 'natural mystic': the body and soul of Marley

Since Marley emerged as a popular cultural icon in North America in the 1970s, his significance has constantly evolved. As American society and culture has

adapted to the presence of new, racialized immigrants, so too has Marley's legend been adapted to fit the changing moods of the past three decades. One can trace this development in three stages:

- The 1970s moment of postcolonial, revolutionary nationalism in the Caribbean, concomitant with the increased migration of West Indians to the United States post-1965, and their initial impact on both black and white American society and culture.
- The incorporation of these immigrants and their American-born children into a newly imagined multicultural American family throughout the 1980s.
- The transnational moment of the 1990s, that situates multicultural America and multinational capital in a global circuit of cultural exchange and labour migration.

Bob Marley's shifting meanings in American culture during these three periods was captured in four cultural documents: the 1972 film *The Harder They Come*, the two CD compilations *Legend* (1984) and *Natural Mystic* (1995), and the four CD boxed set *Songs of Freedom* (1992). Together these four texts stand as an evolving story of the new West Indian immigrants to America since the post-1965 immigration wave.

During the 1970s Marley introduced into American culture and popular consciousness two radical images of the West Indian immigrant. On the one hand, due to his own youthful interactions with other 'bad boys' in the ghetto streets of Trench Town, Marley was known as 'Rude Boy Tuff Gong', a representative symbol of the new impoverished youth coming to political (and criminal) consciousness in 1960s and 1970s Jamaica. On the other hand, after his conversion to Rastafarianism in the late 1960s, Marley also represented this spiritual political cult to the world outside of Jamaica.

These two images of the West Indian came together in the cult classic *The Harder They Come*, which featured Marley's contemporary Jimmy Cliff as the gangster musician Ivan Rhyging. The identification of the Rastafarian/singer with the rude boy/outlaw became a trope of music and film, both in the Caribbean and in the United States. Marley the Rastafarian and Marley the rude boy connected the spiritual and mystical elements of Rastafarianism with a protest against the social conditions of impoverished and ghettoized blacks around the world, producing what would later come to be known as 'roots and culture reggae'. It was precisely because he enabled popular political identifications on these grounds that he was able to have such a profound galvanizing impact throughout the black diaspora and the postcolonial community.

But the Rastafarian/rude boy also epitomized the 'existential outlaw' which white intellectuals such as Norman Mailer were looking for in the realm of black masculinity (Murray, 1989: 78). This image of the Rastafarian outlaw, while liberatory for many black and Third World audiences, also served as the raw material for a corporate fashioning of the performer which would escalate in the

late 1970s and early 1980s after his death. As Paul Gilroy (1987: 169) has described it:

> The gradual involvement of large corporations with a broad base in the leisure industries in the selling of reggae stimulated important changes reflecting a conscious attempt to separate the product from its producers and from its roots in black life . . . [and] it marked the beginning of a new strategy for white consumption. Cinemas showing the film [*The Harder They Come*] became artificially insulated spaces in which images of black life, in this case as backward, violent, sexist and fratricidal could be consumed.

With the release of the 'adventure fantasy' *Countryman* by Island Records in 1982, these images of Jamaican black life were only further fetishized. This second film was 'a simple inversion of the Robinson Crusoe myth [with] "Friday" recast in the form of a Rasta hermit-fisherman endowed with magical powers . . . [who] saves and protects two young white Americans' (Gilroy, 1987). The film was also billed as 'A tribute to Marley'. This imaging of the Rastafarian was obsessed with the black male body in its 'natural' state. The fact that the character, Countryman, spends the whole film almost nude, clad only in a loincloth, is a product of the sexualization of the black performer in American popular culture. As Charles Shaar Murray (1989: 78) has described it, the black body in performance bears the 'accumulated weight of the fantasies and mythologies constructed around black music and black people by whites, hipsters and reactionaries alike . . . black people represent the personification of the untrammeled id – intrinsically wild, sensual, dangerous, "untamed".' Hence in America, 'the growth of reggae as a form of pop or rock music during the 1970s resulted in a proliferation of pictorial "coffee table" books about Rastafari, reggae and Jamaica. Soft core porn photographs of black bodies, male and female, were interspersed with journalistic commentary about the brutishness and hedonism of this Caribbean idyll' (Gilroy, 1987: 169). Adrian Boot, co-editor of the 1995 coffee table book version of *Songs of Freedom*, was also co-editor of both books of this genre in the 1970s, *Bob Marley: Soul Rebel – Natural Mystic* (1981) and *Jah Revenge* (1982). If the body of the black performer has always been a central mythological site in the popular cultural imagination of white America, the 'natural' Rastafarian was simply the fetish in the flesh. When Jay Cocks, in 1992, reviewed Bob Marley's *Songs of Freedom* boxed set as 'one of the most magical and darkly lyrical stories in the whole mythology of contemporary music', he invoked this complex of magic, race and sexuality.

The incorporation of the Rastafarian/rude boy came to an abrupt end with both the close of the 1970s and the death of Marley at the turn of the decade. However, Island Records soon began the process of exhuming the superstar's image, with the release of the *Legend* compilation in 1984, three years after

Marley's death. Chris Blackwell, the Jamaican producer who owned Island records and made Marley internationally famous in the 1970s, admitted to a certain queasiness at the speed of Marley's resurrection:

> I wasn't terribly keen on putting together a *Best of Bob*. We didn't put anything together after he died. In 1984 Dave Robinson was running the company. He thought we should do it. I said I didn't really want to get involved in it, and he said he would do it himself.
>
> (Boot *et al.*, 1995: 206)

But a very different structure of popular feeling in the 1980s required a very different Marley. The slogans of multiculturalism and 'One Love' were replacing those of 'Get Up, Stand Up' from the 1960s and the 1970s, when Jamaican national independence and Black Power signified self-determination and liberation in both the Caribbean and the United States. The field of late twentieth-century corporate marketing was sufficiently developed to meet that challenge, as Chris Blackwell continued to describe:

> [Dave Robinson] approached the whole thing very professionally and very well. He even did some market research on it, finding out what the general public in England thought about reggae. . . . Not the sort of thing I would have done: I was too close to it, I think.

Blackwell invoked his own 'closeness' to the values of a dying era as a rationale for his unwillingness to be involved in the *Legend* project. Rather, research and corporate objectivity, in the figure of Dave Robinson, produced the final concept on which Marley's legend for the future would be based:

> Through all that research he finally came up with what the album cover and title should be. He learned that you should keep the word 'reggae' out of it. Reggae had a mixed reaction: some people liked reggae, some people hated it. A lot of what people didn't like about Bob Marley was the threatening aspect of him, the revolutionary side.
>
> So the picture chosen was one of the softest pictures of Bob. It was a very well conceived and thought-out package. And a very well put together-record. It's an undeniable success. It was Number One in Britain for months. And its one of the Top Three catalogue records of all time.

Island's packaging of Marley in *Legend* erased the fact that the singer was the product of a subversive collective consciousness in Jamaica. Reggae was a social and cultural formation with a specific history and racial politics, often remembered as 'Studio One', the group of reggae musicians and producers who first made the music popular in the years after Jamaican independence. *Legend*

initiated the incorporation of reggae and Marley by removing the 'material sub-stance' of both. By taking 'reggae' and the 'revolutionary' out of the conception of the album, Island's producers isolated all the music's meaning into the body of the individual artist himself; hence Marley as the 'body of reggae'.

Blackwell's comments on *Legend* demonstrated a certain use of personal history in Island's promotion of the Marley legend. The story that seemed to have the most appeal for both the audiences and the producers of the 1980s stressed the 'softer' picture of Marley over and above his more 'revolutionary side'. This picture was reproduced in 1995, with the release of *Natural Mystic*. This CD com-pilation was explicitly designed as a follow-up to 1984's *Legend*. The cover picture, a profile head shot of a gently smiling Marley with his hands at his chin, refers to the same shot of Marley on the *Legend* album taken from a slightly differ-ent angle (Figures 1 and 2). Both were taken from a photo session in 1977 at the

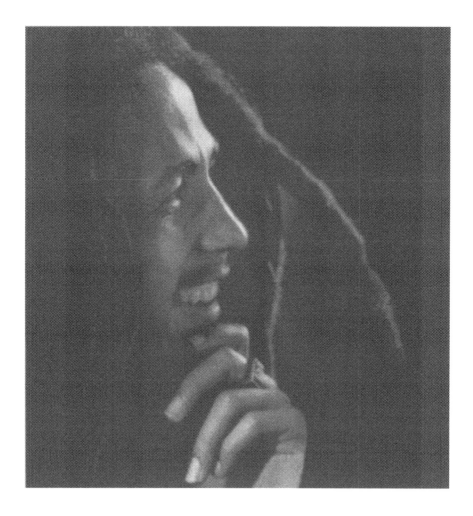

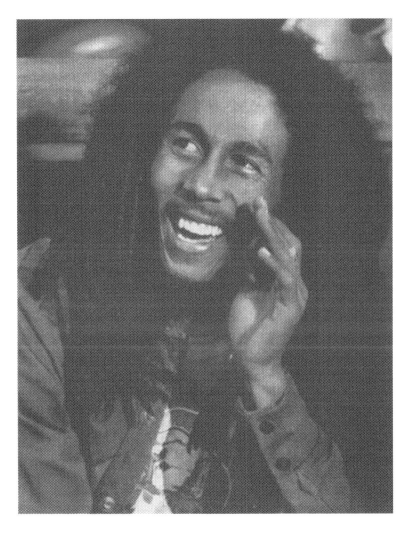

Keskidee Centre in North London, during the video shoot which was meant to be used for Marley's track 'Is This Love'.

The Keskidee footage would ultimately become a 'mother lode' for images of a more humanized Marley as the family man in the 1980s. As described in the *Songs of Freedom* book, the video shoot 'was to be shaped around a children's party, in which Bob played the part of a kind of Rastafarian Pied Piper, even leading the children out of the building and away down the street' (Boot *et al.*, 1995: 197). This was a very different conception of Marley's ability to inspire an audience to 'take to the streets'. This shoot gets twelve pages of coverage in *Songs of Freedom*, with little text and an abundance of beautiful shots of Marley talking, singing, clapping and dancing with a multicultural audience of children amidst balloons, streamers and noise-makers. There are images of Marley blowing noise-makers,

invoking the 'Rastafarian Pied Piper'. There are also shots of Marley watching the children with various looks of amusement, indulgence and delight. It is this series of close-ups of a quiet Marley being entertained by the children which became the source of both the *Legend* and *Natural Mystic* cover shots. The few lines of text surrounding these pictures emphasize that 'the party was entirely contrived, but a delight all the same for the underprivileged three- to-twelve-year-olds of the area who were invited' (ibid.). The caption to one double-page spread concludes, 'Bob Marley loved children, as should be apparent from the number of heirs he left. And at the Keskidee video shoot it soon became evident that the children present also loved Bob' (ibid.: 201).

This was a strikingly different portrait of Bob from that available during the 1970s. As Gilroy (1993: 243) has also pointed out in describing a similarly oriented picture of the Marley family, 'this simple family snapshot of the Marleys would never have emerged while his record company was promoting him as a swaggering and sexually available Rastaman shrouded by a cloud of ganja smoke'. Hence *Song of Freedom's* indulgent reference to Marley's sexual exploits – 'as should be apparent from the number of heirs he left' – becomes in the 1980s simply more evidence of his love for children.

These shots of Marley were not used simply as items of curiosity and nostalgia (Gilroy, 1993: 243). Island's producers confirmed that the video and photographs produced from the Keskidee shoot in 1977 were never shown at the time, precisely because 'it was felt to conflict with a more militant image of Bob that was then being put forward'. Rather, 'the true importance of this photographic session was not to be understood until years later – 1984, to be precise, when the Island Records art department was searching for a suitable cover shot for the *Legend* compilation LP' (Boot *et al.*, 1995: 197–9). The footage shot at the event was also integrated into the video *One Love/People Get Ready*, also produced in 1984. These producers emphasized that these images represented not simply items of nostalgia but the raw material for a new construction of Marley. They were instrumental in introducing a new and 'softer' side of Marley to the audiences of the 1980s.

Legend and *Natural Mystic* serve as brackets for a ten-year period covering the promotion of Bob Marley for North American audiences. The *Legend* release drew from an untapped archive of images in order to humanize the performer and make him more accessible to an audience initially intimidated by the revolutionary aspects of Third World music in the 1970s. *Natural Mystic* contained these references, but also represented a further elaboration of Marley's significance. In *Natural Mystic* Marley achieved the mythic stature of a prophet or visionary, the image of Marley most prevalent in the United States today. By 1995 one could say that Rita Marley's prophecy had come true: 'Like Christ', Marley had returned to the American popular imagination in a 'new name', the 'Natural Mystic'.

Marley's present mythic stature relied on the process initiated ten years

before in the *Legend* release, precisely because, in the attempt to create a more human image of Marley, *Legend* erased the performer's more specific revolutionary context. The 'Natural Mystic' was the product of a concerted reinterpretation of the meaning of Marley's revolutionary internationalism. It represented the dismantling of the specifically *racialized* politics central to Marley's self-promotion as a transnational cultural producer. The artist as prophet was far removed from, and much purer than, both Marley's image as the hedonistic Rastafarian heathen or Marley as the rude boy ghetto gangster. Instead, the newly incorporated natural mystic magically crossed over all national and racial boundaries with a pluralist vision of 'one love' that legitimated the national narrative of a multicultural America. This understanding of Marley has, in his own words, 'lived out' or outlived other possible interpretations of his historical importance, precisely because it has a certain ideological appeal in this cultural moment in the United States.

It was the 1992 four CD boxed set *Songs of Freedom* that provided the comprehensive 'history' which took Marley from the revolutionary and sexual icon he was in the 1970s through the humanist and family man he became in the 1980s to the universal mystic of the 1990s. The very form of the CD boxed set enabled a certain kind of historical work which was simply not possible in the 1984 *Legend* release. The function of the CD boxed set is not merely to present an artist's music but also to produce that artist as a subject of music history. Mark Fenster (1993) has provided some crucial insights into this process in his essay 'Boxing in, opening out: the boxed set and the politics of musical production and consumption':

> The boxed set 'boxes in' the subject by telling its 'story' and by locating its narrative at the intersections of recordings, biography, and history. . . . The use of liner notes, testimonials from peers and critics, etc., explicitly displays, just as the process of the collection of the music implicitly assumes, that the subject of the boxed set was able to transcend artistically an historical moment in order to become an important historical figure.

The boxed set is the emblematic form of cultural incorporation. For commercial purposes, it merges all an artist's previous recordings, labels, concerts and performances into one unit. It also unites in one body the different faces and phases of the artist during his or her career. Finally, the boxed set removes the artist from his or her own corporeal history so that they can '*transcend artistically an historical moment in order to become an important historical figure.*' Bob Marley, the living embodiment of reggae as a social, cultural and political formation in the black Caribbean in the 1970s becomes for American audiences a transcendent artistic 'figure'.

The 'narrative' structure of *Songs of Freedom* was reflected in the set's packaging as a beautifully laminated 'book', the discs discreetly tucked into the front

and back covers with the sixty-four-page biographical booklet constituting the pages of the 'text'. The artistic significance of Marley's narrative was reflected in one industry expert's explanation that the decision to give the set a limited release of only one million copies for sale worldwide allowed the music to be presented 'in the proper artistic light' (*Billboard*, 8 August 1992). This comment, combined with the aesthetic appeal of the set's laminated book-style packaging and photos, signalled that this was a 'high' cultural product within the hierarchy of the music industry, as evidenced by the $50.00 list price of the set.

The accompanying booklet told the story through text and pictures of Marley's origins as a rude boy in Trenchtown, his turn to Rastafari in the late 1960s, and his subsequent rise to international stardom throughout the 1970s. The discs were organized to parallel this history, and were accompanied by portraits of Marley on the face of each disc that were duplicated on the T-shirts and sweaters offered on an order card included in the box. Beginning with the picture of a young, serious Marley, low Afro, entitled 'Air', the portraits moved through the 'Earth' Marley of the early 1970s, with short locks reflecting his recent conversion to Rastafari, to a third entitled 'Fire', of an angry Marley in camouflage shirt and cap before a backdrop of flames, to the last, entitled 'Water', of a fully dreadlocked and goateed Marley, wisely and wondrously pontificating before a backdrop of water. The 'elemental' nature of this categorization established the 'natural' component of Marley's image that we see repeated in the 1995 *Natural Mystic* release. This elemental trajectory was also circular: Marley's 'water' stage doused the 'fire' of urban riots and ghetto revolutions, so Marley could return to the 'air' from which he came.

The biographical booklet contained a new account of Marley's biography. 'In 1967,' Rob Partridge recounted, 'Bob's music reflected his new beliefs. Gone were the Rude Boy anthems; in their place was a growing commitment to spiritual and social issues, the cornerstone of his real legacy' (Marley, 1992: 10). The chronological bias of the set, beginning with Marley's rude boy 'stage' and culminating in his visionary moment of full Rastafari, must not be taken at face value. This was an ideologically motivated construction that served more functions than merely demonstrating the progressive historical importance of this musical figure. Rather, the chronological structure ultimately negated the historical importance of Marley's cultural and racial politics by emphasizing his spiritual 'transcendence'. The implication behind the last 'stage' and this progression is that Marley 'matured' from his authentic representation of the black and minority urban ghetto into a more universal visionary artist or leader. Marley is thereby revalued in the 1990s for his 'evolution from Jamaican Rude Boy to political and spiritual poet' (*The Plain Dealer*, 13 December 1992).

In *Songs of Freedom* Marley's 'universalism', his spiritual transcendence of his particular historical moment, supplants his firm belief in political liberation for the black peoples of the world. For example, the set's distinction between the

revolutionary 'fire' stage and the visionary 'water' stage is disingenuous; it arti-
ficially dismantles Marley's cultural identity and significance. Marley's explicitly
political concert in Zimbabwe, celebrating that country's independence from
colonial rule, occurred only one year before his death in 1981. Two years previ-
ously, in 1979, two songs from the *Survival* album, 'Ambush in the Night' and
'Zimbabwe', were more than enough evidence that Marley openly supported
Jamaican independence, and favoured the black, democratic socialist government
led by Michael Manley's People's National Party. His performances in New
Zealand and Australia left their traces in his wake, inspiring Maori and aborigi-
nal audiences to political consciousness (Lipsitz, 1994: 142). The producers of
the set would have us believe that Marley's central concern in his dying moments
was a transcendent desire for universal peace and harmony, unconnected to these
specific contemporaneous political and historical events.

Marley's 'universalism' was racially and historically specific. In his inter-
national reggae performances in the 1970s, Marley articulated a revolutionary
class and racial cultural politics that overstepped the borders of both Jamaica and
North America, a diasporan consciousness I am calling 'black transnationalism'.
Marley's music enabled transnational political identifications across the black dia-
spora, reinforcing the desire for Third World national liberation rather than a
transcendent universalism.

Reviews of the set, however, emphasized the industry's version of Marley's
universalism by frequently mentioning his lack of popularity among black audi-
ences in the United States during the 1970s. This should come as no surprise,
given both Gilroy's and Charles Shaar Murray's argument that 'the central thrust
of twentieth century American popular music [is] the need to separate black
music (which, by and large, white Americans love) from black people (who, by
and large, they don't)' (Murray, 1989: 86). In the 1970s, the fact that Marley's
black American constituency was not large only enhanced his popularity among
white audiences: 'White Americans loved him all the more for it, and reggae . . .
became something that the white hipoisie considered the black American masses
too bourgeois to appreciate' (Murray, 1989; 95).[1]

This construction of the black American audience determined the focus of
the North American music industry's resources in their marketing of Marley's
music to achieve cross-over appeal. However, there is much evidence to suggest
that Marley made explicit efforts towards the end of his life to counter the
industry's marketing strategies and appeal to African-Americans. Timothy
White (1986) has pointed out that Marley's last scheduled tour, which was can-
celled when he went into hospital, was covered by all the major black publi-
cations in America for the first time in his career. The boxed set blurb on the
song 'Africa Unite' also notes that 'on the *Survival* tour Bob Marley and the
Wailers consciously opened their US dates at the legendary Apollo in Harlem.
Bob felt that he hadn't been marketed sufficiently to black people'. Despite
black America's supposed suspicion of reggae, after the Apollo shows

'longstanding residents of Harlem claimed that the area had not buzzed like that since Marcus Garvey's time there'. Gilroy has also argued that Marley's 'foray into pop stardom was a calculated development in which he was intimately involved. . . . His incorporation of bluesy guitar playing and disco rhythms can be interpreted not as obvious concessions to the demands of a white rock audience (Wallis and Malm, 1984), but as attempts to utilize the very elements most likely to appeal to the black audiences of North America' (Gilroy, 1987: 170). These observations demonstrate Marley's *increasing* consciousness of the importance of connecting with a black American audience as he approached the end of his career. His growing awareness of the racial politics of his cultural production contradicts and complicates reviewers' and music historians' assessment of Marley's 'final' stage as that of the 'universalist' who had transcended the racial allegiances necessary in his own particular historical and political moment.

By promoting his evolution from rude boy tuff gong to the universal figure of the visionary 'natural mystic', *Songs of Freedom* produced a narrative of Marley's life and career in which he transcended a particular history of racial politics in both the United States and Jamaica during the 1970s. The set was extremely successful in its effort to revitalize Marley for a new generation. By January 1993, the set had gone beyond platinum, selling over 300,000 copies. It remained in the top ten on the US album charts from November 1992 through the spring of 1993, coming in number one for top adult alternative in the pop category from February to May 1993. *Songs of Freedom* was issued in a limited release of one million copies, demonstrating that in the ten-year period between 1984 (when only 10,000 copies of *Legend* were released) and 1995, expectations of Marley's sales potential had jumped dramatically.

The reception of the 1992 *Songs of Freedom* boxed set revealed how North American music critics have organized black music history more generally to exclude the political and social history of black musical production in the United States, and the ways this history shaped Marley's work. In their presentation of a softer, gentler Marley, reviewers constructed a false dichotomy between the purported black 'soul' music of the late 1960s and early 1970s, nostalgically remembered as embodying the high 'integrationist' ideals of the civil rights era in 'songs of freedom', as opposed to the more 'militant' values of the late 1960s and early 1970s as expressed in chants and raps for 'Black Power'. In this context, when reviewers promoted Marley's *Songs of Freedom* as 'the last great soul music', the 'memory of a time when music could be soulful, political, brutally honest, never divisive and could still keep the beat' (Cocks, 1992: 77–8), the emphasis here was less on Marley's political and social commentary and more on his ability to fulfil the dreams and ideals of racial harmony that, in the white liberal imagination, have been betrayed.

Cosgrove described this narrative of the place of black music in twentieth-century American music history in the following words: 'One of the enduring

myths of black music is – "one nation under a groove" – the romantic belief that music has the power to unite' (*New Statesman and Society*, 28 July 1989: 46). For Murray, this was the fallacy of multiculturalism, 'one of the great liberal myths . . . that people can live together in harmony once they have learned to eat each other's food and dance to each other's music' (Murray, 1989: 89). 'One nation under a groove' is a specifically American national myth of liberal pluralism and multiculturalism that often ignores the history of racial conflict and divisiveness in the United States. In figuring Marley as 'the last musician with any chance to unite the disparate souls of the world under one love groove' (*The Gazette*, 25 October 1992: D9), reviewers used a facile internationalism – global peace without revolutionary struggle – to imagine, in actuality, national unity. This national myth obscured the specifically *black transnational* history of pan-African-ism to which the actual Parliament-Funkadelic track from 1978, 'One Nation Under A Groove' obliquely referred: that diasporic vision of black national inde-pendence.

Cosgrove's opening reference to the Parliament-Funkadelic track also points us to a significant shift in that black transnational vision and, concomitantly, black music, that occurred during the 1970s. This shift also influenced the direction Marley's music took towards the end of that decade. Gilroy (1987: 178–9) has described the steady decline in assertive statements in black music during the 1970s. Due to the repressive actions of the state against the increasing militancy of the Black Power movement, '[c]lear open statements were replaced, in musical culture at least, by more oblique forms of signification'. Furthermore, '[t]he dream of life beyond the reach of racism acquired an other-worldly, utopian quality and then manifested itself in a flash hi-tech form deliberately remote from the every-day realities of the ghetto life-world.'

The mystical, psychedelic Pan-Africanism of Marley's black American con-temporaries in the 1970s, bands such as Parliament-Funkadelic and Sly and the Family Stone, was the direct result of this shift. Sly Stone 'commented on the transition from Black Power to mystical Pan-Africanism by segueing the track "Africa Talks To You (The Asphalt Jungle)" into a non-existent cut entitled "There's A Riot Going On"' (Gilroy, 1987).[2] While for white liberal audiences the catch-phrase 'one nation under a groove' may have signified an easy uni-versalism meant to heal the nation's wounds, the cover image of Funkadelic's album – 'a squad of "Afronauts" raising the red, black and green standard of Africa as they stepped off the planet earth' – reflected a harsher reality. For these artists, mystic universalism was an artistic flight from state-sanctioned racial oppression rather than the fulfilment of the liberal dream of national racial harmony. It also represented the incorporation of a transnational vision of black liberation.

This shift in black R&B sheds further light on the tensions surrounding Marley as he 'competed' with the R&B market in his efforts to reach a black American audience. Marley's 'evolution' from 'fire' to 'water', from the more

directly militant tracks on the albums between 1973 and 1975 (*Burnin'* and *Natty Dread*) to the more mystical and electric albums between 1976 and 1978 (*Kaya*, a tribute to Rastafari, and *Babylon by Bus*) could have been influenced in very material ways by his sense of the power of the state in both America and Jamaica during this period, and the limits being placed on a black transnational revolutionary music. If we examine Marley's musical production in the context of the political climate in the United States during the late 1970s, his own foregrounding of the mystical becomes a part of his general strategy to follow the shift in black music to mystical Pan-Africanism and thereby appeal to a black American audience, rather than a 'natural' steady progression towards mystic universalism for its own sake.

The North American music industry favours the myth that the cross-over appeal of black music depends upon a universalist vision of racial harmony rather than a protest against the racially specific conditions of the oppressed minorities of the nation. The first allows for the salvation of the nation through unification, 'one nation under a groove', the other threatens its dismantling. The separation of Marley's music from black people is structurally necessary to the cultural politics of the United States, because it is the only way in which racial harmony can be imagined. In the reviews, the last song in the boxed set, 'Redemption Song', which was recorded live from Marley's last concert, is described almost as the black singer's apology for the betrayal of the dream of national unity – 'Redemption Song is about betrayal and forgiveness, repression and rebirth; it is a hymn of hope . . . [the] commodity . . . in short supply just now' (Cocks, 1992: 77).[3]

The erasure of Marley's black transnationalism, the separation of his music from black people, is finally figured in the boxed set's privileging of Marley's solitary acoustic moments. This final act of fetishization literally removes Marley from his community by focusing on the artist as an autonomous individual. The American rock audience of the disco era was 'hopelessly mired in personality-cult' (Murray, 1989: 96). Bob Marley was one of the few 'black personality-cults which the rock audience did accept'. In Murray's analysis, the Marley of the 1970s, as he was understood in the United States, 'amply met the rigorous rockist criteria of . . . individualist autonomy'.

In the 1970s, Marley's personality-cult was an odd mix of the revolutionary and the sexual. In the 1990s, Marley's personality-cult fetishized the aesthetic by focusing on the acoustic. In promoting the seven-song acoustic medley which Marley recorded in Sweden in the summer of 1971 as the highlight of the set, reviewers encouraged a more personal and private experience of the man, his music and the set as a whole. As one critic reconstructed it, 'Among several previously released highlights is an acoustic medley recorded in a hotel bedroom in 1971 – two years before he achieved international stardom – which shows that Marley had the Dylanesque ability to animate his own compositions with the simplest of guitar accompaniments' (*Independent*, 24 December 1992). Though this appears to be merely an aesthetic comment on the quality of Marley's music,

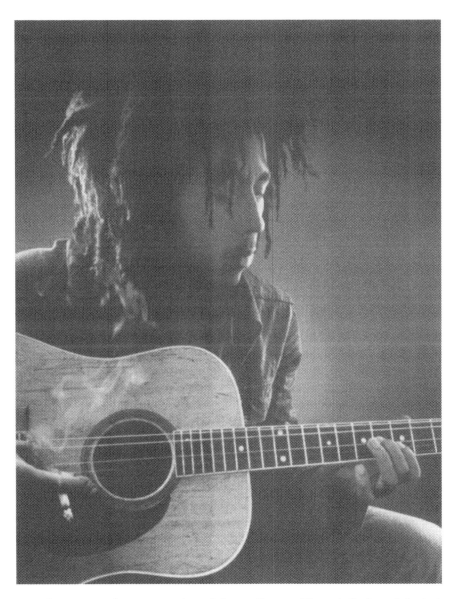

it is also a particular construction of the performer. The privileging of the inti-
mate space of the 'hotel bedroom' over that of the political and politicized space
of the international stage, where Marley had his most significant popular impact,
constructs the primary identity of the artist as that of the autonomous individual,
unaffiliated with either a band or a community of listeners. Marley's 'authen-
ticity' as an artist – 'his Dylanesque ability to animate his own compositions with
the simplest of guitar accompaniments' – erases any recognition of the artist's
public and popular impact by locating this history in the realm of nostalgia, 'two

years before he achieved international stardom'. Marley's political authenticity
for a community of black and Third World listeners such as, for example, the
audience at his Zimbabwe concert on the eve of that country's independence, is
now constructed as a less 'pure' or 'true' experience of his music.

This reviewer's privileging of the acoustic merely reinforced the image of
Marley promoted on the front cover of the boxed set itself (Figure 3). Marley
sits on a stool, head down, brow furrowed, lips pursed, spliff in hand, plucking
at the strings of an acoustic guitar. A soft halo of light surrounds him and serves
as a backdrop, reflecting a golden glow on to the locks at the back of his head.
This image underscores critics' emphasis on the seven-song acoustic medley in
the hotel bedroom. One reviewer described the medley precisely as if it were
the soundtrack for the visual image on the boxed set's cover: 'this medley of
Guava Jelly, This Train, Cornerstone, Comma, Comma, Dewdrops, Stir It Up,
and I'm Hurting Inside features Marley in a rare, intimate setting backed only by
his acoustic guitar' (*Los Angeles Times*, 4 November 1992).

The highlighting of this acoustic moment is integral to understanding the
promotion and reception of *Songs of Freedom*. On the one hand, the focus on the
individual autonomous artist in an acoustic setting humanizes the artist and helps
highlight his place in popular cultural music history, placing Marley in this case
alongside figures such as Bob Dylan. On the other, the focus on the acoustic
makes Marley's music safe for the present and future by accentuating the art of
the music and the aesthetics of its cultural reproduction, over and above the more
political aspects of his musical project. Industry experts do with the political
what the doctors could not do with the cancer cells that finally claimed Marley's
life – isolate and eradicate it in order to preserve the integrity and body of the
artist himself. His cultural politics 'amputated' by the 'scalpel' of the North
American music industry, this process disables Marley's music of its potential to
provide an example of what musical and cultural production can enable for the
future. This aestheticized re-presentation safely boxes Marley within the bound-
aries of the apolitical and the artistic, redefining the meaning of his 'authenticity'
as a black performer. His 'songs of freedom' become 'allegories of individual
expression versus political action'.[4] This is the ultimate figure of the incorpor-
ated natural Marley, body and soul.

Corpses, corpuses and corporations: a contest of wills

In the 1970s Bob Marley and reggae were seen to be part and parcel of what was
dangerous, subversive and counter-cultural in black music. The recent revival of
Marley has been precisely an attempt to reverse his political positioning along
the musical spectrum. This can only be understood in the context of what has
happened within black music since the 1980s, with the rise of politically danger-
ous performers such as Public Enemy and NWA who threaten to dismantle the

liberal myth that the cultural function of black music is to promote racial harmony. Marley is now being canonized as a safer version of black musical protest, as opposed to those rappers who represent the betrayal of the dream of the universalized, unaffiliated black performer. Hence the insistent efforts on the part of the producers of the boxed set to disassociate Marley's revolutionary lyrics from any stigmatic affiliation with present-day, similar musical productions. For example, in an interview with Neville Garrick, the executive director of the Bob Marley Foundation, co-compiler of *Songs of Freedom* and a former disciple of Angela Davis, one interviewer informed us that Garrick 'is on the telephone from Jamaica explaining how the reggae king's [song 'I Shot the Sheriff'] is totally unlike rapper Ice T's "Cop Killer"' (*Toronto Star*, 18 October 1992). Marley's aestheticization distinguishes his 'older' music not only from his own rude boy roots in Kingston ghettos such as Trench Town, but also from the black music being produced in the urban ghetto now.

The production of an authoritative, mainstream history of Marley reflects the larger function of the boxed set not merely to re-present but also to contain and control the meaning of an artist's musical legacy and the future cultural and financial capital it may afford the label. Fenster (1993: 149) has described how the marketing and circulation of the boxed set determines the industry's control over the 'collectibility' of an artist:

> The boxed set is an example not only of trying to reach the 'casual consumer' but also of trying to market directly to the somewhat irrational desires of the collector and fan, who more often operate within the secondary and grey markets of used records and bootlegs. . . . [The boxed set] opens up and makes available, on the 'legitimate' market, new recordings to be consumed, while attempting to close off the secondary and grey markets of fans and collectors who treasure, trade, and sell unauthorized recordings.

Songs of Freedom demonstrates the potential cultural consequences of this very commercial attempt, on the part of a label, to control the consumer's experience of an artist through the CD boxed set. In addition to resurrecting old favourites, *Songs of Freedom's* appeal as a collectable was enhanced by the fact that twenty-eight of the seventy-eight songs recorded were not on any previous Marley album, and eleven of these were previously unreleased songs or mixes. In addition, three of these songs, 'High Tide Low Tide', 'Why Should I', and 'Iron Lion Zion', were completely new songs that, as Rita Marley explained, had been stored in her cupboards and vaults and had only recently been found, adding to the collection the value of the rare and newly discovered manuscript.

These releases are precisely the material fans and collectors would have found in the underground spaces of the music industry. By including them on the set, *Songs of Freedom* extends the industry's reach in its possession of more obscure

and less accessible recordings, undermining and closing off the 'secondary and grey markets' Fenster described. In doing so, the industry is also able to close off 'secondary and grey' interpretations of Marley's music that could contradict the authorized narrative of his transcendent universalism. *Songs of Freedom* ensures that Marley's return 'in a new name' legitimizes the industry construction of Marley as the 'natural mystic'. Hence, as with *Legend*, in their focus on the new songs, reviewers once again promoted a softer, gentler Marley, singing 'never-heard-before songs [about] a lovely promise of loyal friendship called High Tide Low Tide [the water stage] . . . and Why Should I, whose music and message are both delightfully upbeat' (*Financial Post*, 14 November 1992: S13). Rather than stirring up the people to demand change, the new Marley's 'songs of freedom' function to redeem white liberal guilt: 'His music could challenge the conscience, soothe the spirit and stir the soul all at once.'

The industry's protection of the cultural and financial capital invested in their authorized version of Marley was mirrored in two legal controversies over aspects of Marley's estate in the decades following his death. The first involved Marley's refusal to leave a will. For the past ten years, Marley's multi-million dollar estate has been mired in a legal tangle of such complicated proportions that about the only thing the various claimants and defendants have in common is a desire to contain and control Marley's legacy. Ever since his death, a debate has raged in the American press over who are the rightful heirs of this legacy. The enduring fascination with this case in the American media during the late 1980s and early 1990s should be understood as marking a convergence of commercial and ideological interests within the North American music industry.

In a paradigmatic article in *Newsweek* in April 1991, Jerry Adler and Howard Manly set the terms of this debate. They argued that the 'monumental tangle of [Marley's] estate . . . just goes to show, as he might have put it, that "Babylon" always wins in the end.' Since Marley's legacy has been reinvested in the very state he aimed to oppose – 'Jamaica's ruling class of professionals and politicians got it all, at the going rate of $300 an hour for the estate's lawyers' – the politics of his particular stance have been erased in retrospect.

The chaos of Marley's estate involved more than financial assets: 'when the courts advertised for potential heirs, hundreds of would-be Marleys appeared from all over the world.' The singer's widow, Rita Marley, the matriarch of the family legacy since Marley's death, narrowed this international list of 'illegitimate' children down to seven. The attempt to locate and control this proliferation of heirs mirrors the attempt on the part of the North American music industry to locate and narrow down those Marley recordings available in the 'secondary and grey' spaces of the music industry.

The second most recent controversy involves a legal action initiated by Island Records in 1993, in cooperation with the international trade group IFPI, against

other corporations around the world. At least twenty-five suits were brought against companies in the United Kingdom, the United States, Germany, Holland and France, to name a few, for infringement of laws regarding the copyrighting of Marley sound recordings. The Bob Marley Foundation also planned to take action over photographs, artwork and other non-musical infringements of copyright. This IFPI action was described as marking 'the beginning of a new IFPI drive to stamp out international piracy' (Pride, 1992: 14).

Jane Gaines (1991: 133, 233) has described the 'politics of piracy' in post-colonial terms as a counter-cultural act 'of evening up the score against imperial powers'. As such, corporate legal actions against piracy have certain ramifications for a transnational cultural politics. In responding to subversive acts of piracy the North American music industry faces a central contradiction within capitalist production, the tension between circulation and restriction. In theory, restriction maintains the privilege of the artist's right to control the profits from his work, while circulation makes 'creativity' possible by allowing DJs the freedom to experiment with records as their 'cultural raw materials'. Since in this instance the artist is deceased, the legal shift towards the 'restriction' of Marley's work ultimately places the singer's legacy in the hands of the multinational corporation. Too much uncontained circulation, in this cultural moment, limits the 'creativity' afforded the corporation in its attempts to continue to profit from the Marley legacy. Restriction, at this point, is a necessary preventive measure against competing counter-industry and international 'secondary' uses of the Marley legacy against the monopoly of the North American music industry on the world music market.

The fact that a campaign so antithetical to Marley's own transnational racial politics and diasporic philosophy should begin with his own work only serves to underscore his central place at the intersection of various contradictions in this moment of cultural and financial transnationalism. On the one hand, corporate American transnationalism encourages the free circulation of capital across national boundaries. The ideological result is also the transcendence of the internationalist racial consciousness embodied in postcolonial immigrants from the periphery, in favour of a more abstract universalism. However, corporate America's distribution of the Marley legacy on the world market can never fully control for more revolutionary interpretations of that legacy in the periphery. In the 1970s, in the spaces somewhat on the margins of the North American music industry, Bob Marley's outlawed Rastafarian music became the catalyst for oppressed groups from Australia to Zimbabwe to identify with alternative meanings of the transnational: as a 'black', 'outernational' anti-capitalist ideology dangerous for the workings of capital and the power of the 'imperial' corporation (Gilroy, 1987). Understanding this, Marley himself encouraged piracy when it subverted the logic of the global marketplace, for example, making no attempt to curtail artists in Zimbabwe from covering his songs in the service of their

Freedom Movement. Intentional or not, Marley becomes the ideal figure for the IFPI in beginning such a policing campaign.

Both these legal controversies have one common theme – the attempt on the part of institutionalized power to restrict, box in and monopolize the products of Marley's transnational legacy – be they capital, heirs, bootleg recordings or whole secondary markets. In the context of this history, a cultural object such as the CD boxed set *Songs of Freedom* becomes more than simply the commemoration of a legend. The conscious effort to revitalize Marley has as much to do with the present as the past. It represents an active effort on the part of the music industry to contain and control his legacy as it expands beyond their control. The boxed set creates Marley as a 'collectible' commodity in the service of 'the categorization and control of the proliferating and ever-expanding texts of popular music history' (Fenster, 1993: 146).

The industry's fixed version of Marley and reggae has recently been a struggle to maintain even within the nation, as the ideal of national racial harmony is undermined by the increased inflection of America's already existing racial tensions with global concerns. While the corporation struggles to maintain, contain and box in the image of the postcolonial rebel on the cross-over market, a new generation of West Indian immigrants in the United States are re-establishing not only their rights as the true heirs to Marley's legacy, but are redefining that legacy by resurrecting the Rastafarian rude boy tuff gong. This internal conflict was most recently embodied in the simultaneous emergence of two 'new' breeds of reggae in the United States, Ventura County two-tone reggae and Jamaican dance-hall reggae. Until recently, the type of reggae promoted in the United States as the only heir to Marley's legacy was a native offshoot described by Bill Locey in a 1992 article entitled, aptly enough, 'Reggae takes root'. This new 'American' reggae picked up on a particular ska-based movement in Britain during the 1980s. As one music critic described it:

> Jamaica's first indigenous music before reggae, ska blended R&B shuffle, jazz, calypso, rock, African and Cuban styles into a propulsive horn-driven sound. In the '80s, UK artists like The Specials and English Beat (many of whom recorded for the influential 2-tone label) revitalized ska. The latest incarnation of this vibrant, danceable style has blossomed with America's own No Doubt, Fishbone and The Mighty Mighty Bosstones.
>
> (*BMG Music Review*, June 1997)

'America's own' white and racially mixed two-tone bands were producing this new cosmopolitan melange, the new 'Reggae moderne' where, as one Ventura County band member described it, 'race isn't even an issue. There is no color involved in reggae in California'.[5]

In the heart of the nation's racial crisis, as evidenced by the contemporaneous

LA riots, the myth of Marley's 'universalism' reached its truest American expression. Locey described the liberal desire for the erasure of 'race', 'colour' and blackness from reggae as an issue of 'musical taste – hordes of people wanting to listen to and, more to the point, dance to feel-good music'. However, the real issue was the liberal denial of social conflict as expressed in music and culture. As the Ventura County band member described the ethos of 'two-tone' reggae further:

> Peace. . . . That's why reggae is so popular. . . . Things have just gotten so violent in the last 18 months – Desert Storm, the LA Riots. I think when people go out, they don't want friction, they want relaxation.

The Ventura County band member relied on a liberal biopolitics of music as 'relaxation' in his attempt to resolve the geopolitical consequences of American intervention abroad. He reconfigured reggae as that other-worldly incorporeal space where whites can escape blackness and colour on the one hand, and American imperialism on the other.

Cosgrove (1989) told a very different story when he identified the slogan of black music's ability to promote peace and harmony, 'one nation under a groove', as a myth. As he elaborated, 'All the evidence points in another direction. Music, the metaphorical food of love, is generally a recipe for difference, disagreement, and fierce division.' Cosgrove underscored the contested nature of all cultural production and reggae specifically by pointing to the emergence of dance-hall reggae in the United States as a very different contender for Marley's throne. Dance-hall reggae artists challenged the direction which modern reggae was taking. Their alternative cultural production directly contradicted that of the 'Reggae modernists'. As dance-hall artist Super Cat (*Vibe*, September 1992) described 'his art's expanding appeal':

> Well listen, now is *arm*agideon. . . . Time is rough all over the world. Riots in Los Angeles, in the Middle east is war, in Jamaica and Europe, this is a tough time, a rough time, so it's time for a rough music.

Unlike the Californian reggae artists, Super Cat saw the driving force behind reggae as the desire to express and protest, not escape and relax from, the violence of race and class oppression all over the world. Dance-hall reggae artists saw themselves as the heirs to a different aspect of Marley's legacy, where reggae was all about 'friction': 'the music of the yard and therefore the sound most commonly associated with drugs, petty criminality and Jamaica's most infamous criminal ghost the Yardie' (Cosgrove, 1989). In the ritual space of the dance-hall, reggae fulfilled much more than the desire to 'dance to feel-good music'. Here, 'relaxation takes precisely the form of a muscular orgy in which . . . may be

deciphered as in an open book the huge effort of a community to exorcise itself, to liberate itself, to explain itself' (Fanon, 1963: 57). Dance-hall reggae told a different story of black music – as if the earlier Marley ghost first killed with *Legend* – Rude Boy Tuff Gong – had risen from the dead against the wishes and control of the American liberal imagination.

In a manner profoundly counter to the liberal cultural politics of Venturan 'Reggae moderne', this 'new' reggae was a type of 'low' cultural production that was much more difficult to aestheticize than Marley's music. The crude lyrics tended to be mainly about gun culture and sexuality, 'slackness',[6] and were expressed in a thick Jamaican patois which is extremely difficult for an American audience, white or black, to decipher. This was also a more threatening form of reggae music for white audiences because it could not be removed from the very live black bodies who produced, consumed and enjoyed it in the ritual spaces of the dance-hall.

The threat of the dance-hall ultimately lay less in its lyrics than in its inextricable connections with a black community. The music maintained this connection not only in its style but also in its method of distribution through the sound system. Early hip-hop and rap drew their strength not only from a re-examination of the black militancy of the 1960s but also from the technology and cultural ethos of the Jamaican sound system brought to the United States by West Indian producers such as Kool DJ Herc. Sound system culture tended to bypass the personality-cults of the rock industry:

> Perhaps the most important effect of the sound system is revealed in the way that it is centered not on live performances by musicians and singers. . . . Sound system culture redefines the meaning of the term performance by separating the input of the artists who originally made the recording from the equally important work of those who adapt and rework it.
>
> (Gilroy, 1987: 164)

Sound system culture introduced a new 'secondary space' for the cultural production and distribution of both reggae and, later, black American music. This space broke down the categories and personality-cults that were central features of the corporate organization and control of black music. In the underground music industry in Jamaica, 'piracy is the time-honored tradition. In dancehall, the rhythm is king: lyrics and melodies – not to mention singers, royalties, DJs and copyrights – are afterthoughts' (*Vibe*, September 1992: 78).[7] Sound system DJs competed with each other by removing the labels from the records they used. 'The record could be enjoyed without knowing who it was by or where it was in a chart. Its origins were rendered secondary to the use made of it in the creative rituals of the dancehall' (Gilroy, 1987).

The changing reconstructions of Marley's legend over the course of the past thirty years from the racially specific, Third World Rastafarian rude boy to the universalized, mystical artist set the stage for his full-blown emergence as ultimately *the* figure for the transnational in American culture. For some, his 'universalism' mirrors the transcendence of the nation-state touted as the true import of transnationalism today. However, mystic universalism is not revolutionary internationalism, and the cultural politics of transnationalism as transcendence is a politics that typically erases the postcolonial racial other in order to reconstitute a pluralistic liberal nationalism. Incorporate(d) transnationalism is the 1990s face of 1980s multiculturalism.

Black transnational discourse offers a different politics of the transnational that is not new within black communities. We find its traces in the revolutionary pan-Africanism and black communism of the 1920s, in the fundamentally international national liberation movements of the 'Black Power' and postcolonial eras. Black transnationalism is *not* a universalist doctrine, but a vision of the liberation of a very particular, historical racial and class community. This vision seeks to overcome racial division by overthrowing systems of unequal power relations between races and peoples. This vision never assumes that cultural intermingling across lines of difference will occur until peoples can interact with each other on a level social, political and economic playing field. This was the true body and soul of 'one nation under a groove', the bass beat that makes artists such as James Brown and George Clinton still so useful for black musicians.

Marley's music has also become very useful for contemporary black producers of hip-hop, world music and dance-hall reggae, who look back to the revolutionary 1960s and 1970s both nostalgically and politically in order to construct a usable diasporic past. In the hands of these artists, 'transnationalism' becomes a utopian symbolic space between the culture of the racial diaspora and the political economy of the American nation-state. For them, transnationalism is not a simple transcendence of the national but rather an expressive project that samples and mixes the identities of immigrant, citizen and refugee. The struggle to construct a usable past becomes a way to imagine a meaningful present, and plays itself out at the level of popular culture.

Ultimately, Bob Marley's story is a case study and an admonishment against the dangers in projecting the transcendence of the national without holding all the various narratives of the term 'transnationalism' in tension. With the production of *Songs of Freedom* in 1992, industry experts and reviewers attempted to contain a music and a legend that had insinuated itself into every corner of the world, and to box in the cultural and political history of the first superstar of the Third World. Their struggle to reconstruct Marley as the embodiment of pure or true reggae aimed to incorporate reggae itself into a specifically North American national narrative. They removed the music's 'material substance', its

international social force for an imagined black diaspora, by restricting its meaning to the body of one man.

However, reggae's internationalism, and that of black music in general, is precisely the cancerous cell which, having escaped the boundaries of the Marley body and personality-cult, must now be contained by exhuming his legacy. Dance-hall DJs and consumers do not abide by the scalpel of the North American music industry that would cut off the black community from the body of the black performer. By allowing dance-hall, and the social, cultural and political realities this music expresses, to consume and dismantle that fixed identity which was reconstructed for Marley fans of the 1990s, only these new artists can ensure that the vision and the legacy of that legendary 'Rastamon', and the political identifications he enabled, 'live out' in the popular imaginations of the consumers of the 1990s. As Universal Studios builds its memorial to Marley as the child of universalism and incorporated transnationalism, new generations of 'refugees' such as the Fugees attempt their own reconstructions of what it meant to be a Marley, to perform reggae internationally, to be West Indian and to live in America. In the contest of wills over the body and soul of Bob Marley, the meaning of a new America is precisely what is at stake.

Notes

1 It is important to remember that Marley's reception in black America was not preceded by the spread of reggae through a black underground community as it was in the United Kingdom. The black American audience of the 1950s and 1960s grew out of a political struggle for the recognition of African-Americans as 'natural' as opposed to 'naturalized' citizens of the United States. Marley's Third World, rude boy/Rastafarian identity seemed to have little in common with the aspirations of the upwardly mobile black proletariat. Also, Marley's reggae did not enable identifications along a strict black nationalist line because reggae had a profoundly diasporic logic. As a consequence, in the United States reggae was co-opted by whites immediately and had very little impact on the R&B charts. This was compounded by the fact that reggae was seen as a threat to R&B; therefore, for Marley, getting on black radio was virtually impossible. Reggae's popularity in the United States thus came directly through the personality-cult white audiences and producers constructed around Marley in the 1970s.

2 In 1973, Bob Marley and the Wailers signed on as the opening act for twelve Sly and the Family Stone shows. In October, after the fourth show, they were kicked off the tour because they had made too big an impression on the crowd for an opening act. The popular story is that when the Stone musicians saw the Jamaican Rastas they thought they were looking at 'something out of the Old Testament' (White, 1986). As time would prove, Sly had profound reasons for

being wary of Marley's appeal. Maybe what Sly saw prophesied when he threw the Wailers off his tour in 1973 was the ultimate uses to which Marley's reggae, and R&B, would be put in the United States: the flight from the political into the cosmic and the mystical.

3 *Songs of Freedom* also recuperates a certain image of reggae for a 1990s audience. One could say that the construction of reggae music in the United States today is caught in a dialectic between the cultural attitudes of hip-hop on the one hand, and 'world music' on the other. This then also reflects the uncertain status and social identities of black West Indian immigrants in the United States as a whole, associated on the one hand with black Americans and their racial history in North America, and on the other with a multiculturalist smorgasbord of ethnic communities of colour.

4 Anthony Foy, conversation with author, June 1995.

5 The trajectory towards universalism that the Californian two-tone bands exemplify is similar to the direction their forerunners in Britain followed. Founded in 1979, the Two-Tone label was home to the British ska movement, (white) 'Britain's energetic answer to reggae' and the Jamaican Studio One label (*BMG Music Review*, June 1997). The two-tone bands who took over the production of reggae in Britain after Marley's death also shifted their focus from his imperatives of black liberation to visions of racial cooperation and harmony. Soon, in Britain, the popular cultural investment in reggae swung even more sharply to the right, with bands like the Police, the very name of Babylon Rasta least respected, appropriating the political power of reggae as a popular phenomenon and disarming it (Gilroy, 1987: 170).

6 While the misogyny and homophobia present within dance-hall reggae must be critiqued, it should not be the only thing we see as important about the music's cultural emergence. Dance-hall is also, and may be even more so, about race and class, the psychological, physical and social violence of the urban condition for a large number of black people, male or female, Jamaican or American. For a defence of dance-hall reggae see Carolyn Cooper's (1994) suggestive comments on reggae's gun culture lyrics, homophobia and sexism in "Lyrical gun": metaphor and role play in Jamaican dancehall culture'.

7 In addition, the Jamaican audience has resisted the disaffiliation of dance-hall reggae music from the community in which it originated. Their disavowal of those artists whose identities have been latched on to in North America has, to some degree, been oppositionally effective. For example, Epic, the major label with whom dance-hall superstar Shabba Ranks first signed, was forced to tread 'cautiously, making sure that Ranks' sales base in the Jamaican community was not compromised'. Forced to remain responsive to the needs of black Jamaican consumers who provide the music's 'authenticity', industry experts were caught within the contradiction between maximal circulation and restriction, as they struggled to both contain the black rebel in the crossover market and maintain his original audience.

References

Adler, Jerry and Manly, Howard (1991) 'Marley's ghost in Babylon', *Newsweek*, 8 April: 57.

Boot, Adrian and Goldman, Vivien (1981) *Bob Marley: Soul Rebel – Natural Mystic*, United Kingdom Eel Pie/Hutchinson.

Boot, Adrian and Thomas, Michael (1982) *Jah Revenge*, United Kingdom Eel Pie/Hutchinson.

Boot, Adrian and Salewicz, Rita Marley (ex. edn) (1995) *Bob Marley: Songs of Freedom*, New York: Viking Studio Books.

Cocks, Jay (1992) 'Legacy with a future', *Time*, 19 October: 77–8.

Cooper, Carolyn (1994) ' "Lyrical gun": metaphor and role play in Jamaican dance-hall culture', *The Massachussets Review*, xxxv: 3 and 4: 429–47.

—— (1995) *Noises in the Blood: Orality, Gender, and the 'Vulgar' Body of Jamaican Popular Culture*, Durham, NC: Duke University Press.

Cosgrove, Stuart (1989) 'Slack-talk and uptight', *New Statesman and Society*, 28 July: 46.

Fanon, Frantz (1963) *The Wretched of the Earth*, trans. Constance Farrington, New York: Grove Weidenfeld.

Fenster, Mark (1993) 'Boxing in, opening out: the boxed set and the politics of musical production and consumption', *Stanford Humanities Review*, 3(2): 145–53.

Gaines, Jane (1991) *Contested Culture: The Image, The Voice and The Law*, Chapel Hill, NJ: University of North Carolina Press.

Gilroy, Paul (1987) *There Ain't No Black in the Union Jack*, Chicago, Ill: University of Chicago Press.

—— (1993) 'Wearing your art on your sleeve', in *Small Acts*, London: Serpent's Tail, pp. 237–57.

Hall, Stuart (1989) 'New ethnicities' in David Marley and Kuan-Hsing Chen (eds) (1996) *Stuart Hall: Critical Dialogues in Cultural Studies*, London and New York: Routledge.

Jameson, Fredric (1991) *Postmodernism, or the Cultural Logic of Late Capitalism*, Durham, NC: Duke University Press.

Lipsitz, George (1994) *Dangerous Crossroads: Popular Music, Postmodernism and the Poetics of Place*, London: Verso.

Locey, Bill (1992) 'Reggae takes root', *Los Angeles Times*, Ventura County Edition, 19 November.

Marley, Bob (1984) *Legend: The Best of Bob Marley and the Wailers*, Tuff Gong/Island.

—— (1992) *Songs of Freedom*, Tuff Gong/Island.

—— (1995) *Natural Mystic, The Legend Lives On: Bob Marley and the Wailers*, Tuff Gong/Island.

Murray, Charles Shaar (1989) *Crosstown Traffic: Jimi Hendrix and the Rock 'n Roll Revolution*, New York: St Martin's Press.

Pride, Dominic (1992) 'Island seeking Marley copyright offenders: labels open pro-
 ceedings against some Euro firms', *Billboard* 26 December.
Webster's New World Dictionary of the American Language (1968) New York: Simon &
 Schuster, 2nd College Edn.
White, Timothy (1986) *Catch A Fire: The Life of Bob Marley*, New York: Henry Holt &
 Co.

Lianne McTavish

SHOPPING IN THE MUSEUM?
CONSUMER SPACES AND THE
REDEFINITION OF THE LOUVRE

Abstract

This article examines the recent renovations of the Louvre Museum, paying particular attention to the Carrousel du Louvre, a shopping mall which opened in the Richelieu wing in 1993. It argues that the consumer area occupies a precarious position, neither clearly inside nor outside of the museum complex. This marginal location potentially undermines traditional distinctions between 'high' and 'popular' culture, upon which the definition of the museum as a haven for 'high' art is founded. However, through close readings of various representations of the mall, including advertisements for it, the author demonstrates that differences between 'elite' and 'popular' culture, as well as those between desirable and undesirable museum patrons, are not erased. Distinctions of gender, class and nationality are continually unmade and remade in relation to the Carrousel du Louvre. The controversial shopping mall can be understood in terms of the contradictory goals of museum administrators and designers. Even as they strive to present a modern and democratic museum, one that is open to a diverse public, they simultaneously attempt to maintain the status of the Louvre as an elite protector of the French cultural heritage.

Keywords Louvre; shopping malls; museum studies; gender; French culture

Approaching the Louvre

MANY MORNINGS, ESPECIALLY during the busy summer months, visitors waiting to enter the Louvre Museum line up outside I. M. Pei's

Figure 1 I. M. Pei, View of the principal entrance pyramid of the Grand Louvre, Paris.
c/E.P.G.L. Photo/RMN

spectacular pyramid (Figure 1). Once the subject of intense debate, the official entrance to the Louvre has become a favourite site for tourists as well as a symbol of the museum.[1] However, it is also possible to access the Louvre from an underground metropolitan station. Visitors can often avoid an extended outdoor delay by passing directly from the Palais-Royal/Musée du Louvre stop into the subterranean level of the Richelieu wing of the museum.

During December 1994, two advertisements were posted on the walls of this and selected other metro stations in Paris (Figures 2 and 3). The paired images provided the potential museum patron with a visual preview of some of the attractions inside the Louvre. The left panel depicted an enlarged version of the face from Leonardo da Vinci's early sixteenth-century portrait, now known as the *Mona Lisa*. Beside this countenance, a sizeable text announced *51 magasins à ses pieds* (51 stores at her feet). The other advertisement portrayed a magnified and somewhat blurred image of the hands in the famous three-quarter portrait. The words *Le Carrousel du Louvre* appeared in the upper right-hand corner of this promotion, while a smaller text listed various shops in its lower section.

These advertisements publicized the controversial Carrousel du Louvre, a shopping mall that occupies 8300 square metres of space in the subterrestrial level of the Richelieu wing of the Louvre. More than fifty commercial outlets are

Figure 2 Advertisement for the Carrousel du Louvre, December 1994, Paris. Photo/L. McTavish

Figure 3 Advertisement for the Carrousel du Louvre, December 1994, Paris. Photo/L. McTavish

housed in the mall, including a Body Shop, a Virgin Megastore, and a North-American-style food court, the first in France. The Louvre patron is thus able to purchase hamburgers or pizza in the 'Restorama' as part of his or her experience of the museum.

The commercial area was built during the second phase of the 1.3 billion dollar Louvre expansion programme (work began on Phase 1 in 1983). After

Pei's pyramidal entrance was inaugurated in 1989, the Richelieu wing, formerly known as the Minister's wing because it had housed the Ministry of Finance, was gutted.[2] Although the facades were maintained, the eight-storey interior of the Richelieu wing was replaced by, in addition to the underground mall, three more capacious levels. A vast ensemble of 178 new rooms, in which several thousand works of art were installed, added over 22,000 square metres of space to the museum.

Jacques Toubon, the then French Minister of Culture and the Francophone Community, officially praised the removal of the Ministry of Finance and the sub-sequent renovations of the Richelieu wing for 'permit[ting] the Louvre palace to be entirely devoted to museum activities' (1993: 3). He implied that the remod-elled Louvre had reached a stage of completion. This claim for the 'apotheosis' of the museum was made more directly by its new name, the Grand Louvre, which declared that the museum was bigger and better than ever.

In this article, I will examine the motivations for, effects of and debates about the recent renovations of the Louvre.[3] It is particularly important to study the Louvre, not only because the museum is a prime tourist destination, attracting more than five million visitors each year (cited in von Jhering, 1991: 55), but also because it has historically provided a model for other institutions to imitate. The Louvre has furthermore been the inspiration for some of the foundational work on the role of museums in society. In the influential essay, entitled 'The uni-versal survey museum', for example, authors Carol Duncan and Alan Wallach demonstrated how 'the ensemble of art, architecture and installations [in the Louvre] shape[d] the average visitor's experience' (1980: 457–467). The Louvre has undergone substantial alterations since Duncan and Wallach described its 'ritual script'.[4] Museum visitors, for example, no longer enter through the Denon Pavilion, pass into the Daru Gallery with its Roman sculpture, and inevitably move towards the representation of France as the true heir of classical civilization (ibid.: 459). The museum patron now enters the administrative areas of the Grand Louvre through Pei's pyramid, and chooses a path to any of the Denon, Sully or Richelieu wings. However, the most striking difference in the structure of the Grand Louvre, and thus the focus of this article, is that it is also possible to approach the permanent collections from an underground shopping mall.

It surprises me that a substantial commercial area was part of the plans to 'perfect' the Louvre and to 'purify' it of non-museum functions. The Carrousel du Louvre could be considered a practical addition to the museum, since the space was leased in order to finance the construction of a large and much needed underground parking lot. The inclusion of a shopping mall, however, overtly associates the museum with market interests, which indicates a reconceptualiza-tion of both the institutional identity of the Grand Louvre and the activities of the public (although not a homogeneous group) within it.

The Louvre, which has long been considered the epitome of the 'high' art

museum, has also been, as Duncan and Wallach point out, dedicated to the ascendancy of French culture (1980: 459–63). Considering French resistance to EuroDisney (since renamed Disneyland Paris to draw upon the cultural cachet of Paris),[5] the presence of a North American mall within the Grand Louvre would seem intolerable. This apparent paradox gives rise to the question that directs my analysis of the museum: Exactly how can a shopping mall be negotiated within the Grand Louvre, a monument historically devoted to both elitist culture and French cultural supremacy?

I will begin to formulate my answer by examining advertisements for the Carrousel du Louvre, written accounts of the mall, and published descriptions of the renovated Richelieu wing. Various representations of the reconstructed Grand Louvre will be foregrounded in order to avoid either giving agency to the architectural structure, and thus characterizing it as an autonomous 'actor', or privileging the intentions of the builders. Although I interpret the decoration and organization of the renovated areas in conjunction with these representations, my emphasis is on the social understandings of the museum rather than the formal qualities 'intrinsic' to it. The spaces of the Grand Louvre are conceived, in other words, as the products of discourse, and not solely as the external causes of representations.

My approach to the study of the Grand Louvre is both informed by and part of a growing literature that analyses the ways in which museums are invested with cultural authority. In recent studies, museums are not simply understood as neutral areas in which artworks are housed. Many accounts consider how, for example, the spatial organization of museums and the installation of selected pieces within specific sites contribute to the meanings of the artworks and shape the experiences of diverse museum visitors (Clifford, 1988; Karp and Lavine, 1991; Hooper-Greenhill, 1992; Elsner and Cardinal, 1994; Sherman and Rogoff, 1994; Cooke and Wollen, 1995; Bal, 1996).

Particularly useful for my theorization of the changing social role and identity of the Grand Louvre is Ivan Karp's contention that museums are institutions of civil society (1992: 4). His definition of civil society is based on the theories of Antonio Gramsci, who argues that whereas political society exerts coercion, civil society creates hegemony, or the manufacture of consent through the production of cultural and moral systems that legitimate the existing social order (Gramsci, 1971: 206–76). As part of civil society, museums participate in the way society is ordered and governed, although often without easily discernible links with politics. Karp argues that, as part of public culture, museums are 'places for defining who people are and how they should act and places for challenging those definitions' (1992: 4), thus emphasizing both the production and the contestation of social values within museums. I will analyse the struggle over the meanings made in the Grand Louvre, and show how this struggle is both specific to that institution and related to a more general rethinking of the status and role of museums.

My conclusions about the Grand Louvre are also, of course, informed by my own experiences and memories of the museum. I spent time in the Carrousel du Louvre as both a pleasant distraction and an affordable place to eat during the autumn of 1994, while I was examining the installation of seventeenth-century French art in the Richelieu wing as part of the research for a doctoral dissertation. Moving back and forth between the collections and the food court eventually led to my realization that the consumer area crucially informed my understanding of the Grand Louvre and the works within it. I also recognized that my privileged position, both equipped with the cultural capital that allowed me to read the codes of the museum and from a working-class background in Canada, encouraged me to look critically at the exhibitions as well as at the shopping mall.[6] My own social location 'in between' at least partially predetermined my understanding of the Carrousel du Louvre as an intermittent space that both shapes and is shaped by the redefinition of the Grand Louvre.

Where is the Carrousel du Louvre?

A number of visual and written texts, including the advertisements for the Carrousel du Louvre described above, represent the uneasy position of the mall within the museum. The promotions feature, the *Mona Lisa*, is arguably the most famous work in the Grand Louvre, drawing approximately 70 per cent of first-time visitors to the museum (cited in Danto, 1990: 149). The *Mona Lisa* has in fact come to be identified with the museum and thus it can, by means of synecdoche, represent the Grand Louvre. Evidence of this possibility is found in the mall itself, where the museum patron is able to purchase a variety of souvenirs, such as posters, calendars or address books, which feature reproductions of the *Mona Lisa*.

The advertisements use the *Mona Lisa* to represent the museum while also conveying a sense of the shifting relationship of the museum and the mall. The text of the panel on the left positions the shops 'at her feet', making reference to the spatial locations of the mall and the museum. The Carrousel du Louvre is in the subterranean level of the Richelieu wing, while the *Mona Lisa* is placed in the Salle des Etats on the first floor of the Denon wing. The upper portion of the museum is thus identified with the body of the woman known as Mona Lisa, while the mall is positioned outside or, more accurately, underneath this body/museum.[7] The advertisements depict the Carrousel du Louvre as a somewhat debased location from which to worship at the feet of the 'masterpiece'. The mall and its patrons are therefore represented as both paying homage to, and being decidedly unworthy of, the Grand Louvre.

At the same time, on the right-hand panel, the names of the stores in the Carrousel du Louvre overlap the fingers of the *Mona Lisa*. The museum and the mall are thus linked visually, and the typed script of the advertisement functions

as a kind of museum label. This explanatory list of shops suggests that Leonardo's image, which represents the museum, acquires meaning within consumer culture. Although the mall is positioned outside of and 'lower' than the museum in the first advertisement, the commercial area is simultaneously represented as an integral part of the museum in the adjacent one.

Written accounts of the Carrousel du Louvre also articulate a contradictory relationship between the museum and the mall. One official description of the mall states that it is 'a vast shopping mall located between the museum proper and the parking areas' (*The Louvre: The Museum, The Collections, The New Spaces*, 1993: 107), implying that the mall is not really part of the museum. In the same article, the Carrousel du Louvre is called 'a logical and uninterrupted extension of the reception areas under the Cour Napoléon', as if the mall is linked with the administrative functions of the Grand Louvre, and is thus not part of the museum proper. A few lines later, the mall is located as 'an underground thoroughfare . . . at once an extension of the museum and totally independent of it'. Here a compromise between the two earlier descriptions is attempted as the mall is depicted as a kind of border zone that is neither inside nor outside the museum. It is clear that this particular writer is unsure exactly where the mall 'fits' within the renovated museum. Although the mall shifts between the interior and exterior of the museum in these accounts, it is rarely described as directly inside the Louvre. There were, however, some complaints that the mall seemed 'practically' like part of the museum (see e.g. Rohr, 1993: 69; Simons, 1993: 3).

The marginal location of the Carrousel du Louvre is structurally similar to that of the *parergon*, described by the philosopher Jacques Derrida, as existing neither inside nor outside of the artwork, but, like the frame that surrounds a painting, providing the necessary limitation that enables the 'centre' or 'main subject' of the work to become visible (1987: 37–82). In the case of the Grand Louvre, the mall negotiates, while also conceivably undermining, the distinction between the interior and exterior of the museum. The idea that the mall is within the Grand Louvre is problematic, therefore, because the very delineation of the museum is based on an understanding of what is excluded from its domain. Carol Duncan and Alan Wallach argue that the facades of museums are prominent because they signify the transition from the outside world to the interior of the museum (1978: 30–1). The space inside the museum, which is defined as a bastion of cultural treasures that can be viewed within an ahistorical and neutral setting, is coded as different from that of the everyday exterior world. The desired effect is that the museum simply houses works of 'genius' for the education and benefit of an imaginary and largely homogeneous viewing public (Duncan and Wallach, 1980: 451). In contrast, the subterranean mall places commercial exchange as the foundation of the Grand Louvre.

The presence of the mall thus also potentially alters the distinction between 'high' art and 'popular' culture upon which the understanding of the museum as a haven for 'high' art is founded. In an analysis of the hierarchy of values associated

with what are deemed 'high' and 'low' or 'popular' cultural forms, sociologist Pierre Bourdieu contends, in opposition to Immanuel Kant's account of the universality of aesthetic quality, that distinctions of class become distinctions of taste (1984: 11–96). Bourdieu argues that the denigration of 'popular' cultural forms and the privileging of 'high' art indicate the ability of the dominant classes to impose values on differences. In his early study of European museums, for example, Bourdieu found that although the stated goal of most institutions was both to attract and to enlighten a diverse public, the museums were in fact primarily visited by highly educated patrons (Bourdieu and Darbel, 1991). The aesthetic disposition institutionalized in the museum, one of 'pure taste', an intellectual stance of disinterestedness from the object, tended to alienate working-class and less educated visitors. With the potential confusion of 'high' and 'popular' culture in the Grand Louvre, however, the role of the museum in (re)producing social distinctions is less obvious.

The location of the mall would seem to indicate, as argued by John Frow, that both 'high' and 'low' cultural forms are fully absorbed within commodity production (Frow, 1995: 23). Frow claims that Bourdieu presumes a unity of class experiences, mapping them on to pregiven divisions between 'high' and 'low' culture. However, Frow argues that these distinctions cannot adequately account for the complexity of contemporary culture. In his opinion, 'the untenable core of the concept of the popular (of the 'mass'-cultural) is its structural opposition to high culture: a binarism which at once unifies and differentiates each domain' (pp. 81–2). The mall, as an intermittent space, makes it clear that the divisions between 'high' and 'low' are both unstable and shifting; the categories overlap and take on meaning in relation to each other.

At the same time as 'high' and 'low' culture may seem to be indistinguishable in the renovated museum, the visual and written descriptions of the Carrousel du Louvre express a concern to reinstate the separation of the mall and the museum. This segregation, however, cannot easily be maintained. The rest of this article examines how, along with the changing conceptions of the Grand Louvre, distinctions between 'elite' and 'popular' culture, as well as divisions between desirable and undesirable museum visitors, are continually unmade and remade in relation to the renovated museum.

The 'opening' of the Richelieu wing

In response to criticisms of the Carrousel du Louvre, architect I. M. Pei alleged that 'the mixing of art, culture and commerce is not impossible' (cited in Sancton, 1993: 59). Other designers of the renovated Grand Louvre agreed. The shopping mall, according to Jean Lebrat, President of the Public Authority for the Grand Louvre, would encourage people to continue into the museum (Jodidio and Picard, 1993: 42). He and other museum officials envisioned the

consumer area not as separate from but as an enhancement of the museum experience. The potential for greater attendance figures, and thus revenues, was, not surprisingly, a consideration in the construction of the commercial area.[8]

The hope that the mall would appeal to the public is related to the desired, and apparently relatively novel image of the Louvre as catering to visitors. Official accounts of the expansion of the museum stress the increased accessibility and convenience of the newly modern structure. These qualities are described in terms of the newly rationalized plan of the museum as well as its extended hours and greater number of restrooms, shops and restaurants.[9] The Grand Louvre is said to 'have become . . . a museum that is generously opening itself up to the city after two centuries of discreet existence' (Lebrat, 1993: 9).

One instance of the increased accessibility of the museum is the connection of the Carrousel du Louvre with a metropolitan station, which symbolically links the museum with the rest of the city. The apparent 'openness' of the museum is usually related, however, to the new emphasis on transparency in, for example, the glass entrance pyramid and the glass skylights which cover the vast courtyards in the sculpture areas of the Richelieu wing: 'with the opening of Richelieu, the museum becomes like a window on the Rue de Rivoli toward the city. From the outside, one sees the inside . . . through the large windows and the openings on the courtyard' (Lebrat, 1993: 9). The architecture of the expansion is designed to break down the material boundaries of inside and outside, in contrast to the museum ideal outlined by Duncan and Wallach.

The relatively recent invitation of the general public into the Grand Louvre is part of a wider reconceptualization of the function and status of museums. Although studies have shown that connections between museum exhibitions and more 'popular' fairs or department stores exist historically (Saisselin, 1984: 19-49; Silverman, 1986; Bennett, 1995: 29–31), this association is certainly becoming more obvious in contemporary North American museums. Consider, for instance, the mall-like food court area, also designed by I. M. Pei, in the National Gallery in Washington, DC. The designers of the Canadian Museum of Civilization in Ottawa actively studied both open air museums and theme parks like Disney World as plausible models for a museum that would attract and maintain the interest of a wide public (MacDonald, 1992: 170). Several museums have even been built within malls in order to be both accessible to and convenient for visitors.[10] It is in fact becoming common for museum officials to take the desires of museum visitors into consideration in order to compete more effectively for their leisure time (Macdonald and Silverstone, 1990).

However, the new image of the 'hospitable' Grand Louvre is related to more than practical or even monetary considerations. The official opening date of the renovated Richelieu wing was 18 November 1993, precisely two hundred years after the Louvre was initially made available to the public. It thus represents the reconstructed Louvre as fulfilling, or even surpassing, the ambitions associated with the early museum. The Louvre was first transformed into a museum in 1793

after the royal residence and the art collections it contained were confiscated as a result of the French Revolution. The structure was opened to the people as concrete evidence, according to Andrew McClellan, of the strength and democratic values of the new Republic (1994: 91–123). The image of the increasingly 'open' Grand Louvre, complete with transparent surfaces, is thus directly associated with the democratic ideals of the early museum, one open to all the citizens of the Republic.

The strategic opening date of the renovated Grand Louvre links the museum with the foundation of the Republic, and by extension with the administration of former French President François Mitterrand which allocated the building funds for the Louvre in 1981. Like the original Louvre, which was meant to represent the values of the Republic, the renovated Grand Louvre can be read as a representation of a particular conception of the modern French nation. Despite the overt governmental interest in the Louvre building campaign, it does not follow that French politics were directly translated into material form, and then 'thrust' upon an unwitting public (a version of the base/superstructure model of cultural production).[11] Louvre patrons continue to have many different interpretations of the museum, although these differences worry some critics of the renovations as discussed below.

The plans for the Grand Louvre and a host of other ambitious architectural projects in Paris, known as the *grands projets*, were considered part of a political campaign by Mitterrand. French politicians on the right, for example, asserted that Mitterrand had a 'Louis XIV complex'.[12] Indeed, the former President himself saw the museum as an adequate representation of his government and the modern French state; he even held political meetings in the renewed areas (see Northcutt, 1991: 151). The interest of Mitterrand's administration in promoting a French nation more open to foreign trade and influence can be related, for example, to the new emphasis on welcoming visitors (and, by extension, foreign tourists) into the Grand Louvre. Additional indications of the French interest in and acceptance of foreign culture are provided by both the controversial choice of the architect, the Chinese-American I. M.Pei, who was hand-picked by Mitterrand (see Chaslin, 1985: 113–140) and the selection of the Québécois firm Camdi as the developers of the food court in the Carrousel du Louvre.

Despite the association of the renovated Grand Louvre with the historical foundation of Republic, the emphasis on conveniences, such as the shops and restaurants in the Carrousel du Louvre, and the promotion of contemporary architectural forms, present a particularly modern French institution. The incredibly complex glass skylights over the immense courtyards in the Richelieu wing, for example, can be related to Mitterrand's desire to promote a technologically advanced French nation (Northcutt, 1991: 145–58). The covered courtyards feature large-scale seventeenth- and early eighteenth-century French sculpture. Review articles about the Richelieu wing almost always reproduce an

Figure 4 Guillaume Coustou (1677–1746), *Cheval de Marley*, commissioned 1739, Grand Louvre, Paris. c/Photo/RMN- R. G. Ojeda

image of one of Guillaume Coustou's over life-sized *Chevaux de Marly*, which convey a sense of energy and power as they rear upwards towards the skylights[13] (Figure 4). The image of the rearing horse metaphorically implies the energy and strength of an adventurous French nation which, although modern, remains founded upon an auspicious cultural tradition. Many installations in the renovated areas of the Grand Louvre therefore emphasize the continuing hegemony of a progressive French culture.

The Carrousel du Louvre is thus part of both the 'popularization' and modernization of the museum. Although the mall includes 'foreign' shops in a predominantly North American architectural form, it is an important component of the representation of a French institution and, by extension, a democratic French nation 'open' to cultural diversity.

'At her feet': the lowly mall

Although the Carrousel du Louvre and other renovated areas in the Grand Louvre were part of the attempt to present a truly democratic and modern

Grand Louvre, distinctions between desirable and less desirable guests continued to be a concern. Patricia Mounier, the head of the press office of the Louvre, stated, in direct opposition to the concept of the increasing 'openness' of the museum, that since 70 per cent of Louvre visitors in 1988 were foreign, attracting an increasing number of French patrons, particularly those from Paris, was a goal of the renovations (cited in von Jhering, 1991: 55). Mounier voices a particular misgiving about the 'foreign others' who continually enter the museum, and the perceived need to reassert the 'Frenchness' of the Grand Louvre. Questions were raised about the possibly polluting effects of the North-American style shopping mall within the 'high' art museum as well as the kinds of 'outsiders' it might attract. The identity of the Grand Louvre was reworked in a variety of representations, including the advertisements that depicted the shopping mall and its patrons grovelling in a state of submissive desire at the feet of the *Mona Lisa*/Grand Louvre.

In the advertisements for the Carrousel du Louvre, the *Mona Lisa* can represent the conflicted position of the commercial shopping mall within a 'fine' art museum. The image blurs, in its very confirmation of them, the boundaries between 'high' art and consumer culture. In their discussion of the narrative structure of the Louvre, Duncan and Wallach locate the *Mona Lisa* as the prime example of how artworks embody the values of the state. This painting, they argue, has become the paradigmatic example of individual genius and an ahistorical 'high' art aesthetic. Thus, they continue, the *Mona Lisa* conveys notions of the free individual which are directly related to the construction of a state claiming to be based on democracy (Duncan and Wallach, 1980: 451). I would argue, in contrast to Duncan and Wallach's notion of a stable meaning, that the reason why Leonardo's painting has been used repeatedly in advertising and novelty items is precisely for its ability to be reinscribed continuously with different messages. At the same time, the image is still considered to be the ultimate icon of creative genius and artistic progress.

Although the status of the *Mona Lisa* as 'high' art may seem ultimately immutable, the stability of this elevated position should not be overstated. Evidence of mobility within the category of 'high' culture is indicated when the *Mona Lisa* is identified with the Grand Louvre and thus with French culture in the advertisements for the Carrousel du Louvre. This nationalistic claim, which deliberately dislocates the image from its Italian heritage, does not challenge the elevated status of 'high' art. Instead, it shifts the classification by representing the *Mona Lisa* as a kind of trophy, or material signifier, of the triumph of French culture.[14]

The *Mona Lisa*, although an icon of 'high' art, can be associated with 'popular' culture when the painting is perceived, not only as a portrait by Leonardo da Vinci, but also as a representation of a woman, especially a woman with bodily desires. It seems as if imagining the 'feminine' body of the *Mona Lisa* can undermine its status as an aesthetically pure example of individualism and artistic creativity. In 1919, for example, the artist Marcel Duchamp provided *Mona Lisa*

Figure 5 Marcel Duchamp, *L.H.O.O.Q.*, 1930, Private Collection. Photo/Art Resource, NY, c/KINÉMAGE, Montréal, 1997

with a 'bottom' when he altered a photograph of the painting by adding a moustache and goatee to her face, along with the caption L.H.O.O.Q. (Figure 5). The joke becomes apparent when letters are read phonetically in French, *elle a chaud au cul*, and the *Mona Lisa* is described as having a 'hot ass'.[15] The image by Duchamp evokes the sexual desires of the *Mona Lisa* and characterizes her lower bodily realm in an attempt to subvert the position of the painting as a paradigm of 'high' art.

Many advertisements which include the *Mona Lisa* also allude to her corporeal nature, even going so far as to represent her with a lower body. 'She'

is shown with denim-clad legs, for example, in a Parisian promotion of Foster 2 jeans from 1978.[16] In one of the advertisements for the Carrousel du Louvre, the feet of the *Mona Lisa*, and thus 'her' entire lower bodily stratum, are a fantasmatic addition to Leonardo's painting. The subterranean mall is positioned in relation to this imaginary realm. The lower bodily stratum of women has historically been linked with subversion, desire and excess, as argued by Mikhail Bakhtin and other theorists (Bakhtin, 1968: 303–463; Russo, 1994; Baskins, 1993). Expanding upon this traditional association, the advertisement promotes the mall as an erotically charged and even carnivalesque addition to the museum. The shopping that takes place in the mall is figured in terms of unruly 'feminine' desires.[17]

The feet of the *Mona Lisa* which enable 'her' mobility are imagined in another advertisement for the Carrousel du Louvre, in which the subject in Leonardo's portrait has been replaced by the words *De retour à 14h, signé Mona Lisa* (To return at 2 p.m., signed Mona Lisa). The implication is that 'she', the *Mona Lisa*, has gone down to the food court for lunch, as if 'she' is bingeing on food after years of gastronomic denial in the boring old Louvre (see Arseneault, 1994: 49). Even though the advertisement trumpets 'her' descent into the world of commercial exchange and bodily pleasure, it is precisely this potential devaluing of the museum and its art objects which worries critics of the mall.

The advertisement, which emphasizes the absence of the *Mona Lisa* from the museum during her lunch break, enacts a narrative of the exit from and return to the museum. The separation of the museum and the Carrousel du Louvre is reinforced because when the *Mona Lisa* descends to the mall, 'she', like the 'fallen woman' who is part of commodity culture, fulfils 'her' bodily desires. But, according to the emphasis on 'her' inevitable return, the *Mona Lisa* will soon be back where 'she' belongs, in the museum proper, a place associated with intellectual work as opposed to bodily pleasure.

The gendered stratification of the upper and lower realms of the museum in the advertisements for the Carrousel du Louvre reinforces feminist arguments about the traditional historical distinctions made between 'high' and 'low' art. The classification of 'low' or 'popular' art is often related to the manual production of crafts. Feminist art historians, like Rozsika Parker and Griselda Pollock, argue that women's creations, such as needlework and quilting, are linked with repetitive mechanical (bodily) activities and are thereby distinguished from the intellectual 'high' art creations that are featured in museums (1981: 50–81). It is as if women's productions, and aspects allied with 'femininity', are prohibited from the upper levels of the Louvre as part of the definition of the museum as a bastion of 'high' art. In the advertisements for the Carrousel du Louvre, the mall is represented as a desirable 'feminine' zone of pleasure, situated below the intellectual realm of the museum.

Reviewer John Rockwell wonders if an underground culture of 'young restless idlers' will develop inside the seductive mall as 'some Parisians fear'

(1993: 39). He implies that there is a general concern that the 'public', which is envisioned as an unruly mass and associated with the 'lower' classes, might just stay in the pleasurable consumer area and not bother to have a more cerebral experience in the museum. Perhaps it is feared that what John Fiske describes as the guerilla shoplifters and mall rats of large North American commercial areas will begin to inhabit the Carrousel du Louvre (1989: 41).

This anticipation of the unsuitable behaviour of large groups of 'outsiders' is not unrelated to the representation of the Carrousel du Louvre as a 'feminine' realm in the advertisements. The masses have been historically associated with 'femininity'; Bakhtin, for example, relates the grotesque 'feminine' body to the social body, made up of the people of the carnival (1968: 19). In his sociological study of collective behaviour in 1895, Gustave Le Bon argues that crowds are inherently 'feminine' because they are irrational, impulsive and open to suggestion (1968: 39), while Andreas Huyssen (1986) contends that mass culture is figured in terms of 'femininity', which acts as the hidden subtext of modernity in late nineteenth-century French literature. The advertisements for the Carrousel du Louvre and the debates about the commercial zone reconfigure this conventional association. Assumptions about 'femininity' and the 'foreign' 'lower' classes are related to the desirable and dangerous shopping mall. Despite the descriptions of the renovated Grand Louvre as increasingly 'open' to a diverse public, and the seeming confusion of 'popular' and 'high' culture within the museum, distinctions which are formulated in relation to gender, class and nationality are reinforced in both the advertisements for the Carrousel du Louvre and the anxieties of some of its critics.

This rearticulation of differences is made even more obvious by the plan and design of the Carrousel du Louvre. A number of strategies were adopted in order to counter the potentially subversive and contaminating position of the mall within the Grand Louvre complex. The developers of the mall were intent on creating an environment that would discourage inappropriate activities, stressing what they called 'quality' in the leasing of mall space. Although they formed an 'ethics committee' to screen shops for appropriateness (cited in Rohr, 1993: 69), it is not clear on what grounds they made their decisions. There was an interest, however, in an imagined level of quality that seems similar to debates about the elusive 'inherent' values of artworks.

In her analysis of shopping malls, Meaghan Morris (1993) argues that consumer areas are designed to produce a sense of place in the quest for what she calls 'a shopping center identity'. In the Carrousel du Louvre, the shops initially welcomed by developers tended to be expensive ones, like Lalique crystal and Hermès, which catered to wealthy consumers.[18] Clearly, the less affluent museum patron could feel uncomfortable in the aura of elegant refinement associated with these particularly 'French' luxurious shops. Furthermore, the type of boutique noticeably changes according to its location within the mall. Postcards with views of Paris, for example, are for sale near the passage to the

metropolitan station. On the opposite end of the mall, more expensive stores like Courrèges, which sells women's clothing and perfume, are closer to both the Cour Napoléon and the artworks on display.

Another indication of the potentially exclusionary effect of the shopping mall is its decoration. Even though the Carrousel du Louvre is generally described as being outside or on the edges of the museum, critics of the mall are quite right; the plan and aesthetics of the commercial area make it seem like part of the Grand Louvre. The spacious mall, for example, is sheathed in the same beige limestone that covers the walls of the Richelieu wing. The mall also boasts the subdued lighting and high ceilings found in the rest of the wing. Because of the vestiges of the medieval fortress that were uncovered during its construction, the mall actually doubles as an exhibition space. The foundations of the early palace are on display in what is deemed to be a commercial zone.

Unquestionably linking the museum and the mall is the second major transparent pyramid designed by I. M. Pei (Figure 6). The inverted triangular form, which acts as the centrepiece of the mall, does more than provide natural light to the subterranean area. It answers the entrance pyramid, a stable geometrical structure which metaphorically implies that the museum is a timeless temple of cultural preservation. The inversion of the later pyramid may indicate that these values in the Grand Louvre 'proper' have been turned upside down in the mall. Since the two pyramids are situated along a single axis, however, the effect is one of balance and harmony as well as a shared interest in modernity and technical bravado, which links the first phase of the expansion project with the underground mall.

The decoration acts to absorb and (literally) neutralize the presence of the commercial zone. The overall aesthetic of the mall is similar to that of the museum and thus mimics its cultural authority, as if to correct potentially unsuitable behaviour before visitors enter the museum.[19] As a relatively cold space, without places to sit down (save for the restricted zone of the food court), the adornment of the Carrousel du Louvre can be interpreted as a 'masculinization' of that space in order to offset its association with 'feminine' domesticated consumerism and display (see Greenberg, 1996). Despite the potentially subversive position of the Carrousel du Louvre, distinctions of 'high' and 'low' culture are rearticulated in relation to gender, class and nationality in specific representations and aspects of the mall. However, it is still possible for a heterogeneous and less-than-affluent public to eat a taco at the El Rancho before or after entering the exhibition areas of the museum, or even without viewing the artworks at all.

The contradictory Carrousel

A number of conceptions of the museum exist simultaneously. The desire for the Grand Louvre to seem more accessible and welcoming to a broader public

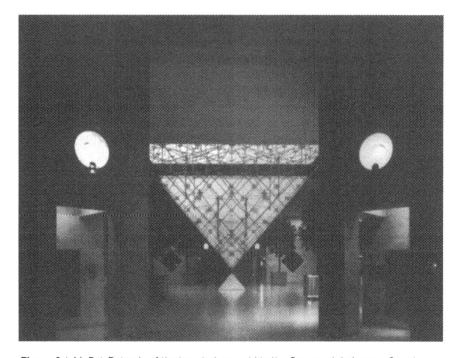

Figure 6 I. M. Pei, Rotunda of the inverted pyramid in the Carrousel du Louvre, Grand Louvre, Paris. c/Photo/RMN- Caroline Rose

conflicts with the idea of it as an elitist 'high' art museum which promotes the intellectual contemplation of artworks within a neutral setting. The Carrousel du Louvre exists in tension between these two museum ideals. It is meant to attract and accommodate a more diverse public, but there are worries that the mall may invite the very public that museum officials have long sought to exclude.

This tension, which is clearly closer to a contradiction, can be related to what Tony Bennett describes as the two opposing forces that informed the origins of the nineteenth-century museum. On the one hand, he argues, there was a homogenizing ideal which stressed the accessibility of the museum in the hopes of teaching and 'civilizing' the masses. On the other hand, the museum was designed to distinguish the 'elite' classes from the 'lower' ones (Bennett, 1995: 28). Within the Grand Louvre, the Carrousel du Louvre negotiates these contradictory goals by attracting and attempting to reform the behaviour of the public.

A further tension in the renovated Grand Louvre is related to the move to represent cultural diversity in a 'democratic' museum and, by extension, portray an open and progressive French nation, while simultaneously maintaining the Grand Louvre as an essentially 'French' monument. Examples of the reassertion of the hegemony of French culture can be found, as noted above, in the sculpture installations of the Richelieu wing, the representation of the *Mona Lisa* as a 'French' object, and even the expensive French shops in the Carrousel du

Louvre. The contradictions of the Grand Louvre are similar to the dilemmas faced by organizers of other contemporary museums. As museum officials struggle to serve the public and attend to a wider range of communities, they simultaneously strive to preserve both the cultural authority and unified national identity of the museum.

As the Grand Louvre is designed both to attract and to contain a larger and more diverse public, additional issues arise about monitoring these potentially unruly crowds. The new emphasis of the Grand Louvre on public accom-modation in a modern and convenient museum goes hand in hand with increased public control in the renovated structure. The transparent pyramids and sky-lights, for example, although representing 'French' modernity, also thematize visual access and can be related to an increased interest in public surveillance and management.[20] The newly rationalized museum, with its central location under Pei's entrance pyramid, is commended for providing the public with clearly demarcated routes and directions, in opposition to the gloomy and confusing cor-ridors of the old museum. Control of public behaviour is also stressed when Pei's spectacular entrance is praised for 'cleaning up' a problematic area. The Cour Napoléon, one referred to as a 'sordid trysting spot' at night, was formerly a parking lot filled with souvenir-hawkers during the day (Rockwell, 1993: C24). Such consumer activity and potentially unruly behaviour have since been removed; they are now either 'safely' enclosed within the underground shopping mall or banished to the city streets and the river embankments beyond.

The inverted pyramid in the Carrousel du Louvre is a site of security concen-tration. Uniformed guards attempt to prevent all photographs of the pyramid, while activities like loitering and ice-cream eating in the immediate vicinity of the inverted form are forbidden. The goal is to restrict bodily and other pleas-ures to specific areas in the mall, like the food court, which is located further away from both the pyramid and the Cour Napoléon. In addition, prospective visitors of the Grand Louvre often have their bags searched as they pass from the mall into the administrative areas of the museum as if there were a clear distinc-tion between the two spaces. Indeed, an inlaid tile on the floor which reads 'Louvre' is meant to inform the museum patrons that they are crossing the threshold into a distinct space.[21] A boundary between the shopping mall and the museum is thus (re)created, which reinforces the role of the museum as the pro-tector of culture. Great pains, in other words, have been taken to ensure that the Carrousel du Louvre is not the carnivalesque realm of an underground 'popular' or 'American' culture that some of its detractors feared it would become.

Not all public desires and potentially subversive behaviours are contained within the renovated Grand Louvre. Although, for instance, the curators of the Grand Louvre would prefer to position the *Mona Lisa* within the narrative of Flor-entine Renaissance art that exists in the museum, the painting is instead situated in the expansive Salle des Etats. This alternative location is able to accommodate the large crowds that congregate in front of the *Mona Lisa* (Danto, 1990: 150) as

well as the resulting increase in museum security. This example indicates that museum officials are required to satisfy, while also attempting to contain, at least some of the heterogeneous demands of the public.

Conclusions

The location of the Carrousel du Louvre within the renovated Richelieu wing of the Grand Louvre reveals the unsteady distinction between aesthetic and consumer interests, amidst the insistence that those concerns remain separate. Differences between 'high' and 'low' culture continue to inform perceptions of the renovated Grand Louvre. Although articulated in rather traditional ways in relation to gender, class and nationality in some representations of the renovated Grand Louvre, these categories will continue to shift, along with changing conceptions of the museum.

This analysis of the conflicting position of a commercial mall within a museum complex makes it clear that the Grand Louvre is not a monolithic establishment with a fixed identity. The relationship of the mall and the museum, which fluctuates in the written and visual descriptions of it, indicates the unstable boundaries of the Grand Louvre. A number of museum ideals meet, overlap and conflict in the renovated museum as the institutional and geographical borders of the Grand Louvre are continuously dissolved and reinscribed. This redefinition of the museum will continue along with and probably beyond the expansion project as it reshapes the Louvre. An updated version of this analysis, for example, will be required once an additional entrance, scheduled to open sometime in 1998, allows museum patrons to begin their visit in the rearranged Egyptian installations on the ground floor of the Sully wing.

Acknowledgements

I would like to thank Mieke Bal, Cristelle L. Baskins, George Dimock, Natasha Goldman, Michael Ann Holly, Beverly Lemire, Lee Spence and Janet Wolff for their comments on earlier drafts of this article. Research was funded by the Social Sciences and Humanities Research Council of Canada.

Notes

1 For some accounts of the debate sparked by Pei's pyramidal entrance see Davey (1989); Ellis (1989); Grauman (1988); Mercillon (1985); Loriers (1989); Foucart (1989); Chaslin (1989).

2 For descriptions of the renovated Richelieu wing see *The Louvre: The Museum,*

The Collections, The New Spaces (1993); Schneider (1992); Viau (1994); Rochette and Saunders (1994); Danto (1994); Coignard (1993); Kaminka (1994). For descriptions of the Carrousel du Louvre see Duparc (1993); Sancton (1993); Kimmelman (1994a, b); Simons (1993); Rockwell (1993); Arseneault (1994); Danto (1993); Rohr (1993).

3 As renovations of the Louvre were ongoing during the writing of this article (1995), the argument primarily focuses on the Richelieu wing. Sections of the Sully and Denon wings remained closed for the reinstallation of works during the summer of 1997.

4 Although Duncan updates her analysis of the Louvre in her new book (1995), she does not include the most recent renovations of the museum.

5 For a discussion of how Disneyland Paris is neither connected with French national identity nor associated with French cultural practices see Spencer (1995). However, the recent restructuring of the theme park has attempted to respond to at least some French expectations. See Crumley and Fisher (1994), and Gubernick (1994).

6 The privileged position of many scholars working on 'popular' culture is discussed by Gripsrud (1989: 198–200).

7 For other examples of a museum figured as a woman's body see Geldin (1987: 10), and Berelowitz (1990: 70–84).

8 Biasini *et al.* (1989: 16) cite 'modest visitor totals' as part of the impetus for the renovations of the Louvre.

9 For descriptions of the modernity of the expanded Louvre, see Chaslin (1985: 113–40); Jodidio (1993: 44, 46, 49); Rockwell (1993); Simons (1993: V, 3); Laclotte (1993: 8–12); Duparc (1993: 41); Sancton (1993: 59); Kimmelman (1994a); von Jhering (1991); Biasini *et al.* (1989: 125). A questionnaire conducted at the Louvre during the spring and summer of 1997 indicates that this interest in public opinion continues. According to the accompanying literature, the visitors' survey was designed 'to get to know the public better and respond more efficiently to its expectations'.

10 For museums in shopping centres, see Conybeare (1991) on the Trowbridge Museum in Wiltshire, and Lewis (1991) on satellite museums in malls. See also Balcomb (1986).

11 For critiques of the base/superstructure model of culture, see Hall (1977), and Wolff (1981: 77–86).

12 The *grands projets* include La Grande Arche de La Défense, the Musée d'Orsay, the Institut du Monde Arabe, and five other buildings. They and the Grand Louvre can be understood as deliberate representations of the status of French culture according to Chaslin (1985) and Lipstadt (1988). Northcutt (1991) and Chaslin (1989: 8–16) document the charges against Mitterrand.

13 Images of the Richelieu wing invariably highlight the covered courtyards. See, for example, Schneider (1992) and Viau (1994). The technical aspects of Pei's inverted pyramid are discussed in Campbell (1994), and the skylights in the courtyard by McDowell *et al.* (1994).

14 I owe this idea of the hybrid nationality of the *Mona Lisa* to Cristelle L. Baskins.
15 For a discussion of Duchamp and of the *Mona Lisa* as an 'object', see Nesbit
 (1991). I thank George Dimock for drawing my attention to the gender trans-
 formation that the goatee and moustache enact upon the face of the *Mona Lisa*.
 Although these attributes may indicate that she has some 'masculine' qualities,
 Duchamp's contrast of the comically rendered facial hair with the invocation
 of her 'hot ass' at the bottom of the image underscores the gendered division
 between her potentially 'manly' upper body and the presence/absence of her
 'feminine' lower body.
16 Reproduced in Storey (1980: 76).
17 For associations of women with luxury and shopping, see Saisselin (1984:
 53–74); Zola (1992), and Miller (1981).
18 Although both the Hermès and Lalique crystal shops are no longer in the
 Carrousel du Louvre, which perhaps indicates a lack of wealthy patrons, an
 aura of luxury, along with other expensive boutiques, remains in the mall.
19 Bennett (1995: 74) discusses how fair zones provided buffer areas during the
 great expositions in nineteenth-century London. He argues that they acted to
 extend the influence of the more sanctioned displays. For an analysis of how
 art museums alter bodily behaviour, see Trondsen (1976).
20 Cristelle L. Baskins suggested that I consider the inverted pyramid as a kind of
 'panopticon'. The idea of surveillance is informed by the arguments of
 Foucault (1977). For articles on surveillance and the museum, see Trondsen
 (1976); Bennett (1995: 63–9); Baudrillard (1982), and Hooper-Greenhill
 (1992: 167–90).
21 Upon returning to the Carrousel du Louvre in 1997, I noticed that there was
 additional security, including X-ray machines used to examine the bags of
 patrons at both entrances to the Grand Louvre. This increase in surveillance
 was also evident at many other major Parisian monuments.

References

Arseneault, Michel (1994) 'Une pizza pour la Joconde'. *L'Actualité*, 1 March: 49.
Bakhtin, Mikhail (1968) *Rabelais and His World*, trans. Hélène Iswolsky, Cambridge,
 MA: MIT Press.
Bal, Mieke (1996) *Double Exposures: The Subject of Cultural Analysis*, New York: Rout-
 ledge.
Balcomb, Mary N. (1986) 'The Bellevue Art Museum: culture comes to a mall',
 Southwest Art, 16: 84.
Baskins, Cristelle L. (1993) 'Typology, sexuality, and the Renaissance Esther', in
 James Grantham Turner (ed.) *Sexuality and Gender in Early Modern Europe: Insti-
 tutions, Texts, Images*, Cambridge: Cambridge University Press, pp. 31–54.
Baudrillard, Jean (1982) 'The Beaubourg-effect: implosion and deterrence', *October*,
 20 (spring): 4–13.

Bennett, Tony (1995) *The Birth of the Museum: History, Theory, Politics*, New York: Routledge.

Berelowitz, Jo-Anne (1990) 'From the body of the Prince to Mickey Mouse', *Oxford Art Journal*, 13 (fall): 70–84.

Biasini, Emile, Biasni, Jean Lebrat, Dominique Bezumbus, Jean-Michel Vincent (1989) *The Grand Louvre: A Museum Transfigured, 1981–1993*, Paris: Electa Moniteur.

Bourdieu, Pierre (1984) *Distinction: A Social Critique of the Judgement of Taste*, trans. Richard Nice, Cambridge, MA: Harvard University Press.

Bourdieu, Pierre and Darbel, Alain with Dominique Schnapper (1991) *The Love of Art: European Art Museums and Their Public*, trans. Caroline Beattie and Nick Merriman, London: Polity Press.

Campbell, Barbara Ann (1994) 'Light periscope', *The Architectural Review*, 194: 18–19.

Chaslin, François (1985) *Les Paris de François Mitterrand: histoire des grands projets architecturaux*, Paris: Gallimard.

—— (1989) 'Grande Louvre, prisme changeant de l'opinion', *L'Architecture d'Aujourd'hui*, 263: 8–16.

Clifford, James (1988) *The Predicament of Culture: Twentieth Century Ethnography, Literature, and Art*, Cambridge, MA: Harvard University Press.

Coignard, Jerome (1993) 'Aile Richelieu: le chaud et le froid', *Beaux Arts*, 118: 9–10.

Conybeare, Clare (1991) 'Mall, mill or museum? (the first museum to be incorporated into a shopping center)', *Museums Journal*, 91: 20–1.

Cooke, Lynne and Wollen, Peter (eds) (1995) *Visual Display: Culture Beyond Appearances*, Seattle: Bay Press.

Crumley, Bruce and Fisher, Christy (1994) 'Euro Disney tries to end evil spell', *Advertising Age*, 65, 7 February: 39.

Danto, Ginger (1990) 'What becomes a legend most', *Art News*, 88: 148–51.

—— (1993) 'Mona and a mall', *Art News*, 92: 98–9.

—— (1994) 'Riches in the Richelieu wing', *Art News*, 93: 47–50.

Davey, Peter (1989) 'The Grand Louvre', *Architectural Review*, 186: 1–20.

Derrida, Jacques (1987) *The Truth in Painting*, trans. Geoff Bennington and Ian McLeod, Chicago, Ill: University of Chicago Press.

Duncan, Carol (1995) *Civilizing Rituals: Inside Public Art Museums*, New York: Routledge.

Duncan, Carol and Wallach, Alan (1978) 'The Museum of Modern Art as late capitalist ritual', *Marxist Perspectives* (winter): 29–51.

—— (1980) 'The universal survey museum', *Art History*, 3: 448–69.

Duparc, Christine (1993) 'Le Louvre, toutes ailes déployées', *L'Express*, 25 November: 38–43.

Ellis, Charlotte (1985) 'Pei off centre', *Architectural Review*, 177: 4.

Elsner, John and Cardinal, Roger (eds) (1994) *The Cultures of Collecting*, Cambridge, MA: Harvard University Press.

Fiske, John (1989) *Understanding Popular Culture*, Boston: Unwin Hyman.

Foucart, Bruno (1989) 'The victory of the pyramid', *Apollo*, 129: 304–6.

Foucault, Michel (1977) *Discipline and Punish: The Birth of the Prison*, trans. Alan Sheridan, New York: Vintage Books.

Frow, John (1995) *Cultural Studies and Cultural Value*, Oxford: Clarendon Press.

Geldin, Sherri (1987) 'One very lucky museum', in Howard Singerman (ed.) *Individuals: A Selected History*, New York: Abbeville Press, pp. 10–23.

Gramsci, Antonio (1971) *Selections from the Prison Notebooks*, trans. Quintin Hoare and Geoffrey Nowell Smith (eds), New York: International Publishers.

Grauman, Brigid (1988) 'Pyramid power', *Art News*, 87: 52.

Greenberg, Reesa (1996) 'The exhibited redistributed: a case for reassessing space', in Reesa Greenberg *et al.* (eds), *Thinking About Exhibitions*, New York: Routledge, pp. 349–67.

Gripsrud, Jostein (1989) '"High culture" revisited', *Cultural Studies*, 3(2): 194–207.

Gubernick, Lisa (1994) 'Mickey n'est pas fini', *Forbes*, 153, 14 February: 42–3.

Hall, Stuart (1977) 'Rethinking the "base and superstructure" metaphor', in J. Bloomfield *et al.* (eds) *Class, Hegemony and Party*, London: Lawrence and Wishart, pp. 43–72.

Hooper-Greenhill, Eilean (1992) *Museums and the Shaping of Knowledge*, New York: Routledge.

Huyssen, Andreas (1986) 'Mass culture as woman: modernism's other', in Tania Modleski (ed.) *Studies in Entertainment: Critical Approaches to Mass Culture*, Bloomington: Indiana University Press, pp. 188–207.

Jodidio, Philip (1993) 'Architecture', in *The Louvre: The Museum, The Collections, The New Spaces*, pp. 44–6, 50–2.

Jodidio, Philip and Picard, Denis (1993) 'For a new museum, an interview with Michel Laclotte and Jean Lebrat', in *The Louvre: The Museum, The Collections, The New Spaces*, pp. 36–42.

Kaminka, Ika (1994) 'The Grand Louvre', *Museum International*, 46: 38–41.

Karp, Ivan (1992) 'Museums and communities', in Ivan Karp *et al.* (eds) *Museums and Communities: The Politics of Public Culture*, Washington, DC: Smithsonian Institution Press, pp. 1–17.

Karp, Ivan and Lavine, Stephen D. (eds) (1991) *Exhibiting Cultures: The Poetics and Politics of Museum Display*, Washington, DC: Smithsonian Institution Press.

Kimmelman, Michael (1994a) 'A grand look at the Louvre', *Toronto Globe and Mail*, 12 February: F12.

—— (1994b) 'More Louvre to love, ready or not', *New York Times*, 28 November: II, 1, 39.

Laclotte, Michel (1993) 'L'Aile Richelieu: du Ministère des Finances au Musée du Louvre', *Revue du Louvre*, 5(6): 8-12.

Le Bon, Gustave (1986) *The Crowd*, Harmondsworth, UK: Penguin.

Lebrat, Jean (1993) 'Introduction', in *The Louvre: The Museum, The Collections, The New Spaces*, p. 9.

Lewis, Roger K. (1991) 'Grafting a branch museum onto a mall or office is delicate work', *Museum News*, 70: 21–3.

Lipstadt, Hélène (1988) 'Les grands projets: Paris, 1979–89', *French Politics and Society*, October: 43–50.

Loriers, Marie Christine (1989) 'The pyramid prevails', *Progressive Architecture*, 70: 37–8.

MacDonald, George F. (1992) 'Change and challenge: museums in the information society', in Ivan Karp et al. (eds) *Museums and Communities: The Politics of Public Culture*, Washington, DC: Smithsonian Institution Press, pp. 158–81.

Macdonald, Sharon and Silverstone, Roger (1990) 'Rewriting the museums' fictions: taxonomies, stories and readers', *Cultural Studies*, 4(2): 176–91.

McClellan, Andrew (1994) *Inventing the Louvre: Art, Politics, and the Origins of the Modern Museum in Eighteenth-Century Paris*, Cambridge: Cambridge University Press.

McDowell, Andrew, Sedgwick, Andrew and Leuczner, Alistair (1994) 'Shedding light on the Louvre', *Architect's Journal*, 199, 27 April: 29-31.

Mercillon, Henri (1985) 'Contre le Grande Louvre', *Connaissance des Arts*, 398: 48–51.

Miller, Michael B. (1981) *The Bon Marché: Bourgeois Culture and the Department Store, 1869–1920*. Princeton, NJ: Princeton University Press.

Morris, Meaghan (1993) 'Things to do with shopping centres', in Simon During (ed.), *The Cultural Studies Reader*, New York: Routledge, pp. 295–319.

Nesbit, Molly (1991) 'The rat's ass', *October*, 56 (spring): 6–20.

Northcutt, Wayne (1991) 'François Mitterrand and the political use of symbols: the construction of a centrist republic', *French Historical Studies*, 17 (spring): 141–58.

Parker, Rozsika and Pollock, Griselda (1981) *Old Mistresses: Women, Art and Ideology*, London: Routledge & Kegan Paul.

Rochette, Anne and Saunders, Wayne (1994) 'Revitalizing the Louvre', *Art in America*, 82: 37–9.

Rockwell, John (1993) 'A grand opening for the "Grand Louvre"', *New York Times*, 18 November: C17, C24.

Rohr, Dixon (1993) 'The new Louvre, Part Deux', *Newsweek*, 122, 29 November: 69.

Russo, Mary (1994) *Female Grotesques: Risk, Excess and Modernity*, New York: Routledge.

Saisselin, Remy (1984) *The Bourgeois and the Bibelot*, New Brunswick, NJ: Rutgers University Press.

Sancton, Thomas (1993) 'Pei's Palace of Art', *Time*, 29 November: 59–60.

Schneider, Pierre (1992) 'Le Louvre: deux siècles, deux visages', *L'Express*, 18 December: 20–2.

Sherman, Daniel J. and Rogoff, Irit (eds) (1994), *Museum Culture: Histories, Discourses, Spectacles*, Minneapolis: University of Minnesota Press.

Silverman, Debora (1986) *Selling Culture: Bloomingdale's, Diana Vreeland, and the New Aristocracy of Taste in Reagan's America*, London: Pantheon Books.

Simons, Marlise (1993) 'For its Bicentennial, Louvre gets a new look', *New York Times*, 7 November: V, 3.

Spencer, Earl P. (1995) 'Educator insights: Euro Disney – what happened? What next?, *Journal of International Marketing*, 3: 103–14.

Storey, Mary Rose (1980) *Mona Lisas*, New York: H. N. Abrams.

The Louvre: The Museum, The Collections, The New Spaces (1993) English edn of a special issue of *Connaissance des Arts*, Paris: Réunion des Musées Nationaux.

Toubon, Jacques (1993) 'The Louvre', in *The Louvre: The Museum, The Collections, The New Spaces*, p. 3.

Trondsen, Norman (1976) 'Social control in the art museum', *Urban Life*, 5(1): 104–19.

Viau, René (1994) 'L'Effet Grand Louvre', *Vie Des Arts*, 39 (spring): 8–9.

von Jhering, Barbara (1991) 'Remaking the Louvre', *World Press Review* (August): 54–5.

Wolff, Janet (1981) *The Social Production of Art*, New York: New York University Press.

Zola, Émile (1992) *The Ladies' Paradise (Au Bonheur des Dames)*, Berkeley: University of California Press.

Daniel Mato

THE TRANSNATIONAL MAKING OF REPRESENTATIONS OF GENDER, ETHNICITY AND CULTURE: INDIGENOUS PEOPLES' ORGANIZATIONS AT THE SMITHSONIAN INSTITUTION'S FESTIVAL*

Abstract

Ongoing globalization processes challenge indigenous peoples' lives in various ways. These processes seem to be to a significant extent fuelled by 'global' agents whose practices are in one way or another informed by the systems of representations, values and beliefs of so-called 'developed' Western societies, those of the US, Canada and Western Europe. Not only are voracious national and transnational economic and political forces avidly seeking to gain control over these peoples' territories, resources and knowledge, but also a variety of self-considered alternative organizations from the 'developed' world (some of which actually advance agendas that in certain ways may be regarded as alternatives to those of mainstream agencies) are actively exposing these peoples to their systems of beliefs and representations, for example, conservationist organizations, indigenous peoples' advocacy organizations, etc. This article discusses the participation of various indigenous peoples' political and economic organizations from 'Latin' America in the Culture and Development Program of the 1994 edition of the Smithsonian's Festival of American Folklife. This festival was an occasion to observe how certain 'world class' events are both the result of and the occasion for the development of transnational relations and how these peoples' representations of themselves and of aspects of their lives

are affected by their participation in these systems of global–local and transnational local–local relations.

Keywords ethnicity; gender; indigenous peoples; representations; festivals; globalization

Most people don't know, but it takes a lot of work to be an indigenous leader in these days. One has to send and receive a lot of faxes, attend numerous international meetings; and now, one also has to learn to handle e-mail.

(A sarcastic comment made by an indigenous leader in the course of a personal conversation; my translation)

O NGOING GLOBALIZATION PROCESSES challenge indigenous peoples' lives in diverse ways. These processes seem to be to a significant extent fuelled by 'global' agents whose practices are in one way or another informed by the systems of representations, values and beliefs of so-called 'developed' Western societies, those of the US, Canada and Western Europe. Not only are voracious national and transnational economic and political forces avidly seeking to gain control over these peoples' territories, resources and knowledge, but also a variety of self-considered alternative organizations from the 'developed' world (some of which actually advance agendas that in certain ways may be regarded as more or less alternative to those of mainstream agencies) are actively exposing these peoples to their systems of values, beliefs and representations. Not surprisingly, at least some of these values, beliefs and representations become part of these peoples' experiences, and therefore are more or less critically appropriated, or at the very least become unavoidable references from which to differentiate themselves, in the social processes of producing their representations of both their collective selves and of diverse aspects of experience. Among these more or less alternative organizations are, for example, conservationist organizations, indigenous peoples' advocacy organizations, museums, anthropologists, journalists, musicians, film-makers, etc.

This article discusses the participation of various indigenous peoples' political and economic organizations from 'Latin' America in the Culture and Development (C&D) Program of the 1994 edition of the Smithsonian's Festival of American Folklife.[1] This festival was an occasion to observe how certain 'world class' events are both the result of and the occasion for the development of transnational relations and how these peoples' representations of themselves and of aspects of their lives are affected – it does not matter whether 'for good' or 'for bad'; the issue cannot and must not be reduced to such a simplistic opposition – by their participation in these systems of global–local and transnational

local–local relations. Although it may not be logically assumed, I have also observed during my field research that other participating agents' representations also change through these relations and events, but these other changes are not the subject of this article.

A transnational festival and the significance of transnational relations

The Festival of American Folklife has been organized every year by the Center for Folklife Programs and Cultural Studies of the Smithsonian Institution since its founding in 1967 and takes place every summer in the US National Mall, Washington, DC. The C&D Program was one of the four programmes of the 1994 Festival's edition[2]. The interesting point here is that this festival programme, as some others before it, was a manifestation of larger fields of transnational relations and a locus for transnational cultural-political representations, confrontations and negotiations connected with indigenous peoples' struggles for their rights in 'Latin' American countries.

The production of the C&D Program directly involved two US agencies whose practices usually extend beyond the US borders: the Smithsonian Institution's Center for Folklife Programs and Cultural Studies (CFPCS), which yearly organizes the festival; and the Inter-American Foundation (IAF), a US agency specializing in grass-roots development that reports directly to the US National Congress, which was the programme's co-organizer and sponsor. In addition, the programme involved the practices of six indigenous peoples' political organizations, eight indigenous communities' grass-roots development organizations and four 'local' development support – or service provider – non-governmental organizations (NGOs) working with indigenous peoples' communities from seven 'Latin' American countries.[3]

The programme was an occasion for the interaction not only of the members and employees of all these organizations among themselves, but also with other individuals and institutions in the United States; among them were representatives of the World Bank and of the Inter-American Development Bank as well as of environmentalist, human rights and alternative development advocacy NGOs, that took part in diverse activities of dialogue and networking initiated either by some of them or by some of the participating indigenous peoples' organizations and/or the 'local' NGOs.

The encounter of all these agents at the festival programme was not coincidental. In recent years this festival has increasingly become a manifestation and locus of transnational relations. For the Smithsonian's Center of Folklife Programs and Cultural Studies, developing collaborative relationships with foreign institutions, communities, and individuals is an institutional practice and a prerequisite for producing the festivals, as is acknowledged by their staff members

and directors (Cadaval, 1993; Kurin, 1991). Developing transnational relations is not only a practice of this Smithsonian Center, but also and very especially of the Inter-American Foundation (IAF), whose particular goal is the fulfilment of a transnational mission: to sponsor grass-roots development organizations in Latin America. In this regard, it is significant that those relations linking the IAF and the festival participants are not at all conjunctural, but have been cultivated for years.

The inclusion of foreign participants in the festival has resulted from the Smithsonian institutional mission in its dynamic relation with the evolving circumstances of US society, and particularly with conflicts and negotiations regarding the participation in the US public spheres of social groups that, in this country, have been depicted as 'minorities'. According to the respective festivals' preparatory documentation and yearbooks, the inclusion of participants from abroad has been – at least at the beginning – linked to decisions to represent the home town/countries' cultures of those 'minorities', as conceived in the 1973–76 programme suggestively named 'Old Ways in the New World'.

In order to understand the transnational character and global significance of the C&D Programme it must be stressed that the politics of culture and representations shaping this programme – and many other programmes and activities of US organizations, both private and public – has been influenced by issues related to the debates on multiculturalism and affirmative action. The recognition of these shaping influences is significant, because it suggests ways in which this and other programmes promoted by governmental and non-governmental US organizations are part of the various means by which US society – or different segments of it – tends to 'export' its own system of representations, problems and solutions to the rest of the world, or at least to influentially expose other peoples of the world to them. It does not matter whether or not such exportations or exposures are planned endeavours of the involved social agents. Of course, this is not just the case of the festival; it is a phenomenon that forms part of larger social dynamics, and not only involves matters of race and ethnic identities but also representations of civil society, democracy, market, progress, etc., as myself and other authors have already pointed out in other instances (see e.g. Mato, 1996a, 1996b, forthcoming a, b; Yúdice, 1995).

At this point, it is necessary to differentiate between at least two main kinds of agents linked through transnational relations. We must distinguish those that may be called 'global' agents from those that may be called 'local' agents. I call 'global' those agents that in spite of having their headquarters in a particular locality – usually, but not necessarily, in the United States or Western Europe – have an almost worldwide scope of action. I call 'local' those agents whose actions are locally planned and largely carried out in the same locality that constitutes its basis of operations. Within this schematic opposition, we might also distinguish between national and more narrowly local agents, and to make all the intermediate level distinctions that may be useful for a particular analysis.

Nevertheless, the name 'local agents' should not lead anyone to think of them as locally limited, because such a situation is rapidly declining in the context of ongoing globalization processes.

I have proposed the idea of transnational complexes of intermediation elsewhere (Mato, 1995c).[4] I think this idea may help us in directing our attention to the study of the connections, conflicts and negotiations among all these kinds of agents in specific local–global and local–local transnational connections, and thus to the ways in which tendencies towards globalization – that is to say, tendencies to the increasing development of closer interconnections among peoples, their cultures and institutions at worldwide levels[5] – take place and are worked through. As illustrated in this article, as well as in some former literature, these complexes involve agents from both sides of the imaginary North–South dividing line. The name of complexes of transnational intermediation must not create the false idea that they are established and closed arrangements of agents. Although there may be some more or less stable arrangements operating on particular subjects and in particular areas of the world, the cases already examined rather show the existence of mutating arrangements (Mato, 1995c, forthcoming d). It seems necessary to emphasize that transnational intermediation processes are shaped by both 'local' and 'global' agents, although the relations among transnational intermediaries involve differences in power. That is, there are relations of power between these different agents, as emerges not only from my own research but also from the analysis of cases presented in other current literature (e.g. Clark, 1991; Fisher, 1993; Schuurman and Heer, 1992).

One might say that certain 'world-class' events are both a result of the work of and a locus for the development of some complexes of transnational intermediation. The C&D Program is one of them. Transnational intermediation and globalization processes take place not only through events, but experience shows that some of these events have been particularly significant in contributing to shape aspects of these processes. An important peculiarity of the Smithsonian Festival's programme is that it has involved the practices of agents linked to two salient kinds of complexes of transnational intermediation: those organized around 'development' issues and those organized around 'cultural' issues.

As I have said, the production of this particular programme has involved two agencies from the US and eighteen organizations from 'Latin' America. It must be emphasized that documents studied and interviews conducted lead me to affirm that all the twenty involved organizations have had significant experience in developing transnational relations before the festival. Nevertheless, there are qualitative differences in both the extent of transnational experience and the knowledge about regional and global tendencies managed by diverse agents, and particularly when comparing 'global' *vis-à-vis* 'local' agents. Global agents usually have a notable advantage in both regarding the amount of experience and the management of information about the other side of the relationship and its circumstances; that is, those of 'local agents'. Strikingly, this advantage is not only

assured through the very involved global agent's direct experience and research but also through privileged access to libraries and documentation sources which store the products of other global agents and scholarly research. This latter point deserves our close attention and reflection about the roles of scholars and scholarly institutions in this regard.[6]

The fact that small and local grass-roots organizations and service-provider NGOs have important experience in maintaining transnational relations and developing global strategies should not surprise anyone. These have been part of their institutional practices, in some cases since their inception and in others for many years. The creation of many of the participating organizations, like that of many others in the region, has been significantly linked to the practice of a variety of 'global' agents. These have been, to mention a few examples, the cases of the Asociación Nativos de Taquile and Cooperativa de Productores Molas and the work of US Peace Corps, and of the Federación Shuar-Achuar and Radio Latacunga and the work of Catholic Church missionaries, both of them justified through institutional rationales of 'assisting the poor', or 'assisting the indigenous communities'. Besides, ISMAM and El Ceibo, on their part, are producers of organic beans (coffee and cocoa respectively) which they almost fully export to the US and Western European countries respectively, and their relations with trade agents in these countries are stable and a key factor of their survival. It should also be noted that their marketing strategies have successfully appealed not only to their customers' interests in consuming 'organic products', but also in 'helping the poor', or 'the indigenous communities', which also reveals the relevance of other systems of production of meaning connected to those that constitute the focus of this article. In addition, in the cases of these and other participating organizations, they have in recent years received direct economic assistance not only from the Inter-American Foundation but also from other sources from abroad, both governmental and non-governmental, which in every case has been framed within institutional rationales similar to those mentioned above.

It is important to note that these organizations do not constitute exceptions to the rule. Developing transnational relations have been a regular practice of numerous 'Latin' American grass-roots organizations as well as of several kinds of NGOs – service-provider, research, and advocacy and issue-driven – since the 1970s, due to political repression and difficult economic conditions that have been diversely but closely associated not only with domestic but also with global factors, like US government-supported *coups d'état* and military regimes, external debt crises, so-called structural adjustment programmes and associated compensatory social programmes involving local organizations and NGOs, etc. (e.g. Bello *et al.*, 1994; Development GAP, 1993; Schuurman and Heer, 1992).

If we ignore these political and economic factors we run the risk of seeing the participation of these organizations in the C&D Program as merely defined by issues of cultural representation. Nevertheless, we must not commit the complementary – and surely more general – mistake of understanding their

participation in this or similar programmes as if it were driven only by economic or political issues. In any case, and given this article's privileged focus on cultural issues, I have to underline that my interviews with festival participants demonstrated that their decisions to participate in the programme were due not only to cultural factors, but also to other issues usually regarded as economic and political, which in some cases – and due to specific factors – were even more a determinant of their decisions.

Developing global strategies and transnational relations has been even more imperative and significant for the cases of most indigenous peoples' organizations in the region than for other grass-roots and diverse kinds of NGOs. They have gained notable experience in acting globally and networking transnationally in recent years. Not incidentally, this is true of several of those participating in the festival, for example, the Shuar-Achuar Federation and the Kuna General Congress, of Ecuador and Panama respectively. Furthermore, the Shuar-Achuar Federation had already participated in the festival in 1991, and the Kuna Congress maintains a permanent relation not only with the Inter-American Foundation (as do the other participating organizations), but also with the Smithsonian Institution. Moreover, it is known that the US government has been a key factor in the Kuna people succeeding in gaining the relative autonomic status they presently hold in Panama.

Transnational networking both for developing their own projects and/or raising support for ongoing conflicts with the governments of the countries in which indigenous peoples live is an important motive for their leadership's participation in events organized by global agents, as I learned through interviews with representatives of indigenous peoples' organizations participating in the Festival.[7] Their comments during these interviews were not only relevant to the festival but also to other events in which they had participated before. In addition, interviews I conducted with numerous indigenous leaders participating in other 'world-class' events, like the Amazon Week in New York in May 1994, and the Workshop on Identity, Community Museums, and Development organized by the Smithsonian's National Museum of the American Indian in Washington, DC in September 1995, also highlighted the importance that accomplishing these kinds of goals has in shaping their interest in participating in these events. In fact, not only did they explain to me the importance of achieving transnational co-ooperation and support for their ongoing projects and struggles in our privately conducted interviews, but they also openly requested such support in their public speeches at all the mentioned events.

As I said above, the most visible and important goals for indigenous peoples' leaders participating in the festival and in other 'world class' events are experiencing recognition and building international legitimacy for their representations of culture as well as obtaining political support and mediating financial and technical resources for their organizations' projects. I have discussed specific examples of how achieving these goals directly contributes to shaping their

agendas elsewhere (Mato, 1996a,b, 1997a), an important matter which I cannot expand here. However, at the same time these events also entail for them personal and institutional experiences that become part of the sources of their making of representations, both of diverse aspects of life and of personal and collective selves.

At an organizational level, my research of this and comparable experiences has shown that involved organizations are stimulated and demanded by their participation in these experiences to present their representations in sharper ways. This research has also shown that they subsequently experience diverse kinds of responses to different elements of these representations, ranging from reinforcing to rejecting reactions. For example, during the festival preparation and celebration, participant organizations and individuals received innumerable explicit reinforcing responses – both from the public and the festival organizers – for what in these contexts is usually regarded and called 'cultural uniqueness', and/or for their 'cultural conservation' efforts. In addition, and at a more personal level, each individual draws his or her own conclusions and sometimes modifies his or her own representations according to these experiences. These individuals take home these new/transformed representations and, given their influential positions in their local societies, it may well happen that they successfully promote these representations and associated cultural changes in their home communities. Through these two levels – individual and organizational – participation in these 'world class' events and preparatory and follow-up transnational relations become sources of possible sociocultural change. I will devote the rest of this article to illustrating these kinds of phenomena through two brief examples.

Transnational experience and the making of representations of culture and ethnicity

The first example is provided by the case of Facundo Sanapí, an Emberá land surveyor, from the region of the Darien Gulf in Panama. His participation was part of a programme section dedicated to presenting the experiences of two indigenous peoples' organizations in mapping their own territories as a procedure of validating their peoples' land rights claims. It is significant that both these experiences were initiated with the support of global agents. One of the involved indigenous peoples was the Shuar from Ecuador and the other the Emberá from Panama. What the public would find in this particular site of the festival was a large tent open on two sides, within which various maps and photographs were displayed on the tent's wall and in a showcase. In attendance at this site as well as being responsible for the scheduled presentations were two Emberá and one Shuar specialist in the subject, explaining their peoples' experiences, and whose words were translated by a US translator, this latter role being alternately played

by one of two members of the US-based NGO Tierras Nativas/Native Lands. Although the subject being presented in this C&D Program section was strikingly important, it did not typically attract as many visitors as did most of the others. Facundo Sanapí – reasonably – attributed this difference to the fact that the most visited sections of the festival were those in which the indigenous peoples' representatives were wearing colourful 'traditional' costumes, performing their dances, singing their songs, or displaying beautiful handicrafts.

Facundo Sanapí was worried about this state of affairs. He concluded, and reiterated during his presentations:

> I am here in foreign clothes, because this costume [at which point he indicated the regular trousers, shirt and shoes that he was wearing] is not mine. It is not my *culture*, I am in foreign *culture*. I left my *culture* at home, because, to tell you the truth, in my home I use my *culture*. Here I get surprised that everyone, every *ethnie* [he used the word '*etnia*' in Spanish] has their *culture* while I am in foreign clothes, and this is very painful to me.
>
> (Emphases added; my translation)

Facundo Sanapí expressed distress about this situation when I later interviewed him privately. He told me:

> Wearing their *own indigenous clothes* [the 'guayuco' that would only cover men's genitals] and body-painting would have been very important for them in order '*to demonstrate that there also are indigenous peoples who truly still conserve their tradition* in the Darien [the region of Panama that constitutes their territory]. [Because] the work we are presenting here is very important, it is a process and a document that is very important for us. But we should present them *as indigenous peoples* in order to make the public see that he who presents this document is *a true indigenous person*.
>
> (Emphases added; my translation)

While I do not know what really happened about this reflection of Mr Sanapí when he returned home, I do know he told me that if the Smithsonian were to invite them again they would wear their *own* costumes. Significantly, this was a matter about which Sanapí and his colleague, Manuel Ortega, devoted some time to elaborate, and both agreed that this was what they would have to do in the future. Indeed, they came the last day of the festival with their bodies painted with some improvised materials, but they were not satisfied with the result and did not cover their skins apart from their chests and backs, and this only for a few hours. What is significant about this example is that this experience seemed to have told them that in order to be effective they not only had to *be* indigenous but to *appear* as such before the eyes of their potential allies, and that they had to represent their Indianness in terms that had already been coded by their

potential allies. They seemed to have learned that wearing exotic costumes and body-painting plays a significant role in this regard. It seemed to me that this apparently freshly acquired knowledge combined very well with aspects of their discourse which seemed to have been elaborated from older exchanges with 'western culture' representatives and institutions.[8] As for example their recurrent use of the words – and ideas – of 'culture' and 'ethnicity' as kind of standardized categories (representaticus) through which they would not only experience life, but also represent experience.

Transnational experience and the making of representations of gender issues

The second example is the case of Indígenas de la Sierra Madre de Motozintla Sociedad de Solidaridad Social (ISMAM) (Social Solidarity Society of the indigenous persons of the Sierra Madre of Motozintla). ISMAM is a cooperative of indigenous organic coffee producers from the state of Chiapas, Mexico, close to the area of the Zapatista uprising that began in January 1994. While most of ISMAM's members may be considered to be Mam individuals there are also members of other indigenous peoples in the cooperative. Five members of this cooperative attended the festival, three of whom were male farmers who were also members of the men-only cooperative governing body. The other two were women, whose main responsibilities in their homeland were the family, the household and several coffee-producing activities. ISMAM's members were accompanied by the organization's administrative and economic adviser, a young and very active Catholic priest. They were the main protagonists of their presentations, although they were also assisted by the distributor of their coffee in the US, the official presenter and translator, who was also a Mexican sociologist, and the Inter-American Foundation country representative. All five Mam participated in the presentations but the men held more protagonistic roles than the women, and a sort of gender division of labour was evident among them. While the men talked about organic agriculture and problems of contamination – before they adopted this kind of 'organic' practice that was repeatedly presented as the legacy of their ancestors – as well as about aspects of their organizational and international trade experience, the women talked about the household, the family, and their specific roles in the productive process. The demonstration area included coffee terrace models, a compost heap, a coffee-drying patio, and a small wooden house where they displayed samples of coffee beans, posters, certificates and other items. On one side of the house there was an area reserved to represent household practices. This was where the two women involved themselves in diverse cooking activities, and where they spent most of their time while not involved in the presentations.

Two months after the festival the curator of the festival's programme received

a letter from ISMAM expressing their satisfaction and appreciation for their participation in the festival. Attached to the letter was a summary of a recent meeting of the cooperative which included a brief report of the presentation made by the festival participants to their cooperative fellows at a recent assembly. The report detailed their experience of the festival and what conclusions they had drawn from this experience. For example, it suggested that people should think more carefully before migrating to the US because of the penury that 'the wetbacks' (they used the Spanish expression 'los mojados') experience in the US, and also made an important statement regarding the importance of women's work. It is worthwhile discussing what this report said about the latter. Although it is difficult for me to translate their wording because of their particular use of the Spanish language, one might say that the report talks about the need, or the pertinence, of recognizing the worth of women's work as being as valuable as men's work (in Spanish: '*También se habló para las mujeres como organización para poder valorizar todo sus trabajos como todos los seres masculinos*').

The recognition of the importance of women's contributions is an important advancement in this 'local' context (and surely in many others too), as may easily be deduced from the above mentioned gender division of labour displayed at the festival. Let us discuss some factors that may contribute to understanding how this has happened. First, one must take into account the sensitivity of the ISMAM's representatives towards this issue. This sensitivity must be interpreted in connection with the demonstrated capacity of the contemporary Mam people – and the cooperative members – for reformulating diverse elements of their collective representations in a dynamic interaction with a variety of external factors. But, very particularly, this sensitivity must be regarded in relation to the important organizational experiences of women's groups in the region, which in these Mam communities' specific case has taken place since the 1970s in connection with the practices of some progressive sectors of the Catholic Church (see e.g. Cadaval, 1995; Hernández Castillo, 1995; Hernández Castillo and Nigh, 1995). Although I cannot provide specific evidence, it also seems relevant to point out that both the development of this sensitivity and the increasing importance of women's activities in the region may also have been influenced by the Zapatistas' and associated indigenous peoples' organizations' discourses and practices regarding gender issues, which more recently have had crucial relevance (Mato, 1996c).

The role played by the female – although, as she has pointed out, not a feminist activist – programme 'curator' (according to the Smithsonian's vocabulary) may constitute another factor in understanding why and how these festival participants reached such a significant conclusion regarding the importance of women's place in their society and organization. As I understood from both my interviews with the programme curator and my observance of her performance during the festival, she placed special emphasis on ensuring women's presence in all the participant organizations. This was particularly important

and usually hard work during her field trips to prepare the C&D Program, when she did everything possible to ensure women's participation. It seems to me that it may be assumed without much argument that during these field trips her practice was not only inspired by her personal feelings and convictions, but also framed by both unavoidable public debates in US society and the institutional discourse of the Smithsonian Institution as an affirmative action/equal opportunities organization – and at the very least the goals of many officers within the Smithsonian. Although in some cases ensuring women's participation was an easy task, for example, because the organization *she – advised or not, depending on the cases – by IAF representatives of the IAF's contracted local professionals selected* for participation in the festival was a women's organization, in other cases this was not such an easy task, as she explained to me during the course of our interviews. That ISMAM was one of these latter cases seems obvious after considering the above mentioned gender division of labour both at home and at the festival.

Finally, another factor in understanding this conclusion made explicit by ISMAM in its communication to the C&D Program curator may be the festival's ambiance regarding gender relations. I would swiftly point out that this ambiance was shaped by various relevant forces: (1) again, the curator's socially equitable attitude and her consequent way of discussing gender issues with everyone, including the indigenous participants; (2) a similar attitude on the part of most festival presenters and other staff members of the Smithsonian Institution and the Inter-American Foundation; and (3) a gender equality discourse and very clearly associated role model provided by at least some of the female participants from 'Latin' America, from both indigenous organizations and diverse kinds of NGOs.

It seems feasible to assert that for these ISMAM members, participating in the festival at the very least involved being exposed to other gender relations' representations, gender divisions of labour, and valorization of women's work. It also seems possible to argue that this exposure may at least have served to reinforce certain tendencies to change that were already being advanced by certain women's groups in their communities.

On the transnational making of representations in the age of globalization

The examples of the ISMAM representatives and that of the Emberá delegates illustrate the fact that these festival participants, as participants in other comparable transnational experiences, are exposed to and potentially affected by other individuals' and organizations' representations that turn out to be either relatively new or at least unexpected, according to their own reports and

behaviour during the festival. Although these two examples basically illustrate representations of *gender, culture* and *ethnicity* issues, other cases in this same festival programme – which I do not have space to discuss here but have explored elsewhere (Mato, 1995a) – illustrate representations of *development*.

One may reflect that there is nothing very peculiar in these two stories, because the confrontation with, the demarcation from and the borrowing and adaptation of other peoples' representations and institutions is a very ancient phenomenon. Nevertheless, I would say that what is notable is that the frequency and intensity of the intercultural transnational encounters that make these confrontations, demarcations, borrowings and adaptation possible is rapidly growing and that they increasingly involve geographically more distant peoples. Moreover, I would also argue that what is notable is that 'local' peoples are increasingly adapting systems of representations that are exhibited and/or promoted by 'global' agents based in a few world-dominant societies. What is also notable is that these two cases, as well as others I have studied, do not represent examples of imperial impositions. Rather, these two specific cases represent examples of the outcomes resulting from the global–local as well as from transnational local–local exchanges that usually take place within the context of more or less informal and mutating complexes of intermediation of resources and representations constituted by 'global' and 'local' agents. These examples, as do others I have studied, show that these 'global' and 'local' agents actively shape current globalization processes in terms not only of representations of gender culture and ethnicity, but also of race, and diverse forms of economic and political organizing (see Mato, 1996, forthcoming a, b, d).

Finally, I would say that what is also notable is that the examples discussed above, as with those other studies I have referred to, show the significance of a relatively curious kind of 'global' agent involved in these processes, and about which we do not hear or read very much in the specialized literature more focused in the mass media, the corporations, or the mainstream government agents. I say 'curious' precisely because these agents must be considered as non-mainstream, at least in relation to certain matters, like those of 'gender' or 'culture'. As a consequence, it is also possible to observe the existence of differences and even conflicts among the representations that this diversity of 'global' agents promote. And to make things even more complex and incompatible with any fantasy of adopting dualistic theoretical models, it even happens that some governmental agencies in the US and Western Europe (for example, the Smithsonian Institution and the Inter-American Foundation in the cases discussed above) may be counted among those promoting non-mainstream representations – along with many 'progressive' non-governmental organizations – at least regarding matters of ethnicity and gender, although usually not involving political issues related to international and transnational relations of power.

Notes

* This article presents partial results of a research project I conducted as a visit-
ing fellow of the Center for Folklife Programs & Cultural Studies of the Smith-
sonian Institution. At the end of my fellowship at the Smithsonian I presented
a research report (Mato, 1995a) on which this text is based. I am grateful to
the Smithsonian Institution for the fellowship I was awarded through its annual
fellowship competition and to the personnel of the Center for Folklife Pro-
grams and Cultural Studies for their support. I am also grateful for the com-
ments and suggestions made about the text on which this article is based by
Richard Bauman, Rafael Bastos Meneses, Olivia Cadaval, Néstor García Can-
clini, Nina Glick-Schiller, Lawrence Grossberg, Richard Handler, Rosalva Aida
Hernández Castillo, Jean Jackson, Richard Kennedy, Charles Kleymeyer,
Richard Kurin, Alberto Moreiras, Richard Price, Sally Price, Peter Seitel,
Diana N'Diaye and George Yúdice. During my fieldwork, I also discussed
some of the ideas developed in this article with several members of the
indigenous peoples' organizations, non-governmental support organizations
and festival presenters participating in the festival to whom I wish to express
my special thanks: Evelyn Barrón (Centro de Capacitación Integral de la Mujer
Campesina, Bolivia), Mónica Cheuquián (Casa de la Mujer Mapuche, Chile),
Marcial Fabricano (Central de Pueblos Indígenas del Oriente Boliviano,
Bolivia), Manuel Fernández (presenter), Ana Victoria García (Cooperación
para el Desarrollo Rural de Occidente, Guatemala), Chris Krueger (Inter-
American Foundation), Gabriel Martínez (Anthropólogos del Sur Andino,
Bolivia), Carlos Moreno (Sistemas de Investigación y Desarrollo Comunitario,
Ecuador), Miguel Tankamash and Felipe Tsenkush (Federación de Centros
Shuar-Achuar, Ecuador), Víctor Toledo Llancaqueo (Coordinadora de Institu-
ciones Mapuches, Chile), Antonio Ugarte (Servicios Múltiples de Desarrollo,
Bolivia), Nicanor González (Congreso Kuna, Panama), Néstor Vega (Sistemas
de Consulta y Servicios, Guatemala), and Elayne Zorn (presenter). The anony-
mous reviewers of *Cultural Studies* have since also provided helpful suggestions.
Nevertheless, I am obviously exclusively responsible for any interpretations,
mistakes and omissions in this text.

1 I should add that, as I have already argued in former writings (e.g. Mato, 1993,
1994a, b, 1995a, b, c, 1996a, 1997a, and particularly in 1998b), while I use
the term 'Latin America', I find it very problematic. The word 'Latin' in this
context recalls a long-term process of social construction of identities and
differences and still serves as a subtle legitimating device in the present system
of exclusion of large population groups in the Americas. So-called *Latinoamer-
icanismo* may be seen as a nationalism building a quasi-continental 'nation'. Its
roots – not the expression itself – come from the period of the anticolonial
movements. At that time, the local elites constituted by the descendants of the
European colonizers – including both 'pure' European and diverse 'Mestizo'
elements – began building the new nation-states upon the system of exclusions

of the colonial period. These elites assumed that they, not the so-called *indios*, nor the imported African slaves and/or their descendants, were 'the people'. The alliances developed among these elites during the quasi-continental anti-colonial war were the origin of the interdependent formation of official national identities and the interstate-crafted representations of what began to be called 'Latin America' and a 'Latin American culture'. Although today the expression 'Latin America' has several and even contested meanings, this inter-dependent system of representations still legitimizes social inequality, cultural discrimination and economic disadvantage to particular population groups – and in particular to indigenous peoples and some populations of African descent – throughout the region, and that is why this note of caution is needed.

2 Some significant book length studies about the festival are by Bauman et al., (1992), Cantwell, (1993), and Price and Price, (1994).

3 The programme also involved the participation of two organizations which were not self-defined as indigenous peoples' ones, the first providing inter-national trade services to Haitian artisans, the second a cooperative of rural producers in Brazil. Here, however, I will focus only on the indigenous peoples' and indigenous communities' organizations, which constituted the vast majority of the programme's participants.

4 In the referred text I used the expression 'brokering' instead of 'intermedia-tion', but several colleagues convincingly insisted on the fact that the expres-sion 'brokering' carries too many financial connotations, which is not the intended meaning. As this article illustrates, agents taking part in these com-plexes intermediate both resources (not only financial) and representations. Remarkably, these representations are significant in the setting up of these agent's agendas (for example, representation of 'development', 'democracy', 'race', 'human rights', etc.).

5 I have extensively discussed the idea of globalization, as well as argued about differences and relations between the expressions 'globalization', 'globaliz-ation processes', 'age of globalization', drawing from specific case studies in other writings (Mato, 1994a, 1995b, 1996a, forthcoming a).

6 I have also addressed this discussion in two recent texts (Mato, 1996b, 1996c).

7 Including the Shuar Federation from Ecuador, the Organization of Indigenous Peoples of Beni from Bolivia, the Emberá from Panama, and Mapuche from Chile, among others; interviews with M. Tankamash (2 July 1994), F. Tsenkush (1 July 1994), M. Fabricano (1 July 1994), and M. Ortega (5 July 1994).

8 I have more widely discussed this subject in two recent articles (Mato, 1996b, 1997a).

References

Bauman, Richard, Patricia Sawin, Inta Gale Carpenter (1992) *Reflections on the Folklife Festival*, Bloomington: Folklore Institute, Indiana University.

Bello, Walden, Shea Cummingham, Bill Rav (1994) *Dark Victory: The United States, Structural Adjustment and Global Poverty*, London: Pluto Press.

Cadaval, Olivia (1993) Patterns of collaboration: the Festival of American Folklife US–Mexico Borderlands Program. Paper presented at the AAA Annual Meeting, Washington, DC, 17–21 November.

Cadaval, Olivia (1995) Negotiating cultural representations through the Smithsonian Festival of American Folklife. Paper prepared for delivery at the 1995 International Meeting of the Latin American Studies Association, Washington, DC, 30 September.

Clark, John (1991) *Democratizing Development: The Role of Voluntary Organizations*, West Hartford, CT: Kumarian Press.

Cantwell, Robert (1993) *Ethnomimeris*, Chapel Hill and London: The University of North Carolina Press.

Development GAP, the (1993) *The Other Side of the Story: The Real Impact of World Bank and IMF Structural Adjustment Programs*, Washington, DC: The Development GAP.

Fisher, Julie (1993) *The Road from Rio: Sustainable Development and the Nongovernmental Movement in the Third World*, Westport, CT: Praeger.

Hernández Castillo, Rosalva Aída (1995) 'De la comunidad a la convención nacional de mujeres: las campesinas chiapanecas y sus demandas de género', in J. Nash and A. Parellada (eds) *La Explosion de las Comunidades en Chiapas*. Documento IWGIA No. 16, Copenhagen: IWGIA, pp. 57–67.

Hernández Castillo, Rosalva Aída and Nigh, Ronald (1995) Global processes and local identity: Indians of the Sierra Madre of Chiapas and the international organic market. Paper presented at the Annual Meeting of the American Anthropological Association, Washington, DC, 18 November.

Kurin, Richard (1991) 'The Festival of American Folklife: building on tradition', in *1991 Festival of American Folklife*, Washington, DC: Smithsonian Institution, pp. 7–20.

Mato, Daniel (1993) 'Construcción de Identidades Pannacionales y Transnacionales en Tiempos de Globalización', in Daniel Mato (ed.) *Diversidad Cultural y Construcción de Identidades*, Caracas: Tropikos, pp. 211–31.

Mato, Daniel (1994a) Transnational and international relations in the making of identities in 'Latin' America in times of globalization. Paper presented at the XVII International Congress of the Latin American Studies Association, Atlanta, 10–12 March.

Mato, Daniel (1994b) 'Procesos de Construcción de Identidades en América 'Latina' en Tiempos de Globalización', in Daniel Mato (ed.) *Teoría y Política de la Construcción de Identidades y Diferencias en América Latina y el Caribe*, Caracas: UNESCO-Nueva Sociedad, pp. 251–61.

Mato, Daniel (1995a) *Beyond the Mall: A View at the Culture and Development Program of the 1994 Smithsonian's Festival of American Folklife in the Context of the Globalization Process*. Research Monograph presented at the Center for Folklife Programs & Cultural Studies of the Smithsonian Institution, September.

Mato, Daniel (1995b) *Crítica de la Modernidad, Globalización y Construcción de Identidades en América Latina y el Caribe*, Caracas: Universidad Central de Venezuela.

Mato, Daniel (1995c) Complexes of brokering and the global–local connections: considerations based on cases in 'Latin' America. Paper prepared for presentation at the XIX Congress of Latin American Studies Association, Washington, DC, 28–30 September.

Mato, Daniel (1996a) 'Globalización, procesos culturales y cambios sociopolíticos en América Latina' in D. Mato, M. Montero and E. Amodio (eds) *América Latina en Tiempos de Globalización: Procesos Culturales y Cambios Sociopolíticos*, Caracas: UNESCO-Asociación Latinoamericana de Sociología-UCV.

Mato, Daniel (1996b) 'On the theory, epistemology, and politics of the social construction of 'cultural identities' in the age of globalization', in *Indigenous Peoples: Global Terrains*, special issue of *Identities: Global Studies in Culture and Power* edited by Jeremy Beckett and Daniel Mato (3(1–2): 61–72).

Mato, Daniel (1996c) 'The indigenous uprising in Chiapas: the politics of institutionalized knowledge and Mexican perspectives', in *Indigenous Peoples: Global Terrains*, special issue of *Identities: Global Studies in Culture and Power* edited by Jeremy Beckett and Daniel Mato (3(1–2): 205–18).

Mato, Daniel (1997a) 'On global–local connections, and the transnational making of identities and associated agendas in "Latin" America', *Identities: Global Studies in Culture and Power*, 4, (4).

Mato, Daniel (1997c) 'Towards a microphysics of the transnational (re)organizing of Latin American Civil Societies in the age of globalization', *Organization* 4(4): 506–513.

Mato, Daniel (1998) 'On the making of transnational identities in the age of globalization: the US Latina/o – "Latin" American Case', *Cultural Studies*.

Mato, Daniel (forthcoming d) 'A research based framework for analyzing processes of (re)construction of "civil societies" in the age of globalization', in Jan Servaes and Rico Lie (eds) *Media and Politics in Transition: Cultural Identity in the Age of Globalization*, Louvain, Belgium: ACCO Publishers and Katholieke Universiteit Brussel.

Price, Richard, Price, Sally (1994) On the mall: Presenting maroon tradition-bearers at the 1992 Festival of American Folklife, Bloomington: Folklore Institute, Indiana University.

Schuurman, Frans J. and Heer, Ellen (1992) *Social Movements and NGOs in Latin America*, Saarbruken-Fort Lauderdale: Verlag Breitenbach Publishers.

Yúdice, George (1995) Transnational brokering of art. Paper prepared for presentation at the XIX Congress of Latin American Studies Association, Washington, DC, 28–30 September.

Victor Mazin and Olessia Tourkina
Translated from the Russian by
Thomas Campbell

THE GOLEM OF CONSCIOUSNESS[4]:
MYTHOGENY'S LIFT-OFF

Abstract

This article is a comparative study of American and Soviet programmes of space/cosmos elaboration in terms of ideological and technological competition during the era of the cold war. It is in a sense a rereading of a book written by Nikolai Nosov for Soviet children called *Neznaika on the Moon* (1965). This book – which was the most popular among Soviet children in the 1960s and 1970s – helps to uncover ideological and technological paradigms of the time when outer space happened to be the scene of the cold war conflict. The subject of space/cosmos has been studied in many contextual respects. However, there are four key notions – such as technology, ideology, time, consciousness – which make it possible to see similarities and differences between American and Soviet scientific approaches to outer space.

Keywords space; technology; ideology; time; consciousness; language

It was around this time that the astronomer Alpha and the lunologist Memega were visiting Space City – they'd arrived with two physicists, Quantik and Kantik. Since they themselves intended to build a rocket and undertake a flight to Earth, they had arrived specially to acquaint themselves with the design of the space rocket and the space suits. Now that the secret of weightlessness had been revealed, such flights had even become accessible for Lunatiks. Znaika decided to present the lunar scientists with detailed blueprints of the rocket and ordered that they be given the remaining stockpiles of lunite and antilunite. Alpha said that the lunar scientists would keep Space City well-maintained and build there a cosmodrome for

spaceships to land on their planet and a launching site for flights to other planets.[1]

(NM, p. 410)

THE GOLEM, a recurring image[2] similar to states of obsessive delirium, is a stereotype for certain relationships between the in-di-vidual's con-scious-ness[3] and his technological handiwork.[4] The determinate nature of these relationships lies in their phobic character, which is manifested in the gap that opens up between opposing ideas and ambivalent relationships.

In this article we will be exploring the relationships of technology, con-sciousness, ideology and time as expressed in the conquest of outer space by the Soviet Union and the United States. We should pause here, however, for the ques-tion might arise: Why should a critique dealing with visual images address Soviet and American 'space technology'? First of all, space technology is one of the summits of technological development in general, i.e. the development of 'techne' as: (1) knowledge; (2) the material incarnation of this knowledge; and (3) the incarnation of the ideological and aesthetic peculiarities of co-knowledge, i.e. con-sciousness. Second, space technology presents us with *visual* material (an image in our mental representation, *visible* 'inside', and an image in objective rep-resentation, *visible* 'outside' – both of them viewed at the same time in their cooperation, mutual induction and penetration. Neznaika as a literary, mytho-ideological hero engenders a mental image, while Gagarin as a real hero engen-ders an objective image. This, however, is only a cursory understanding of this process, for, in fact, Neznaika, technologically 'perfected' first by the artist-illustrator, then by the artist-animator, then once more by the artist-illustrator, already appears as a general, 'objectified' image, while Gagarin, whose 'real' image is gradually disappearing, turns into the same sort of mental product as Daedalus or N. F. Fedorov, despite the fact that his image has been recorded and archived). Third, it is precisely space technology, the avant-garde of the military-industrial complex that, after a certain lag-time, 'launches' its instruments into the general consumer market, including the world of the visual arts. And, finally, the begin-ning of the technological conquest of outer space marks the beginning of global deterritorialization, the beginning of a new era, the era of ex-humanization and ex-presence: massive telecommunications, telepresence, computerization, etc.

Ideology: technology

Our conceptualizing apparatus does not simply semiotically mark our environ-ment, but to one degree or another[5] determines its character.

Competing ideologically and technologically in the 1950s and 1960s, the two superpowers definitively fixed to the 'same' interplanetary, intra- and

intergalactic 'borders' the ideas of 'outer space' and 'cosmos'.[6] Likewise, they named those who venture out into those 'frontiers' 'cosmonaut' and 'astronaut'; the costumes these emissaries donned[7] were dubbed 'space suit' and 'skafandr'.

The differences in these two approaches is evident: 'cosmos' is an enclosed, all-encompassing, harmonious, speculative and 'humanized'[8] sphere, while 'space' exists within the bounds of the Earth's gravity as well as outside of those bounds. That space which we call 'cosmic' is simply 'outer' in relation to earthly, 'inner' space.[9]

These two varying approaches become even more evident when names are given to the emissaries to this 'outer', 'cosmic' space. Both names date back to ancient Greek, but while the Soviet name is linked to the closed space of 'cosmos' ('cosmonaut'), the American name directs its bearer into the distance, into the infinite reaches and towards the distant stars ('astronaut').

Finally, while the astronaut puts on a costume for going out into open space (space suit), the cosmonaut dons a 'skafandr', i.e. the very same apparatus used by the diver for going under water. (In Russian the word *skafandr* means both diving suit and space suit – *Translator's note*.) That is, the cosmonaut wears that which is etymologically connected not with air, but with another element – water.[10] The appearance of a 'cosmic diving suit' is not an absurdity. This word reminds us of the days when Greek mariners were conquering 'acquatic' space: believing that the stars were stationary, they oriented themselves according to the constellations; in the process of navigation, three elements – earth, water and the heavens – were correlated. Greek cosmocentrism, resurrected by the Russian cosmists,[11] is consolidated in the centripetal nature of the Soviet conquest of the cosmos. The notion of cosmos as the embodiment of harmony, fullness and per- fection, for all its non-aggressiveness on the semantic level, turns out to be entangled in global expansion.[12] At the same time *space suit* (connected with the Latin *spatium*, i.e. with that which contains objects) exterritorializes the astro- naut, making his motion in space *de facto* centrifugal.

Triumph in space is linked with the imprinting on mass consciousness of certain images of the triumphant: on the one hand, the image of the amiable Yuri Gagarin, whose smile became his calling card; on the other, the image of the sub- jugator of other worlds – John Glenn, for example.[13]

Space mythology – as opposed to space technology, which in an atmosphere of ideological rivalry was preserved in top secrecy – actively penetrated into mass consciousness, compensating the lack of real technical data with clear models. The rocket and the spaceship, being the avant-garde of weapons tech- nology, carried hidden ideological aggression. The substitution of the real name of the man who designed the first satellites and rockets, S. P. Korolev, with the majestic and fairytale-like title The Chief Constructor[14] might be viewed in a mythological vein. This substitution was effected all the more successfully since technology, developing much more quickly than culture, is, in the form of binary mythologemes, significantly easier for consciousness to assimilate. As a

consequence of its visibility and completedness, space mythology might be regarded as the most successful contemporary example of the mechanism of ideology-formation. The space myth combined the energy of mass culture, the possibilities of new technology and the desire to programme the future with maximal accuracy.

The 'marginal' mythological figure of Neznaika seems especially important in this process of bilateral myth formation. Neznaika not only reflects an 'interest in the conquest of space' (he serves as the only example 'from the Soviet side' in a book dedicated to American space design[15]), but is sent 'to the Moon', to the external, alien technological space of the USA,[16] where he winds up in numerous unforeseen and dangerous situations. Only his friends, flying in from Earth to his aid, save him and liberate all the lunar dwellers from capitalist exploitation. Insofar as the Moon is a prototype of capitalist society, a society located not in the present but in the past, a society where, because of the exploitation of man by man through technological means, social harmony (i.e. the cosmos) is disturbed, Neznaika demonstrates on himself *what* technology means for the human being, where its hidden dangers and temptations lie. Neznaika and his friends present the reader with a stereotype of the new technology, of the problems of adapting to a new environment in conditions of changing solar rhythms[17] and weightlessness.[18]

Any ideology finds its own technology, i.e. its own array of methods and means of functioning. If we view ideology as a set of instruments allowing one to bring certain mythologemes to large parts of the population, then this set of tools might be seen as a kind of technology. At the present moment technology is dominated by the production of visual images (mass media), as opposed to the previous epoch, an epoch oriented towards the written word, and so the delivery of ideology into the consciousness of its bearers or its users is carried out mainly by means of television and advertisements. The dominance of the visual leads to the disappearance of the need for literacy as such. Neznaika, using the technological achievements of Znaika, outstrips the latter in time and space. He outstrips Znaika because he uses. The link between ideology and technology does not entail a certain fatal coincidence, a particular determined relationship between them. It is the case that at any given moment there is a particular technology which corresponds to a particular state of consciousness and this technology is employed by ideology. Ideology and technology are interconnected within a particular paradigm. A given technology corresponds to every given ideology and vice versa. Thus space technology was actively developed during that ideological period dubbed 'the cold war'. This technology itself, however, formed not only as a result of the unfolding of the cold war, but as the consequence of particular scientific and technical achievements. All the same, it is precisely ideology which by means of economic levers sets in motion one or another form of technology.[19] In other words, every Neznaika needs a Znaika. And vice versa.

Shoving aside 'mimetic', analogue technology, digital computer–'neo-pythagorean' technology, functioning as an instrument of ideology, improves the accuracy and speed with which information on the screen is transmitted, the speed with which images are formed: such technology is programmed to overcome established space–time barriers. Despite of and thanks to the switch from one technology for reproducing images to another, the visual and figurative reorient the mechanism of perception as such. As an image projected outwards, the Golem of consciousness evolves and, as before, serves to remove the natural functional limitations of man.

In turn, any technology is ideological – first, because it belongs to a certain period of time; second, because it is used. Being in the employ of politics, space technology fulfils not merely the function of deterritorialization, but also the attainment of metaterritorial domination. Reflecting the interest of one or another group, technology engenders a certain kind of technophobia, a fear of ex-humanization connected to a terrible presentiment of the Golem's virtual exit into unrestricted open space.[20]

In the actual world the interaction of ideology and technology, the boundary between inner and external space predetermine the corresponding image of the world. In simplified form these interactions might be envisioned as follows: mechanical technology – capitalist ideology; electronic technology – industrial ideology; computer technology – post-industrial society.

Technology: consciousness

> One morning Neznaika got up a little bit earlier and climbed into the pavilion in such a way that nobody noticed him. There he grabbed the degravitizer and headed to the river. For some reason he suddenly wanted to see what the fish would do in a state of weightlessness. It's not clear why he got such an idea into his head. Perhaps he had begun thinking of fish because he himself floated around weightless for days at a time in the pavilion.
>
> (NM, p. 59)

Consciousness is itself a form of technology, a set of tools and devices for communicating with oneself, with other beings and with the environment. Without leaving home, consciousness carries out the designation and demarcation of inner and outer space. The technology of consciousness organizes the concreteness and abstraction of our perceptions, the introjection of the external and the projection of the internal, the integrity and fragmentedness of intellectual representations, the suppression of the unconscious and subordination to it. However, we are speaking here of consciousness as a form of collective psychic assistance.

Plans for the first virtual flights appear in consciousness long before any real flights. The morphogenetic-phantasmic realization of the virtual future takes

place in consciousness, which acts as a prognosticating and decision-making organ. Mental technology solves problems by constructing plans and images of the external world, including images of the distant future slated for eventual realization.[21] Knowledge and action in this system do not merely act in concert insofar as 'psychical' action constitutes an inalienable component of empirical knowledge. The configuration of mental space predetermines the spectrum of technological possibilities.[22]

Plans accumulate in memory, where they are preserved, reworked, deformed and reformed depending on the condition of the organism and the environment. For its realization the plan needs to be plugged into memory – i.e. a metaplan for preserving, recalling and applying the plan needs to operate as well. Aside from natural mechanisms, memory, one of the technologies of consciousness, now includes artificial means in its arsenal – from mnemonics to libraries and archives, from video and film libraries to computer memory. Memory is carried outside, leaving behind the territory of individual consciousness and, consequently, collective consciousness. Aside from external means of increasing memory, the possibility of using implanted memory chips is currently being discussed.[23] Information is already distributed, transmitted and redistributed beyond the bounds of our earth. One more impending achievement is the overcoming of the speed of light, the surpassing by photon computers of an established limit in the storage and processing of information.

The functioning of con-sciousness – more precisely, the coupling of consciousness and the hand – predetermines the development by man of technological extensions[24] for mastering space (in a wider sense, the mastering of cosmic space through the unity of plans and images, the unity of word and deed which was prophetically envisaged by N. F. Fedorov[25] around the turn of the century), as well as the means for the continual altering of this space not only through immediate contact but through remote telepresence.[26] With the beginning of anthropogeny the biosphere evolves into noosphere[27] and the technosphere.[28]

Extensions technologies, one example of which is the spaceship, evolve against a backdrop of man's endogenetic stability, i.e. such technologies attain certain limits, not by means of psychophysical reformation, but by increasing the efficiency and speed of the contrivances of macrocosmic exterritorialization.

In this situation consciousness reassigns its own functions to technology. Not only memory, but even the decision-making mechanism is gradually externalized. In particular, space-flight and nuclear-power systems are controlled not by consciousness itself but by *self-organizing* extensions.[29] Capable of escaping our control, such a self-organizing and self-developing system engenders an unconscious terror, a terror familiar to our distant ancestors or a child by virtue of their inability to control those internal or external processes which cause them pain or pleasure. Moreover, whereas primitive man or a child might cope with his phobia using the mental technology known to us as the omnipotence of thought,

the postmodern individual, immersed in the scientific paradigm, will hardly resort to this method. (Doing so, he finds himself lost in a state of delirium.) And thus self-regulating technology is liberated, the long-ago released Golem of con-sciousness turns out to be just as apocalyptic in the scientific paradigm as it once was in the religious. Even if it is clear who is making the decisions, the process is irreversible:

> At that moment Ponchik pressed the button which activated the electronic guidance system. And the electronic guidance system, as had been provided for by the constructors, activated the degravitizer, fired up the jet engine and all other systems. And so the rocket headed off into cosmic flight just at that moment when everyone had least expected it.
>
> (NM, p. 69)

That gaping hole between technology and consciousness is filled up by visual images: here art as a technology for reconstructing the actual and the virtual becomes a membrane for detecting the presence of the Golem, which is already absent from the individual's consciousness. The nonfunctional, nondesignated use of high technology is connected, on the one hand, with the *para-logical* products of the inventor's paranoidal delirium or the engineer's hallucinations; on the other hand, with *techno-logical* output. (Here we might repeat after the inventor Shpuntik, 'What a devilish stroke of genius!' and experience his feelings of joy: 'Ideas were simply bubbling in Shpuntik's brain. His eyes were on fire, a happy smile wandered across his face' (NM, p. 39). In art the movement of consciousness's representations becomes 'freely fluctuating' and 'aim-displaced' and takes on the role of a para-technological intermediary. We might consider such 'quasi-functionality' in technology-oriented art one of the many manifestations of the phenomenon of total aestheticization, a phenomenon characteristic of contemporary culture as a whole.

Time: consciousness

Any kind of collective consciousness has its own notion of time. This representation of time reorients consciousness and reorganizes its basic concepts, the 'fulcrums' of thinking. Being a continuously self-reorganizing system which simultaneously strives to stabilize its images, consciousness needs time in order to function. The time necessary to make a decision is incommensurable with the time required by a computer to perform the same operations. Man is beginning to realize that he thinks slowly. The distinction between 'slow' and 'fast' became one of consciousness's fundamental notions around the beginning of this century[30] – but only today, with the widespread use of personal computers and the introduction of a global communication system whose speed is incomparable

to early systems, is this notion experienced by the individual as a gap between
the rates of biological and technological evolution.[31] The desire to perfect our-
selves as a species, to outstrip Darwinian evolution and break loose of its inhibit-
ing influence demands the development of mechanisms for mentally adapting to
technological time's runaway momentum. At the same time, in the process of
man's evolution scientific discoveries become one of his mechanisms for adapt-
ing.[32] Here the role of a link synchronizing technological time and mental time
might be played by art, which has always depended on existing technology, but
is capable of adapting ordinary perception (always lagging behind theoretical
science) to new ideas.

Art, however, possesses its own temporal parameters. In video and computer
installations art, acquiring duration, becomes directly temporal. In such works
of art time becomes one of the fundamental parameters – consciousness con-
ceptualizes the virtuality of programmed and unprogrammed events in time. By
irrevocably pairing time and consciousness such installations eliminate the domi-
nance of space characteristic of the visual arts: it is not the space of conscious-
ness that is demonstrated in these works but its time. In video installations space
is represented in 'shot' form – the artist/viewer does not 'domesticate' a space
where objects are arranged in a particular order, the space of cause and effect –
rather, he is simultaneously located in several spaces, in 'real' space and the space
of the screen. The viewing time is what unites both spaces.

In cosmic, 'external' space perception of the surrounding world is 'dis-
lodged' and 'displaced': the formation of an expedient action programme for
sensory systems is complicated by the total heterogeneity of the situation.
Because a model for this does not exist in human memory environmental
afferentation signals that something is wrong. The process of 'normal' percep-
tion is halted: 'I felt that inside of me everything had stopped still, become cold,
as when you're frightened, although there wasn't any feeling of fright' (NM, p.
13). In weightless states times loses all its properties; one might suppose that it
contracts, turns around, becomes distorted, i.e. disappears in the manner
common to dream states: 'It's one of two things: either I'm weightless or else
I'm sleeping and only dreaming all of this' (NM, p. 27).[33]

Cosmic space not only radically differs from earthly space; its conquest is
measured by a purely temporal unit – the light year. We might imagine it in the
following way: consciousness strives to gain the upper hand over time, to return
to the myth of paradise, to the myth of the end of evolutionary history, includ-
ing the history of technological development. The idea of vanquishing time and
space is linked to the quest for immortality:

> Universal resurrection is the complete victory over space and time. The
> passage 'from earth to the heavens' is the victory, the triumph over space
> (or successive omnipresence). The passage from death to life, or the simul-
> taneous coexistence of *all times* (generations), the coexistence of

succession, is the triumph over time. The idealness of these forms of know-
ledge (of space and time) will become a reality. Universal resurrection will
become the unity of history and astronomy, or the unity of the succession
of generations in the aggregate, the fullness, the integrity of the worlds. A
transcendental (preexperiential) esthetics of space and time will become
our real experience or universal cause.[34]

The rationalization of the entire cosmos, the gradual transfiguration that trans-
lates the other into the same should, in accordance with a final harmonic model
of cosmology, complete the task of overcoming time's irreversibility (a sort of
'temporal gravity') and in some regressive-phantasmic way unite body and soul,
word and deed.[35]

> Shortly thereafter a big, white building in the form of an upside-down
> porcelain cup sprung up near the Space City. Over its entrance the words
> 'Pavilion of Weightlessness' were written in large, beautiful letters. Now
> everyone could see with their own eyes that all the talk about weightless-
> ness was not mere idle fantasy, but truth itself. Everyone who entered the
> pavilion instantly became weightless and began helplessly floundering in air.
> There was a small plastic booth in the center of the pavilion. The degravi-
> tizer was located in that booth.
>
> (NM, p. 58)[36]

Technology: time

Technological evolution alters our preception and notion of time. What once
'took' a lot of time, now 'takes', it would seem, very little time. Moreover,
technological consciousness strives to gather sufficient velocity – if we assume
that it is precisely in velocity that space and time are realized – in order to over-
come time, in order to realize paralogical, nonlinear time.

Those temporal frontiers, repetitions, returns and journeys to which the
external time machine aspires are well known to the internal time machine, the
technology of memory, the technology of the Mnemonic Golem (for which time
is simultaneously reversible and irreversible) as well as to photo, video and com-
puter technology, all of which seemingly stop, capture and reverse time.

In the linear model of time the technology of the future, the technology of
foresight and prophecy is perceived in terms of the symmetrical technology of
the past. In turn, foresight and prophecy are inescapably tied to the structure of
disappointed expectations, which forms a parallel mythology that crashes the
'alien intruder's' programme.[37] From the very beginnings of anthropogeny
technological development was dependent on the right prophecy at the right
time, was dependent on the choice of that Golem,[38] more precisely, that quality

of the Golem which in the future would allow the problem posed by time to be solved. The scientist dreams of future recognition, he sees himself as a prophet: 'Znaika was right. He was a very intelligent shorty and foresaw what no one else had foreseen' (NM, p. 19). It stands to reason, however, that here it is more a matter of prognoses supported by natural knowledge and creative intuition than of supernatural prophecy, more the scientific approach coming into play than the religious. Although in the case of Russian cosmism it is clear that three different movements contributed to the eventual launch of the spaceship: the natural-scientific (N. A. Umov, V. I. Vernadsky, K. E. Tsiolkovsky, A. L. Chizhevsky), the religio-philosophic (N. F. Fedorov), and the poetic-artistic (V. F. Odoevsky, A. V. Sukhovo-Kobylin). We might suppose that only the rhythmic development of these three approaches led to the spaceship's launch. Foresight converges with theoretical predetermination and the selection of the 'right' tendency:

> 'You, my friend, are a great scientist! To you goes the honor of discover-ing not only lunite, but antilunite: that's what I propose we call this new substance.' 'But this substance hasn't yet been discovered,' Znaika objected. 'Discovered, my dear man, discovered!' Starochkin shouted, 'You discov-ered antilunite, as they say, theoretically. All that we have to do is prove its existence practically, Many scientific discoveries were made in this way. Theory always lights the way for practice. Otherwise it wouldn't be worth anything!'
>
> (NM, pp. 334–5)

It is in this way that the rhythms of present and future, of practical and theoreti-cal reason are laid down.

Rhythm is one of the most important characteristics of organic and inorganic matter. The unconscious activity of the masses is subordinated to solar rhythms,[39] the rhythm of cosmic radiation affects the human soma and psyche.

Rhythm is one of the fundamental characteristics of time – one might say that rhythm is a sort of domestication of time, a form of its discontinuity. Insofar as contemporary technology is no longer concerned with the mastery of space (which had been the priority of the previous 'mechanistic' and 'electronic' phases of technogeny) but with the conquest of time, rhythm is now the area of tech-nology's primary application. In turn rhythm in the visual arts unites the tem-poral parameters of a phenomenon with its spatial parameters. This rhythmic nature is particularly manifested in the introduction into the spatial arts of such temporal components as sound and light.

Ideology: consciousness

Every ideology employs a particular conceptual apparatus, a particular discourse. Any form of consciousness is ideological. Ideology does not exist outside of

consciousness. Consciousness does not exist apart from ideology. Communication is possible within the limits of a particular ideology, within a general paradigm predetermined by ideology.

By ideology might be implied the technology by which a symbolic order as such functions. In such an order any individual becomes con-scious in the light of a particular ideology, through the prism of the Golem's transparent body, through entry into the world of communication – from the moment he is born the infant is plunged into an already existing symbolic field.[40] At the same time the imaginary and phantasmic space of every conscious individual is principally different from that of others and is characteristic of him alone. One might say that an individual's only private property is not his consciousness (a consciousness he shares with others), but his phantasmic Golem – not Golem as a conceptual project, but Golem as a realized image, obsessively pursuing the individual. For four hundred years there was never any question of mass-producing Golem, but even so Golem was never alone. Moreover, Golem is virulent. It is passed from one individual to another, it multiplies, it takes control of minds, it subjugates the individual's consciousness, it covers consciousness in a space helmet, it outraces the rhythms of the past. But it remains simultaneously a slave of time, a slave of the technology of time and the lord of consciousness.

Consciousness covers us in a variety of veils, but is itself shrouded in a multitude of ideological membranes. One of these membranes is space suit design. Here the differences are visible: Soviet space suits are more anthropocentric, more 'cosmic', while American space suits are more technologized, more cyberneticized. The anthropocentrism of Soviet space suits is apparent on the level of functional aesthetics, which underwent radical functional alterations from one flight to the next.[41] Soviet space suits were made 'in the image and likeness' of man; American space suits were made in the image of 'the cosmic alien'. The anthropocentrism of the Soviet space suit is apparent in the fact that the first cosmonauts could themselves put on and take off the exo-suit for space walks, while the first astronauts were not able to do this without assistance.

In other words, the Soviet space suit is closer to the Golem-Man; the American – to the Man of Golem. This distinction becomes especially clear when we compare the hard suits designed in the late 1960s for astronauts participating in the Lunar Advanced Apollo Programme (the futurological design of these suits looks like the perfected shell of a mass-mediafied Golem) with the Soviet space suit, which, despite all the elements of fantasy, is surprisingly well described in *Neznaika on the Moon*:

> Each of these suits consisted of three parts: a cosmic jump-suit, a pressurized helmet and cosmic boots. The cosmic jump-suit was made up of metallic plates and rings bound by a flexible, silver-colored cosmoplastic. On the back of the jump-suit there was a backpack containing an air-cleaning and ventilation apparatus, as well as a battery which powered an electric lamp

fastened to the chest. Under the backpack there was an automatically unfolding hood – a parachute which would open like a pair of wings in the event of an emergency. The pressurized helmet was placed over the head and was made of hard cosmoplastic bound in stainless steel. In the forward part of the helmet there was a round porthole made of shatterproof glass; there was also a small radio-link with telephone for conversing in the airless expanses. As far as the cosmic boots go, they were barely distinguishable from ordinary boots, if one doesn't take into consideration that the soles were made of a special heat-resistant substance. . . . Having put on the jump-suit, Neznaika felt that it fit rather snugly around his body, but the helmet was so spacious that he was able to leave his hat on.

(NM, p. 85)

In his far from alien-like suit Neznaika represents the work of the collective unconscious. His suit is not only functional but shares many details characteristic of actual Soviet space suits: for example, a distinguishing feature of Soviet suits designed for work in open space was the backpack life-support system.[42] In his techno-ideological expedition to the Moon, Neznaika not only imparted a technically accurate form to children's fantasies but carried out expansion on to that planet which had already been conquered, in the person of an American astronaut, by his ideological rival.

Ideology: time

What would this mysterious, unknown world called the Moon be like? How would it receive these uninvited strangers? Would the space suits prove to be a reliable defence in the airless expanses? For one little crack, one little aperture in the suit was all it would take for the air to rush out, threatening the travellers with swift death.

(NM, p. 85)

Every ideology has its own notion of time, not only as a physical magnitude but as a measure of value – for example, the value of building utopia. Of course time itself is also teleological: society aspires to some final goal, to perfection, to nonexistence. This striving should be correlated to the death-drive characteristic of all organic matter. Insofar as it is bound to function on the dead body of a particular myth, that has already been constructed and fixed, every ideology is a short-circuiting of time in the process of self-destruction. Ideology is entropic, but time consists of ideological eras characterized by their own periodicity, by that sensation of velocity and rhythm which is dependent on technogeny.

Time as chronometry reflects a particular ideology: the cosmic myth, one of the clearest models of technology, has its own place in time (1957, 1961, 1969).

This myth has its own origin (from the Greeks to the cosmists, the astrophysicists, the cosmobiologists and exobiologists), its time of trial and its time of fulfilment, its time of dying. The Golem is projected from one object on to another: 'Star Wars' is replaced by 'Aliens'; 'Aliens' by 'Alien Intruders'.

The rate at which a myth is conceived and dies depends on the time of its functioning within a micro-ideology: in Russia this myth is no longer – it died along with the Soviet Union. By all appearances, however, one might say that this myth no longer exists in the United States, that it dispersed with the disappearance of the most significant opposition in this century – a techno-ideological opposition that within one earthly lifetime took root in biological memory as a cardinal anthropological difference.

> At first it seemed that the mystery of the Flying Saucers had an entirely earthly provenance: it was assumed that the saucers had flown in from the wilds of the Soviet Union, from that world whose designs were just as unclear as the designs of space aliens. Already in this form the myth in embryo held out the possibility of interplanetary extrapolation; and if from a Soviet rocket the saucer so easily turned into a Martian ship, we see that Western mythology ascribes to the communist world that same alienness that it might ascribe to any other planet: the USSR is a world halfway between Earth and Mars. In the course of its development, however, the mystery changed its meaning: from a myth of encounter it became a myth of judgment. Until marching orders are given, Mars will not interfere: Martians appeared on Earth in order to judge it, but before they pass sentence they want to look around and listen. From that moment the great confrontation between the USSR and the USA begins to be felt as the source of guilt, a sense of danger gains the upper hand over the idea of the struggle for truth and justice; this is the source of that mythological appeal to the heavenly gaze, a gaze mighty enough to terrify both parties.[43]

Acknowledgements

Without the kindly assistance of Leanne Mella (it was in conversation with her that the idea for this investigation arose) this article would never have been written. We would also like to express our gratitude to Simms Gardner, the staff of the Paul E. Garber Facility of the National Air and Space Museum, Smithsonian Institution (Washington, DC), the staff of the Museum of the A. F. Mozhaisky Military Space Engineering Academy (Saint Petersburg) and, of course, Charles Stainback.

Notes

1 Neznaika, the hero of a series of children's books written by Nikolai Nosov in the 1950s to 1960s (*The Adventures of Neznaika and His Friends* (1954); *Neznaika in the Solar City* (1958); *Neznaika on the Moon* (1964–65)), is typologically linked to that category of heroes who find a way out of any situation due to their paralogical behaviour. Nosov's book *Neznaika on the Moon* (N. Nosov. *Neznaika na Lune*. Roman-skazka dlia detei mladshego shkol'nogo vozrasta. Moscow: 1993; hereafter referred to as NM) served as our guide in the writing of 'The Golem of consciousness⁴'. This book combines a view of the new space-age technology with an allegory of the ideological confrontation between the Soviet Union and the United States.

2 An image that recurs in a series of essays entitled 'The Golems of con-sciousness': 'Golem so-znaniia¹' (*Kabinet*, 7, 1994); 'Golem so-znaniia. Vvedenie: membrany/prototipy' and 'Golem so-znaniia: vera v sebia' (*Acta Psychiatrica, Psychologica, Psychotherapeutica et Ethologica Tavrica*, 2(4), 1995); 'Golem so-znaniia²: porozhdenie kiberpanka' (unpublished); 'Golem so-znaniia³: s teatral'noi stseny na virtual'nuiu' (*Kabinet*, 14, 1996). 'The Golem of con-sciousness⁴' was published in Russian in a sightly different form in the catalogue for the exhibition *U Predela* (*Along the Frontier*) (The State Russian Museum, St Petersburg; International Center of Photography, New York, 1996).

It would seem to make sense here to help the reader recall *the figure* of the Golem: the Golem (Hebrew for 'lump', 'unready' and 'unformed') is a being from Jewish mythology, a clay giant brought to life with the help of the Kaballah's magical means. Jewish legends name several historical figures as creators of the Golem, the most famous among them being the creator of 'The Prague Golem', Rabbi Judah Loew ben Bezalel (sixteenth to start of seventeenth century).

The Golem is brought to life either by writing the name of God or the word 'life' on its brow. The Golem, however, is not capable of speech and does not possess a human soul, being similar to Adam before he received 'the breath of life'. Reminding us of the time of Adam, other beings at times enter into competition with God: thus in the film *The Prophecy* (Gregory Widen, director) soulless angels struggle with humans for closeness to God. In this 'construction' man is situated between his 'fundamental' Golems, between abstract spirit and animal-like force – in psychoanalytical terms, between the superego and the id.

The Golem is an embodiment of the dream of 'robots', living and obedient beings. The two main functions of the Golem are the performance of work that is beyond man's strength and the defence of the people from its enemies. At the same time the Golem represents danger, the terror before a creature that has escaped the control of its creator. In the present day this terror appears more clearly than during the Prague rabbi's time, which is fully explicable in

the light of developments in the realms of genetic engineering and artificial reason, robotics and nanotechnology. In cinema, in particular, the examples of such 'creatures gone out of control' are more than sufficient. One of the most vivid of these films is *Prototype X 29 A* (Scandiuzzi and Roth, directors). In an attempt to regain control and suppress the population, cyborgs known as 'omegas' are created. Within a few years of their appearance the omegas begin to reprogramme themselves. In order to put down the omegas, new cyber-netic entities known as 'prototypes' are created. Their only mission is to ter-minate the omegas.

The biblical Adam is the Golem's prototype in the Judaeo-Christian tra-dition, but 'golemic' motifs, it goes without saying, appear in various cultures and historical periods. One of the most noteworthy examples is the ancient Greek writer Lucian's dialogue 'The lover of lies, or, Neverus'. Three moments in this dialogue are worth mentioning here. (1) A certain Glaukius fruitlessly tries to win the affections of Chrysida; he resorts to the services of a Hyperborean magician who performs a series of magical rites and finally fash-ions a tiny Eros from clay: there is no 'genuine' Eros; he is copied, moreover, from 'the very same' material – clay. (2) Eucrates recounts the story of Pan-cratos, who possessed the technology of transforming things into a 'man' that renders various forms of assistance. Eucrates 'steals' this secret (the verbal formula of 'golem-formation') from Pancratos and turns a wooden pestle into a water-carrier. This water-carrier goes out of control and floods Eucrates' house. (3) Fables and other tales of wonders are, like the Golem, virulent. It is of this which Philocles speaks at the end of the dialogue, comparing these tales' infectious nature with the hydrophobia passed by dog to man, from one man to another, and so forth.

The Golem is now a literary being. The first mention of the Golem is con-tained in Reichlin's 'On the art of the Kabbalah'. Jacob Emden's legend of a Golem fashioned from clay by Rabbi Elijah of Chelm was published in the eighteenth century. The image of the Golem surfaces in the works of the German Romantics Achim von Arnim ('Isabella of Egypt') and E. T. A. Hoffman ('Secrets'). The Golem is once and for all established in literature with the publication of Gustav Meyrink's novel of the same name. And 'finally' Borges dedicated one of his poems to the Golem.

We should also mention that in contemporary literature the direct analogy between the Golem and the Cyborg is being made (cf. for example, Marge Piercy's novel *Body of Glass*, 1992).

For our purposes, though, it is not so much important *what* the Golem *is* as *how* it is, how it evolves. The Golem is an absolute phantasm and exists only to the extent to which *Homo sapiens* sapiens exist. This specific doubling, this 'intelligent intelligent' points us towards the process of excretion–generation itself, towards the possibility of self-consciousness, con-sciousness. Any phan-tasm linked to the generation of a surrogate/helper is already the beginning of technology, the beginning of the prostheticization of reality. The Golem's

material form – be it clay or synthetic, with a magical scroll in its mouth or with chips in its brain – depends on the evolution of con-sciousness and its phantasms, on universal tendencies in technology development (cf. the works of Andre Leroi-Gourhan).

3 The division of these words 'con-sciousness' and 'in-di-vidual', into their semantic components (discussed in greater detail in the previous 'Golems') indicates their collective parameters.

4 Used here in a wider sense encompassing both productivity in external space (the production of material objects) and in internal space (the production of mental objects). These two spaces intersect and, according to Ortega y Gasset, in the near future external space will be saturated with mental objects to such a degree that humans will travel in that space the way that we now travel in our personal internal space (cf. Ortega y Gasset, *Man and People* (1957, pp. 20–1)).

5 To the same degree to which the well-known formulas of Sapir/Whorf, Wittgenstein and Lacan concerning the relationships between language and the world and between symbolic and imaginary spaces are true.

6 We borrow here an instructive passage from E. Roudinesco's book *Lacan* (Fayard, 1993, pp. 364–5), an episode that demonstrates the sometimes 'fateful' significance of these kinds of distinctions. After Yuri Gagarin completed the first space flight, Jacques Lacan desperately wanted to travel to the Soviet Union and lecture there. ('Now that man is going out into open space, a new psychology will appear there.') A meeting with the vice-president of the Soviet Academy of Sciences, A. Leontiev, was arranged for Lacan. While the two men were talking about Soviet research on the psychophysiology of cosmonauts, Lacan suddenly interjected: 'There is no such thing as a cosmonaut.' Offended, Leontiev was prepared to cite all the evidence proving that cosmonauts really existed, but the psychoanalyst went further: 'There aren't any cosmonauts simply because there isn't any cosmos. The cosmos is a point of view.' The incompatibility of these two points of view on the problem of outer space sparks Znaika's and Professor Starochkin's argument about the composition of the Moon: ' "Well, well!?" Starochkin interrupted, "Just explain to us, please, why you've got it into your head that the Moon is hollow inside?" The people who had come to listen to the lecture laughed, but Znaika wasn't bothered by this and said, "you would get it through your thick skulls if you'd just think for a minute. If originally the Moon was an igneous mass, then it began to cool not from the inside but on its surface, since it is precisely the Moon's surface that is in contact with cold outer space. Thus it was the surface that first cooled and hardened, as a result of which the Moon became something like a gigantic, ball-shaped vessel" ' (NM, p. 11).

7 A description of the first 'suiting-up': 'It came time to don the space suit. I put on a light but warm sky-blue jumpsuit. Then my comrades set about putting me into the bright-orange protective suit which would enable me to work even should the ship's cabin become depressurized. All the instruments and devices

with which the suit had been outfitted were checked on the spot. This pro-
cedure took a good deal of time. I put an intercommed helmet on my head,
then over that a pressurized helmet on which the letters "USSR" had been
brightly painted' (Yuri Gagarin, *Doroga v kosmos* (Moscow: Voenizdat, 1978)).

8 It is not surprising that one of the theoretical fathers of the Russian space pro-
gramme, V. I. Vernadsky, when speaking about outer space, used the notions
of 'The One and Indivisible Cosmos' and 'our cosmos'. Cosmos represents
stability, eternity, fraternity, etc.

The notions of space and cosmos relate to different discourses; they belong
to different paradigms of thought and do not simply, as it might seem, differ
as regards linguistic genesis. Cosmos is based on a notion of stability and order,
on the possibility of counting everything, reducing everything to a single
denominator. It is hardly surprising that against the backdrop of the conquest
of the cosmos people began arguing about which worldview prevailed in the
USSR – the Platonic or the Aristotelian. These everyday conversations wit-
nessed to the fact that the ancient Greek tradition was no less important than
the officially accepted Hegelian dialetic upon which Marx's system had ger-
minated. In these conversations some maintained that a Platonic ideology pre-
vailed in the USSR insofar as the country seemed just as abstract as Plato's ideal
state. Others held that the materialism of Soviet society originated from Aris-
totelian metaphysics. The figures of the ancient Greek philosophers appeared
in Soviet schools practically simultaneously with the first notions of cosmic
space. At first, a close cosmos appeared, a cosmos that gradually opened into
endless space. Space, according to Aristotle, is the aggregate of the locations
of all bodies, while cosmos is a primordially set structure, a metastructure
which gives each object a concrete location.

9 The word 'space' is from the Latin *spatium*, a word meaning 'space', as opposed
to the Greek *kosmos*, which means 'order, ornament, harmony'. 'Cosmos' is
often seen as a pre-Copernican, purely speculative notion, while 'space',
accepted as a physical concept during Einstein's lifetime, simply 'is'. These dis-
tinctions are important when we consider how this difference in interpreting
technological problems is manifested on the conceptual level, i.e. on the level
of ideologization: 'space' and 'cosmos' engendered the entire lexicon of 'The
Space Age/The Cosmic Era' and of 'space ships/cosmic ships'. The names of
the first manned ships illustrate this: *Vostok* ('East' – one of the cosmic hor-
izons, i.e. 'inner' space) and *Mercury* (one of the planets, i.e. 'outer' space).
Investing abstract notions and technological means with a name, the ideologi-
cal controllers introduce ideological membranes or contextual representations
into consciousness: 'it is not technique, not technology, not machines which
are the mechanical means of repression, but the fact of their masters' deter-
mining their number, the period of their existence, their possibilities, their
place in life and the need for them' (Herbert Marcuse, *An Essay on Liberation*,
1969, p. 12). For Marcuse, the conquest of cosmic space signified a renuncia-
tion of work on inner, earthly space (which is, strictly speaking, the Cosmos):

'Instead of the further conquest of nature, the reconstruction of nature. Instead of the Moon, the Earth; instead of the conquest of outer space, the creation of inner space' (Herbert Marcuse, *The Responsibility of Science*).

10 *Skaphe* – boat, canoe; *aner (andros)* – man. However, '-naut' *(nautes* – mariner) indicates the connection with water and navigation, just as spaceship is a 'cosmic ship' traversing the cosmic seas.

11 In Russian cosmism the relationship to the world as cosmos (characteristic of the ancient Greeks and distinct from the Christian view of the world as history) is reborn.

12 This centripetality is reflected, in particular, in illustrated propaganda. In a poster 'Peace to you, our Earth' (G. V. Serebriakova, 1981), a cosmonaut orbits an earth surrounded by stalks of wheat which come together in a small red star at its centre. Thus, centripetal expansion is visualized by a series of substitutions: USSR = Earth = Cosmos.

Such is one example of the ideological representation of technology. From the point of view of the role foisted on technology in the social scientific socialism as the ideology of Soviet society is a technocratic socialism insofar as it is based on know-how and the ability to plan history: 'In reality that which is usually called "scientific socialism" (as distinct from "utopian socialism") might with greater accuracy be called "technical socialism" precisely because it constitutes a socialism based in the true sense of the word on "know-how" as regards the social world and the ability to "plan" history with the end of receiving certain results' (Carl Mitcham, *What is the Philosophy of Technology?*, Moscow: 1995, p. 59).

13 'For example' insofar as, it seems, Yuri Gagarin donned the international 'crown of the firstcomer'. When asked who is the most famous American astronaut, Americans often erred at first, naming Gagarin, and then gave *one of three* answers: Alan Shepard, John Glenn, Neil Armstrong.

14 In the environment of strict secrecy which reigned in the Soviet Union not only was no mention made of military space programmes, but the existence of special military units (whose officers wore airforce uniforms) was also concealed.

15 Lillian D. Kozloski, *U.S. Space Gear* (Washington: Smithsonian Institute Press, 1994, p. 97). In the interests of accuracy, however, we should point out that Neznaika himself does not appear in this scholarly book: an illustration from the novel's dustjacket depicting Neznaika's 'colleague' in flight, Ponchik, is reproduced on one of the book's final pages.

16 There is no direct evidence that the action of *Neznaika on the Moon* takes place in the United States – nevertheless, a number of details suggest that the Moon 'is' America. (1) At a time when Soviets saw the United States as the embodiment of a capitalist country in which money is king, the social structure of the Moon represents a typically anti-utopian vision of capitalist society: 'in conclusion Neznaika asked why lunar astrologers and lunologists hadn't yet constructed a flying machine capable of reaching the Moon's outer shell. Memega

answered that the construction of such an apparatus would cost too much and the lunar scientists simply didn't have any money. Only the rich have money, but no rich man would consent to waste his riches on a deal that didn't promise large profits' (NM, p. 155). (2) The absolute rule of capital is guarded by clever and cruel policemen, whose symbol is – thanks to the Soviet media – the rubber truncheon: ' "A rubber stick!" the policeman mimicked, "Well, it's clear that you're a fool! THIS is the much-improved electrified rubber truncheon, MERT, for short. Come on, stand at attention!" he commanded. "Hands on your heads! And no Lip!" ' (NM, p. 106). (3) Advertising (whose pernicious effect on Americans was being discussed during this time in the Soviet Union) on the Moon is developed to the point of absurdity: 'Ah, the mores of the lunar dwellers! A lunar shorty [all the characters in the Neznaika books are referred to as 'shorties' and depicted in the accompanying illustrations as slightly child-like, pudgy midgets – Translator's note] wouldn't even think of eating candy, gingerbread, sausage, bread or icecream from a factory that didn't run ads in the newspapers, wouldn't think of going to a doctor who hadn't thought up a mind-busting ad campaign for the amusement of his patients. As a rule a Lunatic will buy only those things he's read about in the papers, and if he should see a clever billboard somewhere, then he might just buy something that he doesn't need at all' (NM, p. 152). (4) The creation and failure of joint-stock companies, one of which is 'Gigantic Plants, Inc' (Gigantic plants, whose seeds are flown in from Earth and which bring social welfare to all the lunar 'shorties', are essentially a form of symbolic compensation for the distressing comparison of Soviet and American agriculture made by Nikita Khrushchev during his visit 'beyond the sea'. This revolutionary project is organized by Neznaika). (5) Panic on the stock exchange: one of the chapters is even entitled, 'Panic on the Davilonian Stock Exchange'. (6) The existence of private property: ' "What, maybe you don't recognize private property?" Klops asked suspiciously. "Why not?" Neznaika responded, confused, "I recognize it, only I just don't know what kind of property it is! We don't have private property. We sow crops together, we plant trees together, then each takes what he needs. We have more than plenty." ' (7) The grinding poverty of poor lunar shorties and the eccentricities of the rich: 'There are special salons for dogs. There are special stores for dogs which sell all kinds of canine delicacies, restaurants for dogs, candy shops and cafes for dogs, special sports complexes and stadiums for dogs. There are dogs who enjoy racing each other at such stadiums. They're awarded medals for this. There are even dogs who love acquatic sports, who participate in swim meets or play water polo. Then there are dogs who don't enjoy playing sports but love watching other dogs compete. I heard that in the city of Davilon they even built a theatre for dogs' (NM, p. 293). (8) Profit-directed development of technology, a technology invested mainly in mass-entertainment culture – all this and much else of what comprised Soviets' fairytale-stereotypical image of America is described in Nosov's book. Finally, (9) the toponymy of the Moon is itself revealing – the names of its cities

are reminiscent of well-known American cities such as Los Angeles and San Francisco, but also contain not very well-hidden allegories: Los Svinos, Los Boaros, Los Filthos and San Mosquito.

17 The effect on the human body of a complete change in the usual rhythm of day and night (in particular, the absence of the alternation of solar light and darkness) is borne out by the cosmonauts' experience: 'During our flight,' writes the commander of *Soyuz-9*, A. G. Nikolaev, 'in the course of approximately three days (from the 3rd to the 6th day of our flight) our ship orbited along the "terminator" line (the line dividing day and night on the earth's surface), and all three days we were above the sunlit side of the earth. The sun didn't dip below the horizon. Then it began to set for a few seconds, the interval between sunset and sunrise gradually increasing. . . . In these unusual conditions we lost all sense of the change between day and night and gradually became used to counting the days purely conditionally; we lived according to our watches' (B. S. Aliakrinsky, S. I. Stepanova, *Po zakonu ritma* (Moscow: Nauka, 1985, p. 113).

18 'Being a constant factor in space flight, weightlessness apparently causes the most significant adaptive changes, changes directed towards establishing the proper correlations between the body and the environment' (O. G. Gazenko, A. I. Grigoriev, A. D. Egorov, 'Reaktsii organizma cheloveka v kosmicheskom polete', *Fisologicheskie problemy nevesomosti* (Moscow: Meditsina, 1990, p. 19)).

19 Thus from two projects for the creation of artificial intellect (one of which constructs models (nerve nets) from mathematically idealized neurons; the second from computer programs) the Defense Advanced Research Projects Agency (DARPA) selects the second, which leads to its intensive development, while the first dies from lack of financing.

20 This particular symptomology is clearly manifested in a number of recent films: *Cyborg* (Albert Pyun, director), *Cyborg 2* (Michael Schroeder, director) and *Twelve Monkeys* (Terry Gilliam, director) are just a few of these. With the development of nanotechnology, contemporary technophobia becomes more and more interiorized, takes on the form of a fear of the penetration of another into oneself, and on the mythological level creates the fear of oneself as the other.

21 If we view the activity of consciousness in the terms proposed by Miller, Galanter and Pribram (Miller, G. A., Galanter, E. and Pribram, K., *Plans and the Structure of Behavior*, NY: A Holt-Dryden Book, 1960), for whom a plan is any sort of hierarchically constructed process controlling the order in which operations are performed, while an image is that system of representations of the self and the world which permits planning.

22 According to Ortega y Gasset, at a certain stage of anthropogeny man's ancestors began producing a number of 'fantasies' as a result of an unknown genetic mutation, and individual beings acquired the ability to choose between various fantastic possibilities.

23 One example of this is the brain implants used by Johnny Mnemonic in the film of the same name (Robert Longo, director; William Gibson, screenplay).

In this film we see how technology is internalized and fused with the human organism. One of the characters in the film, Preacher (an adept of the techno-ideo-religion of this future society), reconstructs and strengthens his own body by implanting various artificial organs. According to Marvin Minsky, it will be possible in the future not only to replace individual organs but to make use of more radical means to perfect that ever-changing end-product of evolution – *Homo sapiens*. In particular, nanotechnology will allow us to effect substitutions on the level of atoms and molecules (Marvin Minsky, 'Will robots inherit the Earth?', *Scientific American* (special issue): *Life in the Universe*, October 1994, pp. 109–113).

24 'Extensions' as understood by Marshall McLuhan (cf. McLuhan, *Understanding Media: The Extensions of Man*, NY: A Signet Book, 1964). Also in the sense of the hand as that instrument for pointing and distinguishing which, along with consciousness, sets the human race apart. And in the sense of the hand, 'which it is impossible to discuss, without discussing technics' (J. Derrida, 'La main de Heidegger', *Psyche*, Galilee, 1987, p. 424). And in the literal sense of the artist-scientist Stellarc's third mechanical hand, a hand operating on the boundary between the technological and the biological.

25 According to N. F. Fedorov (librarian, philosopher and forefather of Soviet cos-monautics) we should produce within ourselves an organism which 'is that unity of knowledge and practice; this organism's nourishment is the con-sciously creative process by which man transforms elementary cosmic sub-stances into mineral, then vegetable, and finally, living tissues. This organism's organs will be those instruments by means of which man will act upon those conditions upon which vegetable and animal life depend. I.e., farming as a practice through which knowledge of the earth is revealed will become an organ in this organism, one of its accessories. Those aeronautical and ethero-nautical means by which it will move through space and acquire the cosmic material necessary for its own construction will also become organs. Man will bear within himself the entire history of discoveries, the whole course of progress; in man will be contained physics, chemistry – in a word, all cos-mology, only not in the form of thought-images, but in the form of a cosmic apparatus which allows man to become a genuine cosmopolitan, i.e., to be everywhere; only then will man become a genuinely enlightened being' (N. F. Fedorov, *Sochineniia*, Moscow: Mysl', 1982, p. 405).

26 Telepresence presupposes the possibility of performing work in another room or on another planet without the worker actually being present in those places: the movement of the hand is reproduced by mobile mechanical arms.

27 'Under the influence of scientific thought and human labor the biosphere passes over into a new condition – into the noosphere' (V. I. Vernadsky, *Nauch-naia mysl' kak planetarnoe iavlenie*, Moscow: Nauka, 1981, p. 20).

28 Cf. Leroi-Gourhan, *Milieu et technique*, Albin Michel, 1945; B. Stiegler, *La tech-nique et le temps*, Galilee, 1994.

29 During one of his lectures Bernard Stiegler described the schema for such a

system: radars observing for the presence of nuclear warheads function as the system's input; a computer processes this information; rockets serve as output. A decision-making system is built into the computer: owing to this fact, the entire system, just like a living being, operates reflexively.

30 The distinction between 'slow' and 'fast' appears in physics with the introduction of the universal constant c. 'Universal constants engender such distinctions: c allows us to distinguish slow from fast, h – heavy from light. Instead of the unified structure of all physical objects we now discover a plurality of structures' (Ilya Prigogine, 'Einshtein: triumfy i kollizii', *Einshteinovskii sbornik*, 1978–79, Moscow: Nauka, 1983, p. 121).

31 Both Bernard Stiegler and Marvin Minsky treat this problem – but with very different results. Stiegler describes the gap between consciousness and technology as a fundamental peculiarity of human activity (Bernard Stiegler, *La technique et le temp – 1. La faute d'Epimethee*, Galilee, 1994). Minsky proposes various ways of overcoming this gap by means of technology – in particular, through the creation of our 'mind-children', i.e. Golems of consciousness.

32 'It has certainly been true in the past that what we call intelligence and scientific discovery have conveyed a survival advantage' (Stephen Hawking, *A Brief History of Time*, London: Bantam Books, p. 14).

33 The experience of weightlessness is familiar to everyone to a certain degree: we might speak here not only of a regression into the timelessness of the dreamworld, but also of a regression into the prenatal condition: 'During the process of ontogeny humans and the majority of mammals exist for several months in conditions of partial weightlessness and hypodynamia during the period of gestation. It is worth noting that the fragile and unperfected organism of the human and other mammals, in the first stages of its development, is protected not only from a series of other factors but is also delivered from the harsh effects of gravity's power, a force that creates deformities and exerts a heavy load on all the organism's systems' (E. A. Kovalenko and I. I. Kas'ian, 'K probleme deistviia na organizm nevesomosti', in *Fisiologicheskie problemy nevesomosti*, Moscow: Meditsina, 1990, p. 233).

34 N. F. Fedorov, *Filosofiia obshchego dela*. Vol. II, Moscow, 1913. Cited in *Sochineniia*, Moscow: Mysl', 1982, p. 572.

35 'The question of the earth's position in heavenly space, of the insignificance of its magnitude, of the stars (the planets), as well as of other earthlike bodies, the investigation of the interplanetary and interstellar expanses, etc. – if all of this has not awakened in man a consciousness of his true mission, brought him to the realization that not only the earth but the whole world demands that man become expedient, that the entire world should become man's profession – if all this has not been recognized and come to pass, then it is thanks to only the fact that thought and deed have become separated and embodied, so to say, in different estates' (N. F. Fedorov, *Filosofiia obshchego dela*, Vol. 1, Verny: 1906. Cited in *Sochineniia*, Moscow: Mysl', 1982, p. 310). However, the first step on to another heavenly body, made by Neil Armstrong on 21 June 1969,

the first sensation of another soil underfoot changes – or at the very least, should change – our entire *Weltanschaaung*, our entire system of spatial references. (In this regard, cf. P. Virilio, 'Vitesse, vieillesse du monde', *Chimeres*, May 1990, no. 8.)

36 The overcoming of gravity demands the right choice of technologies for co-ordinating the astronaut's body and various flying machines. (For details cf. V. B. Raushenbakh, V. N. Sokol'skii and A. A. Giurdzhian, 'Istoricheskie aspekty osvoeniia kosmosa', in *Kosmos i ego osvoenie*, Moscow: Nauka, Washington, DC, AIAA, 1994, p. 14.) An analogous choice faces Znaika: ' "Weightlessness is a tremendous force if one knows how to approach it," he thought to himself, "With the help of weightlessness it is possible to lift and move heavy objects. . . . One can construct a big rocket and journey on it to the stars. But today we're forced to carry a huge supply of fuel in order to achieve the necessary velocity; if the rocket weren't to weigh anything, then we'd need an altogether small amount of fuel and in place of fuel reserves we'd be able to take on more passengers and food supplies" ' (NM, p. 53).

37 When a computer virus in the form of a beautiful woman penetrates their virtual reality program, the heroes of Ricardo Jacque Gale's film *Alien Intruder* cry in indignation, 'This is not [our] program. . . . Everything should have turned out differently'. The 'alien', having lost its palpability on the conceptual level, channels desire in order to crash the program.

38 The Golem here is practically identical to that delirium which, according to Vlavy Sakrus' formula – 'Yesterday's nonsense is today's science; today's nonsense is tomorrow's science' – has an even chance of proving prophetic.

39 There is a surprising similarity between a remark made by A. L. Chizhevsky and one passage in *Neznaika on the Moon*. Chizhevsky, studying the exclusive role which solar radiation plays in the life of the biosphere, writes: 'The majority of the biosphere's activity, manifested as a whole and in its particulars, is conditioned by this radiation' (A. L. Chizhevsky, *Zemnoe ekho solnechnykh bur'*, Moscow: Mysl', 1976, p. 245). In *Neznaika* we read the following description of the rhythm of night and day on the Moon: 'The lunologist Memega explained to Neznaika that the Sun, along with its visible rays, gave off a mass of invisible rays which possess, however, great penetrating force. Penetrating the Moon's crust, these invisible rays, cause its inner surface to shine, that is, to give off a luminescence – this will be observable, however, only in that hemisphere of the Moon which is turned towards the Sun' (NM, p. 155).

40 Cf. Louis Althusser, 'Lettre a D . . . (No. 2)', *Ecrits sur la psychanalyse Freud et Lacan*, Paris: STOCK/IMEC, 1993, pp. 83–110. Here we should once more stress that con-sciousness is the product of collective notions. Con-sciousness includes both specific schemes for perception of the environment and images characteristic of a given stage in the evolution of symbolic space. Con-sciousness is the producer and the product of ideology, the receiver and the transmitter of ideology. It is the agent of the collective space of ideas. Ideology

does not exist apart from consciousness to the same degree as consciousness does not exist apart from ideology.

41 Thus the outer casing of the Soviet high-altitude lifesaving suit (*Sokol-K*), designed for landings, was always a buddhist orange colour, a fact explained by the need to find the cosmonaut who had just landed as quickly as possible; the outer casings of American space suits were variegated.

42 Compare the description of Neznaika's space suit with the following article from the *Soviet Space Encyclopedia*: 'In general the following components make up the Suit: a pressurized suit, a pressurized helmet, gloves and shoes, a water-cooling suit, an apparatus for the receiving of food and water, a device for the collection and removal of urine, a feces collector, a radiotelephone, a cable-hose, through which blended oxygen, electricity and radio signals are directed from on board the Space ship (this feature is completely absent in free suits), backpack life-support system, as well as an emergency back-up life-support system. . . . The pressurized helmet protects the head from injury and supports the visor. The visor is comprised of a transparent viewing glass hermetically sealed to the helmet and a light-filter which shields the cosmonaut's eyes and face from blinding solar light and from the effects of the Sun's heat and ultraviolet rays. Inside the helmet there are the telephones and microphones for radio communication.'

43 Roland Barthes, *Mythologies*, Paris: Editions du Seuil, 1957, p. 42.

James L. Hevia

THE ARCHIVE STATE AND THE
FEAR OF POLLUTION: FROM THE
OPIUM WARS TO FU-MANCHU

Abstract

This article considers the relationship between the production of a British imperial archive on China and the global politics of empire over the last century and a half. Drawing upon the theoretical work of Bruno Latour, Gayatri Spivak and Thomas Richards, the archive is explored as a coherent set of material practices designed to decode and recode China and other colonized territories. Imagined as an interface between knowledge and the state, the British archive required the establishment of an epistemological network designed to generate knowledge on China. The knowledge so produced was then used to manipulate local scenes and to provide intelligence in 'the Great Game', the continuing contest with Russia over domination in Central Asia. Because of its desire for comprehensive knowledge of other peoples and places, the archive also generated its own phantasms, ones which threatened to undermine and destroy empire. This process of self-haunting is explored through the figure of Fu-Manchu, a discernible mutation of epistemological empire, and linked to the cold war which emerged on the Eurasian landmass after 1945.

Keywords imperial archive; postcolonial studies; epistemology; Great Game; China; Fu-Manchu

A T THE END of the First World War, a drug panic gripped Great Britain. While concern with the infiltration of exotic drugs into England dated to before the war,[1] this particular hysteria seems to have had its source in the unusual cultural mixture that connected jaded aristocrats, the lower orders in the theatre and dance-hall districts of London, and men of colour. The immediate cause was the drug-related deaths of several chorus girls and actresses. According to reports in the tabloid press, all the women had died as a result of dangerously combining forbidden sex with drugs, and had been enticed into doing so by yellow and black men. This conjunction, the tabloids added, was hardly accidental. Rather,

it appeared to be part of a vast conspiracy, one designed to degrade white women and to undermine the moral and physical strength of the British imperial centre. The point of origin of the conspiracy lay on the frontiers of the empire, in those zones of contact that were not quite inside yet not quite outside the imperial purview – zones often labelled 'spheres of influence'.

In this case, drugs such as opium and cocaine were being smuggled into England by an organization at the head of which was a criminal mastermind, a crafty 'Chinaman'. Dubbed by the press as 'Brilliant' Chang, partly because of his purported intelligence and partly because of his un-Oriental style of dress, he was arrested in 1924 and deported after being convicted of cocaine possession. Yet, like arch-villains of popular fiction such as Professor Moriarty and Fu-Manchu, both of whom also threatened the stability and health of the imperial centre, Chang did not disappear. It was said that he jumped ship before reaching China and resumed operations out of Zurich, Antwerp, Brussels, even Paris. Character- ized as the 'Emperor of Dope' at the head of an operation known as a 'Dope Octopus', Chang was blamed for drug-related deaths throughout Europe well into the next decade. Moreover, his reputation extended well into the 1950s.[2]

These references to race, degradation, gender and conspiracy are, of course, not unusual features of tabloid journalism or the social world of the spectacular that emerged in the imperial centres of Western Europe and North America in the second half of the nineteenth century. Nor is it unusual to see the spectre of a threat to white women raised in this connection. Postcolonial feminist critics, particularly those working on the construction of masculinity in the national and colonial contexts, have argued that women do not so much mediate relations between the sovereign male subjects of empire and others as provide the occasions or sites for working out certain problems or contradictions in histori- cally variable masculine subjectivities (De Lauretis, 1984; Mani, 1985; Smith- Rosenberg, 1985; Stoler, 1989).[3]

Enticing as it is to read the drug panic that gripped Great Britain in the early 1920s directly through the powerful interpretive framework provided by femin- ist theory, my purpose here is somewhat different, and begins with a recognition that the panic itself was in some sense a repetition of one already described in various forms of fictional literature. In particular, it mimics plot features to be found in the works of Arthur Ward, better known as Sax Rohmer, the creator of Fu-Manchu. In two non-Fu-Manchu novels, *The Yellow Claw*, first published in 1915, and *Dope*, which appeared in 1919, Rohmer wrote about mastermind Chinese criminals like Brilliant Chang who spun drug conspiracies within Britain and who sought to entrap upper-class women, actresses and effeminate men in the nefarious world of drug use. The Fu-Manchu series extended these anxieties well into the 1950s and 1960s, recycling fantasies of the many threats to white masculinity and femininity posed by an awakened Asia.

More significantly, perhaps, Rohmer's foreshadowing of the 1920s drug panic appears to have been firmly rooted in fears of the problems of empire

coming home to roost in England and in widely diffused understandings of the history of the Anglo-Chinese contact in the nineteenth century. In the latter case, knowledge about China was central to the historiography of contact. This knowledge, in turn, took its place in the China portion of an imperial archive created by the British. My concern, therefore, is with the way in which Rohmer's fiction drew from the archive in order to create plausible fantasies about Chinese ambitions towards the West. To put this another way, I want to treat the Fu-Manchu novels as sites for locating China in broader discourses about problems of global conflict and competition between powerful imperial formations in the last century and a half.

Scholars in postcolonial studies have, of course, pointed to the writings of British authors like Rohmer as embodying more than simply a reflection of colonial era reality. Indeed, the Fu-Manchu stories and the drug panic in postwar Great Britain invite analysis of the relation between the real and the fictional as categories mutually implicated and dependent upon each other. Yet, as productive as such an approach has been among literary critics, it has tended to treat historical records of colonialism as an unproblematic terrain against which imaginary literature can be juxtaposed, rather than interrogating the nature of the real in the imperial archive itself.[4] Placing matters in these terms raises epistemological issues about archives: How would one begin to evaluate the historical status of the knowledge the archive is purported to preserve, or of the archive itself? Moreover, what kinds of epistemological issues are raised when the Fu-Manchu novels are read alongside the China memoirs of Christian missionaries, the trade returns of British consuls, and the travel accounts of British explorers into China's interior? On what grounds could a determination be made that one or another of these sources deserves to be taken more seriously because it produces a purer and more authentic China?

Posing matters in epistemological terms also allows an interrogation of a binary opposition central to the interpretation of nineteenth-century imperial and colonial adventures. Was colonialism a salvation project or simply the logical extension of an aggressive and expansive European capitalism? How do we reconcile, for example, missionary activities in China with the opium trade, particularly when we recognize that both sought to penetrate and re-configure the same body/polity? The moral overtones implicit in these questions have neither disappeared nor been resolved in the debates that have emerged in postcolonial studies. If, however, colonialism is understood as a continuously dual movement of conquest *and* administration – what Deleuze and Guattari have termed deterritorialization and reterritorialization – there may be other ways of thinking through nineteenth-century European colonial expansion. While not abandoning the moral dimension, they may help to break up the either/or binary of conventional interpretation, without losing sight of the particular histories of the missionary enterprise or of the opium trade.

As a way of proceeding, I want to focus attention on deterritorialization and

reterritorialization projects carried out primarily by British agents in China between 1840 and the early twentieth-century advent of Brilliant Chang. What I am particularly interested in is the mundane, everyday processes through which an alien regime decoded and recoded Africa and Asia, and permanently transformed them. Administrative practices are, of course, hardly the stuff of exciting and interesting historical and cultural investigation. Yet they are absolutely critical, I would argue, for understanding the relation between the real and the fictional, between the archives and imaginings of empire. Let me begin, then, with the least exotic aspect of this dull subject: paperwork.

From paperwork to the imperial archive

With only a few noteworthy exceptions,[6] the actual bureaucratic practices (paper shuffling), as opposed to theories about bureaucracy, that created and maintained the British empire have received little scholarly attention. But, as Bruno Latour has observed, 'paper shuffling' is a 'source of essential power' in our world. Why then is the paperwork of empire seldom studied? According to Latour, it 'escapes attention' primarily because 'its materiality is ignored' (1990: 55). Over the last decade, Latour's work has centred on that materiality. Beginning with the way scientific experimentation produces objects in nature through the processing of information on paper (and, more recently, magnetic media), he extended his investigations to include European global expansion from the seventeenth century on. According to Latour, the inscriptions of European explorers and colonial agents also produced objects of analysis; in this case diverse peoples and places. In addition, these signs on paper – drawings, text, numbers and symbols of various kinds – travelled along networks that were superimposed over the material worlds of others and, eventually, were linked through various technologies to collection sites (archives). As such sites, the inscriptions made legible to a planning and administering eye what was once far away and indistinct.[7]

Latour calls the inscriptions that travel through the imperial or colonizing network *immutable mobiles*, a term which captures two crucial senses of the epistemological object produced in the inscriptional networks. Inscriptions are immutable in the sense that they do not alter their character or degenerate as they travel, and in the sense that they can achieve *optical consistency*. Such travelling inscriptions are presentable, legible, scalable and combinable with other similarly constructed items on flat surfaces (for example, Mercator projection maps, census data, commercial reports, notes on natural history and human behaviour). With real subjects and objects in the world translated on to a two-dimensional surface, they could now be manipulated through a limited number of representational devices – English descriptive prose, statistics, tables, charts and maps – to be optically consistent with one another. Once optical consistency was achieved, once the drawings, numbers and descriptions were arranged on a

common surface and in a compatible scale, the immutable could become mobile. On paper, far-away things could be transported to other sites where they could be held in the hands of one person, scanned by their two eyes, reproduced and spread at little cost throughout the networks of empire. It was suddenly possible to gather instances of another time and space in other times and other places. At such sites, the accumulated information allowed work to be planned and man-power to be dispatched. It also allowed authority to collect at the site where the many immutable mobiles converged (Latour, 1990: 26–35).

The collection of immutable mobiles was, however, not in itself sufficient to explain how small-scale inscriptional practices could lead to large-scale domi-nation. In order for collections to have been of use in imperial and colonial pro-jects, they had to be made easily accessible to policy makers. Optical consistency allowed collections to be summarized and cross-referenced. Now they could be further reduced in scale – harder facts were made by turning great volumes of paper into less paper, creating files of files (Latourian cascades), indexes, cata-logues, bibliographies, and bibliographies of bibliographies – so that ever more information could be manipulated by fewer and fewer hands. Latour calls the sites where this summing up occurred *centres of calculation*. Here cartographers, merchants, engineers, jurists and civil servants superimposed, reshuffled, recom-bined and further summarized inscriptions before storing them for future use. (In the context of this study, these sites would include the East India Company's London offices, the Foreign Office, the Royal Asiatic Society's London head-quarters, the British Museum and Library, the Victoria & Albert Museum, and elite university libraries.)

Latour's insistence on following and analysing inscriptional processes has a number of interesting consequences. For one thing, it seems to provide a welcome materialist orientation to the definition of bureaucracy, one that moves us away from the 'rationalizing mind' of Hegel and Weber to the files themselves. Equally important, his refusal to separate the mental from the material leads him to conclude that the files are actually 'totally new phenomena', ones that are hidden from those from whom the inscriptions were exacted (1990: 60).

In redefining epistemology as material practices and directing attention to the fabricated nature of the epistemological objects in the archive, Latour's work intersects with critical scholarship on colonialism. Gayatri Spivak, for example, also questions the epistemological status of the Western archive, specifically that produced by agents of the British East India Company in India. At the same time, Spivak is not only concerned with the decoding of India by Company agents, but also with reterritorialization – the practical means by which India was colonized and transformed by British inscriptional practices. In order to operate within India, British agents had to superimpose an alien coding network over India, one that would allow them to gather what they could process as information and use to manage the Indian scene. For example, to tax agriculture, the British administrators transformed complex use rights to land into private property

rights, and then mobilized a judicial system to enforce such rights.[8] In so doing, they not only indexed the land for calculation purposes but, in the act of doing so, created a new Indian reality. The 'totally new phenomena' that Latour points to were, in effect, fabulous products of the inscriptional-archive project, rather than neutral representations of 'foreign' realities. The 'misreading' of Indian realities was, in turn, sustained by the fiction that there was no slippage between the representational regime of East India Company agents (their decoding of India) and that which they represented. Misreading their fictions as Indian reality produced a collection of 'effects of the real', the most notable being the proper name 'India' itself (Spivak, 1985: 129).

If understood as comments about decoding and recoding procedures, the observations of Latour and Spivak on the epistemological status of the archive suggests that there need not have been any actual fit between the apparatuses of coding and the human/material landscape into which Europeans ventured from the seventeenth century on. As in India, the disjunction in the archive project was elided through the fiction that the fit was close enough, that the reality effects of coding procedures described and organized India effectively.

Of particular interest in this interpretation of the archive is the suggestion that the epistemological project of empire was fundamentally unstable or internally contradictory. Yet, when confronted with contradiction or with a discontinuity between an immutable mobile and the other it was supposed to represent, the reaction was seldom to question epistemological assumptions, but rather to call for more and better administration (better disciplining of the local population, more information, new forms of summarization). Moreover, as the archive grew, contradictions and inconsistencies were further resolved by broadening and expanding the vista of empire (Greenhalgh, 1988).

Thus, beyond the routines of local imperial administration, global representations operated through statements like the 'sun never sets on the British Empire'; or by means of visual imagery such as schoolroom maps filled with red spaces denoting geographical regions under British control.[9] According to Thomas Richards, these sorts of effects of the real were sustained by an imperial imaginary that envisaged the archive as an interface between knowledge and the state. This imaginary then linked information gathering (encyclopedic knowledge of other peoples) to Britain's global pre-eminence. Understood as an interface, Richards argues, 'the archive was less a specific institution than an entire epistemological complex for representing a comprehensive knowledge within the domain of Empire' (1993: 14).

To summarize: by directing attention to an imperial imaginary and to the ways knowledge about the colonial world was produced, Latour, Spivak and Richards shift attention from the correspondence between representations and real objects and from the moral ambivalence of the colonial encounter to the material practices – census-taking, map-making, ethnographic and natural history description, and the collecting and inventorying of these various

inscriptional media – through which the epistemological complex of empire operated. They further argue that what held this complex together were certain fictional or imaginary constructs. These non-empirical aspects of the knowledge-archive-state apparatus were, however, evaded by reference to the obvious success of this epistemological complex in producing useful information about other people, other places and other things; and by ignoring the materiality of the acts that produced that information.

This understanding of the British imperial archive seems particularly useful when confronted with the seemingly heterogenous activities of missionaries, merchants, diplomats, military officials and fiction writers in settings ranging from direct administration of colonized peoples to less formal arrangements on the frontiers of empire. To put this another way, the theorists discussed here allow us to think about British activities in China alongside those of British subjects in Africa, Southeast Asia, India and Central Asia without recourse to quantitative categories such as full colonialism, semi-colonialism, informal empire, or more or less reluctant imperialists. And, as in the more prominent examples of European colonization, they allow us to note that China also had its paper shufflers who created a particular collection of facts matched by fiction, and sustained them with fantasies of total knowledge. British misreadings of Chinese realities helped to generate proper names like China, Brilliant Chang and Fu-Manchu, each of which can be understood as an outcome of the decoding and recoding procedures of what I will call the archive state. In order to retain a focus on a global imaginary, while still exploring the particular coding practices pertinent to China, I will consider those practices in relation to the rivalry involving Russia and Great Britain in Asia, better known in political history circles as the Great Game.

From the Great Game to the archive state

After the defeat of the Sikh armies of the Punjab in 1848,[10] Great Britain found itself engaged with imperial Russia in strategic warfare in the 'Near' and 'Far' East. After a brief flurry of open hostilities from 1854 to 1856 (the Crimean War), Great Britain settled into a war of position designed to check or contain Russian expansion into Central Asia and to protect British interests in the Mediterranean, on the southern edges of Eurasia, and in the eastern provinces of China.[11] As a number of contemporary participants, popularizers of empire like Rudyard Kipling, and some recent historians have observed, this sort of limited warfare was less about muscle and armaments than it was a contest of wits, a Great Game.[12] The game was played out in that vast expanse of territory stretching in an arc from the Amur River region of Manchuria, along the border regions of Mongolia and Chinese Turkestan, to Afghanistan in the southwest.

It was precisely the assertion that Great Game operations required superior

mental, rather than physical capacities, that made an information oriented system of warfare attractive to British imperial strategists. In order to contain Russia, they needed the sort of local knowledge and knowledge about the activities of rivals that epistemological projects had already begun to produce. It is no surprise then that Great Britain, perhaps more than any other imperial power of the nineteenth century, perfected this kind of warfare. Those familiar aspects of European imperialism in Africa and Asia that involved the military occupation of territory and the definition of skirmishes along geographical borders appear of less significance in the context of the subtle practices of the Great Game. Far more important for Great Game strategizing was the construction of immutable mobiles, the building of networks to guarantee their uninhibited flow to centres of calculation, and the capacity to bring power to bear at strategic points when necessary.

Yet, even though the epistemological complex of empire seems to have given the British an edge in the Great Game, efforts to limit Russian advances into Central Asia faced serious obstacles. The map, that premier immutable mobile of European colonial expansion, indicated that bracketing each side of the game board were two older empires – the Ottoman and Chinese or Qing (Ch'ing). As the extensive literature on the 'Eastern Question' indicates, the problem these two empires posed was that both were weak and, if pressed too hard by British or Russian force, capable of collapsing at any moment.[13] From the British perspective, if they did break up, the only conceivable beneficiary was Russia, which (as the map indicated) directly abutted the northern frontiers of each of them. As a consequence, in addition to thickening and lengthening the information-producing network of empire, British imperial strategists also played a delicate game of propping up the Ottoman and Qing empires so that no power vacuum would emerge at either end of Asia to threaten British interests.

In China, this meant that there would be no thoroughgoing deterritorialization and reterritorialization such as occurred in India. Rather, British activities in China were selective; they involved gathering intelligence (decoding) and establishing a limited number of institutions within China that could interface (or recode) political/economic structures with the global network of the British empire.

Decoding China

In order to understand the decoding procedures deployed by British agents in China, it is useful to remind ourselves that none of the participants in these operations was working completely in the dark. For much of the seventeenth and eighteenth centuries a substantial amount of European knowledge about China had been generated by Catholic missionaries in the employ of the Ming and Qing courts, by merchants trading at a limited number of ports on the east China coast, and by members of diplomatic missions sent to the court at Peking. By the nineteenth century, this kind of intelligence had been superseded by a more

scientific form modelled after the Cook voyages to the Pacific at the end of the eighteenth century. According to Marshall and Williams (1982), 'precise empirical knowledge, such as measurements, statistics, thermometer readings, botanical and zoological specimens, or exact plans' were now considered more valuable than reflections upon the similarities and differences between Asian and European societies.[14]

By the 1830s, the trend towards the production of useful empirical knowledge was firmly established in the pages of commercial dictionaries and in the publications of the Royal Society.[15] In China, the British effort to organize knowledge into new empirical categories was spearheaded by the growing number of Protestant missionaries and East India Company officials who, with the aid of native teachers at Canton, began to learn Chinese in the 1820s. In addition to producing grammars, syllabaries and dictionaries, and translating the Bible into Chinese and the Qing legal code into English, they produced a monthly journal, *The Chinese Repository*. Modelled after the journal of the Royal Asiatic Society published in Bengal, the editors of the *Repository* sought to replace the less scientific, and hence suspect knowledge produced by earlier Western writing on China with the more empirically based form described above. Their objective was not only to fill in the new empirical categories of knowledge with fresh data, but to do so by drawing extensively upon Chinese language sources. While the editors granted that they did not expect to find Chinese sources that would rival the arts and sciences or Holy writ of the West, they insisted that China's vast and accessible literate tradition provided a convenient entry point for understanding the human and natural environment of the world's oldest living empire.[16] They asserted, in other words, that another archive, the alien archive of China, would prove to be an invaluable tool in their own epistemological project – and that assertion echoed down through the nineteenth century as a fundamental organizing principle for all those who followed these pioneers.

When the *Repository* began publication, however, the ambitious project outlined by its editors was stymied by the policies of the Qing government. According to most European observers of the time, the Qing sat securely ensconced behind high walls of exclusion, jealous of foreigners and ignorant of the technological advances of the West. It refused all forms of equal exchange, whether commercial, diplomatic or intellectual, and limited all contact with Europeans to the single port of Canton. The first (1840–42) and second (1858–60) opium wars between Great Britain and the Qing changed all that.

After these conflicts, the British imposed treaties that established extraterritorial enclaves or treaty ports[17] along the China coast and gave foreign powers the right to maintain embassies in the imperial capital at Peking. The decoding of China now became centred in new institutions that emerged at these sites – the British legation in Peking, and the various branches of the Imperial Maritime Customs and the Royal Asiatic Society established in treaty ports like Amoy, Ningbo, Shanghai, and at the crown colony of Hong Kong. These institutions may

be understood as local centres of collection, each of which produced paperwork specific to its function in China. The legation, for example, collected data and generated reports on the Qing government's ability to adapt itself to the 'norms' of international relations. The Imperial Maritime Customs decoded Chinese weights, measures and currencies, and generated statistics on Euro-American trade through the treaty ports. The Royal Asiatic Society organized a library of old and new works on China, published empirical research in its journal, and acted as a meeting site for merchants, missionaries and diplomats operating in China. At each site, British subjects created immutable mobiles and invented ways of more efficiently indexing information on China.

At the British Embassy in Peking, for instance, Sir Thomas F. Wade, a diplomat who began his career in China in the early 1840s, gathered together a library of key sources concerning the operation of the Chinese empire historically and geographically. From this library, Wade generated a new kind of immutable mobile. In reports to the foreign office in London, he included research into the Chinese language sources of his library, footnoted citations from them, and added relevant Chinese ideograms in the margins.[18] Wade also helped to accelerate the process of information collecting by compiling grammars and syllabaries on documentary and colloquial Chinese. Widely circulated and reprinted in an abbreviated form in 1905,[19] his primer contained actual Qing government documents, many of which were related to intercourse with the British, and glossaries of documentary terminology.

Wade is perhaps best known, however, for his orthographic efforts, a scheme he devised in the 1870s for standardizing the romanization of Chinese ideograms. Previously, romanization had not only been haphazard, but included efforts to duplicate the different sounds of words in the many dialects spoken on the east coast of China. In contrast, Wade's system was keyed to the language of the Qing court and its officialdom, the four-tone pronunciation of north China referred to in the West as Mandarin. Later modified by Herbert Giles, Wade–Giles romanization became the norm throughout the British empire and in the United States, where it had a vast effect on enhancing optical consistency between various forms of information about China. At a stroke, orthographic regularity made it possible to draw together dictionaries, bibliographies and biographical dictionaries, and to cross-reference them.[20]

Such consistency became all the more important as the volume of information gathered by British agents in China increased with the establishment of new treaty ports after 1860. English consuls were stationed at each of these ports to facilitate British commercial penetration of China. Consular duties included generating commercial intelligence reports, surveying the hinterlands around the ports, compiling trade statistics, and making recommendations about how British commerce could be better developed in their region. The reports circulated back to London and were eventually published in Parliamentary Papers.[21]

As these and other kinds of reporting expanded the China portion of the

imperial archive, they were complemented by translation projects that allowed for more systematic organization of data. For example, well into the 1870s there were no accepted standards for rendering the names of Chinese government offices or the titles of Qing functionaries. William F. Mayers, a member of the British legation in Peking, published *The Chinese Government* (1877) in an effort to eliminate confusion and provide consistency in translation. Drawing upon the *Collected Statutes of the Qing Dynasty (Da Qing huidian)*,[22] a source in which 'every detail of the Chinese polity is anticipated and prescribed for' (p. iv), Mayers included Chinese ideograms and translations for offices and titles at all levels of the Qing bureaucracy. Appendices dealt with forms of official correspondence between the British legation and the newly established Qing foreign office (*Zongli yamen*), the titles in Chinese and English for various kinds of documents, and Chinese renderings of European titles as found in Qing documentary sources. A third edition of this work was revised by British consul G.M.H. Playfair. Playfair's specific contribution was to alter Mayers' orthography, substituting Wade's romanization, thus bringing the book 'into line with the majority of similar works of reference having to do with China' (Mayers 1877: ix).

Playfair also made another kind of contribution to optical consistency. In 1879, he published a geographical dictionary of the cities and towns of China, with longitude and latitude designations, alternative place names from different dynasties, and Chinese characters and cross-references, all of which was indexed by the Wade–Giles system. Based on an earlier work in French by Biot, Playfair's *Cities and Towns of China* added a host of new names drawn from research that appeared in *The Chinese Repository* and, after 1851, in the latter's successor, the *Transactions of the North China Branch of the Royal Asiatic Society*.

At the same time that British diplomatic agents such as Wade, Mayers and Playfair facilitated the creation and collection of immutable Chinese mobiles, new institutions like the Chinese Imperial Maritime Customs (IMC) assembled other kinds of information. The IMC Statistical Department in Shanghai, for example, summarized, usually in annual and decennial reports, the commercial information produced in the treaty ports. It also invented the reporting forms upon which IMC agents inscribed this information, and printed the postage stamps used by the reorganized Imperial Post, an offshoot of the IMC.

One of its members, Hosea B. Morse, published a raft of widely circulated pieces on the new Chinese economy, the segment created by the European presence, all of which was further summarized in his *Trade and Administration of the Chinese Empire* (1908). This work combined maps, statistical tables and IMC documents with a narrative history. Morse also made a study of Chinese commercial guilds (1909), and of Chinese currency, weights, and measures (1906–7 and 1907). The latter publication sorted out regional variations and provided a basis for future 'reform', or the recoding of China by the Chinese themselves.

After he left the IMC, Morse turned his attention to another kind of summary, chronological histories of Sino–British relations. In a multi-volume

work entitled *The Chronicles of the East India Company Trading to China, 1615–1834*, he took numerous bound volumes of parchment, roughly 24 in × 18 in × 6 in in size from the dirty, dusty archives of the East India Company, and reduced them to five easily reproducible volumes.[23] A second multi-volume project, *The International Relations of the Chinese Empire, 1834–1911*, sorted out foreign office records, Parliamentary Papers and memoirs to produce a similar summary and miniaturization. According to Morse's biographer, John K. Fairbank, the significance of these studies was 'to establish chronology and try to get the story accurate and consistent'. Morse's chronology became, in fact, an international standard – even cold war era anti-imperialist historians in the Soviet Union and Communist China found it indispensable.[24]

These many efforts to produce and better organize knowledge about China were complemented by the rapid growth in the publication of firsthand accounts of China in the post-opium war era. In some cases, these publications made their initial appearances as oral presentations at the meetings of the North China Branch of the Royal Asiatic Society in Shanghai, and eventually entered the pages of the Society's journal. An index prepared by Henri Cordier in 1876 indicates the scope of the early years of this part of the decoding operation. Built upon, but vastly expanding the work of *The Chinese Repository*, it capitalized on the unprecedented access which Europeans now had to the Qing empire. In its first two decades of publication, the journal included articles on Chinese law; nautical and meteorological observations along China's eastern seaboard; the natural history of silkworms and birds; cotton and sugar cane production; geology and mineral deposits; music; medical practice and medicines; geography, usually in the form of firsthand accounts of travel into China's interior; history and biography; myth, legends and folklore; translations of ancient stone stele; and information on Chinese manners and customs. Cordier himself maintained a mania for the index, eventually producing two five-volume bibliographies of Western writings on China and Southeast Asia (1904–8 and 1912).

As the scale of the China archive grew, Cordier's bibliographic efforts were complemented by other sorts of summaries. Numerous authors, reviewing the work of their predecessors, recapitulated various aspects of the archive, wrote and rewrote Chinese history, and re-evaluated the contemporary scene. They also produced ever more sophisticated accounts of the Chinese character, and of the place of China in the global strategic concerns of the British empire. The net effect of these efforts was to construct a uniform referential grid of things Chinese, the legibility of which was enhanced by uniform terminology and standardized romanization of Chinese proper names and concepts. These field-of-knowledge effects made it possible to produce consistent indexing in an individual work, to cross-reference works of different authors, and to incorporate ever greater amounts of Chinese nomenclature within a given epistemological object.

The construction of standardized knowledge informed by a referential grid

of indexical sources had, in turn, broader implications. By the last decade of the nineteenth century, optical consistency made institutional and geographic diction-aries accessible to a growing English-speaking and reading audience, multiplied the expanse of the British imaginary of China, organized maps and charts, and filled empty spaces in the taxonomy of the imperial archive, China branch. Now that signs signified a uniform set of proper names of people, places and things, more and more people far removed from the China scene could collect 'authen-tic' information and contribute commentary upon the situation in the East. They could, in other words, look over the shoulder of Arthur Smith as he entered a Chinese village (1899) or reflected on the essences of China, as in his *Chinese Characteristics* (1894). Or they could follow D. Warres Smith into the European settlements in the treaty ports of China as he described local conditions and insti-tutions, and reviewed the commercial returns of the Imperial Maritime Customs (1900). Or they could draw back and become armchair Great Gamesmen with D. C. Boulger (1879, 1885 and 1893), A. R. Colquhoun (1898 and 1900), and Alexis Krausse (1900a, b and 1903), whose ever 'vigilant and scrutinizing eye[s]'[25] analysed published summaries of the archive project to uncover Russian machi-nations in eastern Asia and evaluate the condition of the Chinese empire.[26]

As a result of a little more than half a century of dedicated work, English-men could now hold China in the palms of their hands, scan it, and claim they understood it – an alien empire had been decoded, classified, summarized, and, as a result, was known as it had never been known before.

Recoding China

The ability to produce such knowledge was not exclusively a function of decod-ing, however. At the same time as the epistemological project was creating immutable mobiles, its agents were laying their own alien networks over China. These networks, made up of missionary, commercial and diplomatic enter-prises, functioned in two ways. On the one hand, they provided secure channels along which information could flow. On the other, through replication (identi-cal structures laid over newly opened territory), they penetrated deeper into China, selectively recoding the local and linking these new formations to the global.

The Imperial Maritime Customs, mentioned above, was one such recoding mechanism.[27] Originally created in the late 1850s when the Qing government appeared on the verge of collapse as a result of the Taiping Rebellion, the Customs was designed to ensure the maintenance of treaty provisions involving tariffs on foreign goods imported into China. After becoming a formal part of the Qing administrative structure in the 1860s, its director, British subject Sir Robert Hart, began to expand its reach beyond the collection of tariffs. From its unique position as both part of and alien to its host, the IMC did the book-keeping, printed the identification tags and generated all the other pieces of paper

that captured Chinese and foreign things and allowed them to exchange. In addition, the IMC opened new treaty ports; organized China's coastline on the European navigational model with lighthouses, buoys, etc.; directed the building of port facilities based on 'international' standards; and encouraged the spread of its book-keeping methods into other areas of Qing administration. These various efforts were complemented by the IMC's education department, which established a school for training Chinese interpreters of European languages and translating European language works into Chinese.[28] Finally, its statistical bureau helped to integrate China into the global capitalist economy of the late nineteenth century. By the end of the century, the IMC oversaw treaty port operations in every major coastal city of China, as far north as the Amur River in Manchuria, deep into central China along the Yangzi River, in the southeast on the West River, and in Yunnan close to the borders of Burma and Vietnam.[29] It became so indispensable an agency for the 'Westernization' of China that after the fall of the Qing dynasty in 1911, the IMC continued operations as the Chinese Maritime Customs until the Communist revolution of 1949.

While the IMC was recoding China from inside the Qing administration, other coding operations sought to firmly link coastal and interior China via the treaty ports to Europe and North America. The missionary enterprise, which combined educational and medical missions with proselytizing, is probably the best known among these recoding operations, but there were others as well. The North China Branch of the Royal Asiatic Society linked the foreign community in China and Westernizing Chinese to the network of Asiatic Societies that culminated in London. There were also organizations such as the Society for the Diffusion of Useful Knowledge, the Society for the Diffusion of Christian and General Knowledge Among the Chinese, and the Young Men's Christian Association, to say nothing of commercial banks and trading firms, each of which reorganized Chinese reality and connected the resulting forms to global networks. At different points in their lives, Europeans (and, by the end of the century, reformed Chinese) might touch down at different nodes in these networks, sometimes decoding and sometimes recoding China. H. B. Morse, for example, was a member of each of the associations in China mentioned above. When he retired to England after 1909, he joined the Council of the Royal Asiatic Society, the Committee of the China Association, the Royal Geographic Society and the Royal Societies Club, serving in many cases in an executive capacity in one or another of them.

In this way, parallel or overlapping networks were integrated horizontally, recoding China as effectively as any gunboat deployed during the opium wars, while they also accelerated the accumulation of immutable mobiles and the summarization of information on China. The nodal points in these networks were not only prime sites for the display and circulation of new knowledge but themselves helped to lengthen networks, making it possible to envision the gradual achievement of comprehensive knowledge about China and the Chinese.

Spectres in the archive

If the epistemological empire created by the archive state was designed to manip-
ulate native populations and penetrate new regions while warding off rivals, spec-
tres, Thomas Richards tells us, nevertheless haunted the project; some of these
phantasms were at the imperial centre, others on the periphery of empire (1993:
43–4, 57). At the centre, the policy-making apparatus of empire found it diffi-
cult to keep up with the activities of its subordinate parts: the work of summar-
izing and indexing information lagged behind the production of new knowledge
by field agents, while sub-centres of calculation might employ their own methods
for indexing and storing information independent of their related parts.[30] As a
result, new knowledge was often literally misplaced or forgotten at cavernous
collection sites and collateral storage facilities.[31] Temporal lag and inconsistent
filing meant that the centre occasionally found itself working at cross-purposes
with its agents on the frontiers of empire. This disjunction led at times to
moments of panic-stricken disavowal or conflict between field agents and policy
makers in London.[32]

The archive state was also affected by a fundamental contradiction in its
effort to create an epistemological empire. As decoding and recoding networks
spread, technological change accelerated processes of circulation and collection.
Thus even as the archive state strove to produce total knowledge, even as more
and more 'reality' captured by the coding networks was being reduced to two-
dimensional surfaces, knowledge itself increasingly appeared to be transitory
(Matsuda, 1996: 11). This not only raised the spectre of epistemological rela-
tivism, but suggested a kind of constant deferral of the ultimate goal of the
project, making knowledge producers and indexers little more than worker bees
in a seemingly endless process of collecting and filing.

As doubts, uncertainties and perhaps even boredom crept into the archive
project, an even more disturbing spectre began to take shape. What if a similar
project, an alien archive, were to solve the contradiction between certainty and
acceleration, and do so by combining its own properties with those of the
imperial archive? The resulting combinations might subvert or pollute the British
epistemological networks, either severing connections between the centre and
its peripheries or creating suspicion about the quality of information on the
network. And, since the archive was imagined as the interface between know-
ledge and the imperial state, the entire empire was at risk if the archive's network
was compromised.

A fourth set of problems had to do with the unevenness of the spatial dis-
persion of the epistemological empire. By this I mean that the knowledge pro-
duced by the archive state was not evenly spread across the terrain, nor
completely accessible to the stratified population of the empire. To be sure, by
the late nineteenth century, there were new kinds of host sites to display and
summarize the immutable mobiles produced by field agents – international

expositions, public museums and libraries, new journals of opinion, illustrated newspapers and children's books, plus a growing number of novels with empire as their theme – but the content of representation at each of these venues was not only diverse, but cross-cut with historically shifting signs of race, class and gender. This meant that the subjects of empire experienced otherness in a wide variety of ways, opening the possibility that some, especially those with questionable mental capacities, might, like those under the influence of Brilliant Chang, be attracted to rather than repelled by otherness. Preventing this sort of pollution became, as a result, a critical element for maintaining the integrity of the archive state.

Apprehensions about the stability of imperial networks resonated with more widely diffused fears of hybridity,[33] creating among other things anxieties over the wholesomeness of elements flowing through the coding networks. Great Britain's links to China provide a case in point. Since at least the end of the eighteenth century, when the opium trade with China increased and opium became more widely available in England, apprehensions had been voiced over a possible backlash to the British presence in China. These concerns became even more plausible when British military forces broke open China's doors in 1840 and 1860 to protect the opium trade. By the second half of the century, the small Chinese migrant community in London could raise spectres of clever 'Chinamen' using opium as a means for retaliation against British aggression. Meanwhile, the growth of the 'Coolie' trade in British colonies fuelled 'Yellow Peril' anxieties, conjuring visions of the imperial network being flooded and overwhelmed by Asiatic hoards.[34] These various concerns were kept alive in the tabloid press, in the publications of organizations like the Anti-Opium League, and in popular literature; and gained additional credibility after attacks on Christian missionaries in China in 1870. Among other things, the real and imagined reversal of flows on the imperial networks suggested that unanticipated 'mutations' were appearing on the periphery of empire, ones which held the potential for haunting the archive state in any number of ways.

At the same time, the very fact that China seemed impotent in the face of British military and technological power led to apprehensions over the possible collapse and dismemberment of the Qing empire. Adding credence to these concerns were a series of Chinese military disasters – defeat by France in 1884 and Japan (!) in 1895 – and the Russian push across Siberia which culminated in the construction of a rail line linking Vladivostok to Moscow. According to one Great Gamesman, these events effectively shifted 'the centre of gravity . . . of the whole political world' (Michie, 1893a: 635). By 1900, a rich literature, combining its own decodings of the Russian empire with knowledge produced by the China-based network, tied British–Russian Great Game rivalries in Central Asia directly to the Far East.[35] Many of these publications also focused on the possibility of a Russian takeover of Manchuria and north China, and the consequences for the British empire in Asia. Such concerns were, in turn, predicated on having

identified a number of Oriental characteristics that the Russians shared with the Chinese, conjuring up visions of an atavistic oriental despotism dangerously fused with modern technology.[36] Thus, at virtually the same moment that Englishmen could most conveniently hold China in the palms of their hands, spectres of hybridity, relativism, alien archives, Chinese vengeance and Russian grand designs in eastern Asia imperilled the British project in the Qing empire. They also provided fertile ground for nightmares of popular writing like Brilliant Chang, or Fu-Manchu, the 'specter out of the east'.[37]

Fu-Manchu and the apotheosis of the alien archive

It is with these overdetermined imaginings and the powerful modes of cultural production to which they were tied that we may begin to understand the nature of the threat Fu-Manchu posed to the archive state. Spawned in the feverish imagination of Sax Rohmer, and the central and shadowy figure in thirteen of his novels published between 1913 and 1959, Fu-Manchu has functioned for much of this century as the very embodiment of deep-seated anxieties over global cross-cultural relations. For many Europeans and Americans, he has stood as the sign of a world fundamentally, and perhaps irreconcilably, divided between East and West. As Nayland Smith, Rohmer's protagonist put it, Fu-Manchu was not only 'the yellow peril incarnate in one man' (Rohmer, 1913: 17), he threatened to inundate the West with even greater numbers of yellow, black and brown aliens than had already made their way there.[38] Yet, as powerful as this racial imagery might appear, it is in itself insufficient to explain how Fu-Manchu could become such a dominant iconic figure in the Euro-American imaginary about Asia.[39] In order to explore both the magnitude of Fu-Manchu's threat and his ongoing emblematic significance, it might be worth cataloguing some of the structural elements around which Rohmer organized the first four Fu-Manchu novels (1913, 1916, 1917 and 1930). My specific concerns will be with those aspects of these works that seem to have some connection to the archive state and its projects.

Let me begin with Fu-Manchu's Chineseness. Like other members of his 'race', he was clever, cunning, insensitive to his own pain and that of others, cruel, industrious and pragmatic. In addition to these racial characteristics associated with all 'Chinamen', Fu-Manchu was also well educated, sophisticated, aloof, arrogant, and convinced, in spite of the many military defeats suffered at the hands of Western powers, of his own and China's superiority. He was, in other words, an almost perfect copy of the upper-class 'Mandarin', the antagonist of upright Englishmen generated in the reports of diplomats, consuls and Imperial Maritime Customs agents, and in the flood of accounts and reminiscences that poured out of China after 1860.[40] And, like other members of imperial China's ruling elite, he was decadent, addicted to opium, capable of

disarming charm, a confusing mix of feminine and masculine features, an hon-
ourable man of his word, and susceptible to the 'childish trifles which sway the
life of intellectual China' (Rohmer, 1916: 79).

At the same time, however, Fu-Manchu (not unlike Brilliant Chang) was
different from the old ruling class and from ordinary 'Chinamen'. What separ-
ated him from his race and class, as well as from Englishmen, was his command
of esoteric Eastern knowledge[41] (for example, 'Indo-Chinese jugglery,' sorcery
(Rohmer, 1917: 138)) and modern Western scientific knowledge (Rohmer,
1913: 16–17), the combination of which gave him unique powers over nature,
making him 'seemingly . . . immune from natural laws' (Rohmer, 1917: 49). As
a result of this combination, the danger which Fu-Manchu posed was more dis-
turbing than the classic European fantasy of barbarian invasions from the East and
more profound than an inundation of cheap Chinese labour into Europe and
North America. His fusion of Eastern and Western knowledge had the potential
to undermine the structure of empire and of global white supremacy, and could
conceivably topple the British and other Western empires like a row of domi-
noes.

This universalist and totalizing dimension of the Fu-Manchu challenge is
extremely important. It not only mimics the archive project and fears for its
safety, it points directly to a common 'misreading' of China produced by the
project. This is the notion that since historically the Chinese empire saw itself as
the 'Middle Kingdom', the centre of the universe, the Chinese emperor must
also claim to rule the entire world. Such pretensions could be contrasted with
the Westernizing republican nation-state that had been established in Nanjing in
1912. This new China was not 'the China of '98' (Rohmer, 1913: 49), the arro-
gant empire that European powers carved up into spheres of influence at the end
of the nineteenth century, but rather an awakened China that was setting out on
a path of reform and modernization. Fu-Manchu was not, however, part of this
reform movement. Rather, he was a throwback, a Mandarin of imperial China,
and as such he sought retribution against those who humiliated and degraded the
Chinese empire. His project was, in other words, to restore the old order and
expand its dominion; he wanted to create 'a universal Yellow empire' (Rohmer,
1916: 162), first by absorbing Russia and then the Asian and African empire of
Great Britain, thereby reversing the direction of flows of the epistemological
empire and ending the Great Game.

At his disposal for reconstituting empire were two primary instruments. The
first of these was a secret organization called the Si-Fan, 'the greatest mystery of
the mysterious East', which he headed.[42] The second was Fu-Manchu's head
itself, that is, his extraordinary mental capacities. The Si-Fan, according to
Nayland Smith, was 'hidden behind a veil of Lamaism . . . a sort of Eleusian
Mystery holding some kind of dominion over the Eastern mind, and boasting ini-
tiates throughout the Orient' (Rohmer, 1917: 67). It was also a kind of central
intelligence agency over which Fu-Manchu operated as a spy-master. In this

capacity he organized his conspiracy through a number of fronts, all of which drew on the rich imagery of Asian and African malcontents within or bordering the British empire. They included fanatical Muslim fundamentalist sects, drug-smuggling criminal organizations, more conventional Chinese secret societies, and a host of anti-British fanatics, such as Kali-worshipping Indian Thuggees and acrobatic Burmese robber-assassins called Dacoits.[43]

Through these agencies, Fu-Manchu delivered a threat that was local and immediate – he invaded London, the imperial centre *par excellence*. And, although the terrain was familiar, Rohmer's protagonists seldom felt comfortably at home. Literally working beneath and on the margins of the imperial centre, Fu-Manchu was able to transform London into a fantastical and horrific alien space. Mobilizing dark and mysterious powers, he induced in those with whom he struggled dream states, 'horrible phantasmagoria', waking dreams and 'subjective hallucinations'. As reality distorted, paragons of empire like Nayland Smith and Dr Petrie found it increasingly difficult to separate illusion from fact, thus creating in them a profound sense of epistemological crisis.[44]

The ability to cause this confusion, to destabilize white male rationality was, in turn, a function of Fu-Manchu's unusual mental capacities. He was more than a master of ancient oriental science, more than a clever Chinaman, and more than a manipulator of various sorts of drugs. He also possessed a prodigious knowledge of Western science, which he learned at European universities – and he sought more! In order to gain more knowledge, he first secretly infiltrated the colonial periphery of the British empire and then the imperial centre itself. In London, he set about (1) assassinating those who had suspicions about what he was up to; and (2) (this, I think, is perhaps the most wonderful part of Sax Rohmer's mania) kidnapping the greatest scientists of the age and transporting them back to the 'head centre', where their knowledge was to be extracted from them![45]

Such monstrous schemes were, moreover, the product of a mental genius who was anything but normal. Through the fusion of ancient and modern knowledge, Fu-Manchu had been able to physically transform himself, to induce a kind of mutation. His unusually large head and emerald-green eyes, central signs of his mutation, testified to the fact that he had not only learned how to manipulate opium and other mind-altering drugs, but had been able to do so in order to enhance his already formidable mental capacities! He then used his mutant brain to unlock other secrets of nature and to create additional frightening monstrosities like himself.[46]

Fu-Manchu's extraordinary mental capacities are only one aspect of the epistemological obsessions that suffuse Rohmer's novels. Repeatedly, he directed attention to kinds of knowledge, to the necessity for secrecy and covert knowledge, to how knowledge is produced, to the dangers of disseminating certain kinds of knowledge, to the risks inherent in having *knowledge* (1930: 69), and to the shortage of knowledge about Fu-Manchu's plans (1917: 123). The resulting

contest over and the mutual obsession of protagonists and antagonists for knowledge produced an overwhelming sense of crisis, of epistemological para- noia, re-enforcing the need for secrecy and the collection of more information. It is telling, in this respect, that Nayland Smith was always able to keep the activi- ties of Fu-Manchu and the stratagems he himself directed against the latter out of the newspapers, and generally in the realm of the 'need to know'. And he did this as an agent of the archive state.

As the sheer breadth and depth of Fu-Manchu's conspiracy unfolds from one novel to the next, Nayland Smith must alter his assessment of the threat the British empire faces. At first he argues that contrary to appearances, Fu-Manchu was not the head-centre of whatever schemes might presently be afoot. Nor, as noted earlier, was Fu-Manchu part of the Young China Movement. Rather he was the extension, the advance agent, of a 'huge secret machine', a 'Third Party' (Rohmer, 1913: 155), the Si-Fan headquartered high above India and China in the vastness of Tibet.[47] Later Smith must revise this assessment when it becomes clear that the existence of a higher leader was another of Fu-Manchu's clever arti- fices.

Such decodings of Fu-Manchu's conspiracies served to establish a powerful link between Rohmer's narrative and the machinations of the Great Game, British interests in Tibet, and the threat an alien archive poses to Britain's actual epistemological empire.[48] In the latter case, whereas such concerns were usually associated with the secret activities of Britain's rivals on the Continent, the Fu- Manchu narrative centres on the possibility of an alien archive that has suddenly awakened after a prolonged oriental slumber and is attempting to alter the direc- tion of the Great Game. As embodied in the figure of Fu-Manchu, the alien archive is not content to remain simply oriental; it is also working to transform itself by absorbing other archives, encompassing their networks, and thereby reversing the flow of information. It would then add modern technological knowledge to its own ancient and secret store of knowledge (much of which had yet to be decoded by British agents) and thereby create an almost undefeatable adversary for the archive state.

Plots like these involving nefarious conspiracies by people of colour and puzzle-solving by white males were not unique to Sax Rohmer. This particular imaginary is, however, peculiar precisely because it is not reducible either to Yellow Peril anxieties or to Asia in general. A suddenly awakened China becomes in Rohmer's hands a supreme threat to British mastery in Asia. This assertion was, in turn, made credible by widely diffused anxieties over Chinese revenge for the opium trade and opium wars. They also gained validity from the fact that the network of empire allowed bidirectional flows, from fears over the dissemi- nation of technologies and technological knowledge to the non-white races, and from the permanent state of hot and cold war that empire seemed to entail. In such an atmosphere, it was perhaps not too difficult to imagine or believe in Chinese conspiracies or in the possibility that some clever oriental might fuse

ancient and modern scientific knowledge. From there it was a short step to conjuring a China that could lead the Orient against Western empires, first pushing out Great Gamesmen, then entire colonial administrations from Asia, and rolling Europe back to the tiny peninsula it historically occupied on the isolated edge of the enormous Eurasian landmass.

From the alien archive to cold war containment

If Fu-Manchu is understood as a product of early twentieth-century British fears projected on to China, he is also something more. By working the symbolically rich representations of China-knowledge and Great Gamesmanship into the structure of the Fu-Manchu stories, Rohmer literally fixed a set of narrative elements that became staples in the succession of paranoid fantasies that have sustained the archive state in this century.[49] Threats would always be total, the prize would always be the world, victories would never be complete, the danger could never be entirely eliminated. Fu-Manchu could be shot through his prodigious brain at the end of one novel and return restored in the next.

The state of apprehension that such horrific possibilities engender is not unlike the postwar drug panic that gripped England in the early 1920s. Such anxieties have become a part of our collective culture, infusing the descendants of the British imperial archive – the United States and its North Atlantic allies – with a permanent sense of unease, of a world perpetually on the brink of chaos, of an endless repetition of global crises. Who among us can recall when there wasn't a cold war? Or when there wasn't a state of emergency? Or when Asia didn't pose a global threat? When wasn't the sense of secret conspiracy a normal part of the rhetoric of the archive state or deeply embedded in popular culture? From the plots of Ming the Merciless in Alex Raymond's *Flash Gordon*[50] to the Japanese conspiracy for world domination uncovered by Jimmy Cagney in *Blood on the Sun* to Ian Fleming's *Dr. No*, the fusion of the archive project with a modernizing oriental menace has been a staple in popular consciousness.[51] And the plot has seldom changed – mind manipulation, deadly mutant technologies, underground invasions and horrid, merciless weapons of mass destruction eternally return.[52]

With the creation of the People's Republic of China in 1950 and the explosion of a Chinese atomic bomb a little over a decade later, fears of a modernizing China were reinvigorated. In the process, the Fu-Manchu narrative returned to animate the culture of the most recent cold war and its global anti-communist crusade. In this climate, the insidious doctor replicated himself; his avatars continued the assault against the sanity and ingenuity of white men. In the novel and movie *The Manchurian Candidate*, American POWs in Korea have their brains 'washed' and 'dry-cleaned' by a Chinese Communist Pavlovian psychologist who, 'smiling like Fu-Manchu', makes them 'commit acts too

unspeakable to cite' here.[53] In the film *Battle Beneath the Earth* (1967), the Red Army, led by a Mandarin-like figure, created an atomic power drilling device that was used to tunnel under the Pacific Ocean and all the major cities and military installations in the United States. During the Vietnam War, Wo Fat, a Chinese Communist agent, spun one global conspiracy after another, only to be foiled by Nayland Smith's reincarnation, *Hawaii Five-O's* Steve McGarrett.[54]

At the same time, in a literal reversal of the history of Sino–Western contact, Milt Caniff's *Steve Canyon*, witnesses before the Senate Judiciary Committee, and a host of 'authoritative' publications, including ones by the head of the Federal Bureau of Narcotics and a representative of the American Federation of Labor in Asia, charged that Red China had become the centre of the international opium and heroin trade. The goal: to poison the West with drugs as a means of global supremacy.[55] In an atmosphere rich in symbolic demonology, fears of pollution and mania over Red Chinese science, Fu-Manchu himself returned in five British-made films between 1965 and 1968.[56]

More recently, following the collapse of the Soviet Union and renewed interest in the history of the Great Game (Hopkirk, 1992, 1995), familiar tropes from the Fu-Manchu corpus provide helpful ways to represent the threat post-Mao China poses to the West. High atop his John M. Olin Foundation chair at Harvard University, Samuel P. Huntington has a waking nightmare of the 'Clash of Civilizations', of a 'Confucian–Islamic' alliance which, armed with home-made conventional and nuclear weapons and outside the rule of law, threatens Western civilization.[57] Meanwhile in his novel *Pax Pacifica*, Tom Clancy's collaborator Steve Pieczenik worries about the consequences of China's 'Middle Kingdom Complex' becoming fused with advanced technology and a dynamic economy. As Sax Rohmer might have put it, 'China versus America is really a contest between which moral, ethical, and religious philosophy will dominate the world – Oriental or Occidental' (Pieczenik, 1995: 153).[58] Others, such as Richard Bernstein and Ross Munro, raise the spectre of a 'coming conflict' between the United States and an expansive China with sophisticated military technology (1997).

All these writers suggest that the cold war has hardly ended, that containment of an oriental peril is still necessary, and that more and better knowledge is needed to defend against the new Chinese threat. Thus, just as the Chinese mind constructed by diligent British agents in nineteenth-century China remains relatively stable, so does the project of the archive state. Monotonously linked together, they produce a seemingly interminable repetition of Rohmer's endlessly repeated scenario – the danger of an alien archive and the necessity for determined efforts to contain it. Even those who may balk at Fu-Manchu revivalism and who are aware of the history of Western imperialism in Asia can only conclude that the Chinese must be shown that there is 'no profit in expansion'.[59]

Rohmerian discourse seems, therefore, to be firmly grounded in the material practices of the archive state and in the knowledge its epistemological network

produced about China. Comprised of a collection of unimpeachable Chinese behaviour patterns – clever, cruel, anti-foreign, arrogant – discerned in immutable mobiles sent from China, Fu-Manchu was a virtual child of the China branch of Great Britain's epistemological empire. As such, it is difficult to imagine Rohmer's invention independently of the imperial archive and the Great Game. It is also difficult to imagine the archive without Fu-Manchu. Rohmer's creation might be understood as an objective – and all too necessary – hallucination produced by the archive itself, a kind of self-haunting that was generated at the interface between knowledge and the state. In this sense, the phantoms of the archive that Richards points to are no more than a product of the archive state's mania for total knowledge – an obsession which served, in turn, to re-configure the relationship between the realities of empire and fantasies about global administration, and to propel it and its border disputes through the twentieth century.

Notes

1 See Berridge and Edwards, 1981; Milligan, 1995; Parssinen, 1983.
2 This description of the drug panic in Great Britain is taken from Kohn (1992). In a sensationalized history of Soho written in 1956, Arthur Tietjen wrote: 'Chang possessed a strangely macabre – some said hypnotic – power to persuade women to sniff cocaine. It may well have been that he did so as a member of the yellow race to degrade white women.' See Kohn, 1992: 173. On Chang see also Parssinen, 1983: 169–72.
3 In this case, the issue was how to deal with a modern-looking Asian male whose appeal might have been more than simply that of a conduit for forbidden drugs.
4 White raises this issue in terms of all historical archives; see 1978: 125–6.
5 Deleuze and Guattari, 1977 and 1988. Here I follow Young (1995: 166–72).
6 See Guha, 1943 and essays in Cohn, 1987 and 1996.
7 In developing the notion of networks, Latour draws upon the works of Deleuze and Guattari cited above. For further elaboration, see Latour, 1993.
8 See B. Cohn, 'From Indian status to British contract' (1987).
9 Some historical maps still have British 'possessions' in red or shades of red. The ones in the classrooms where I teach are from the Rand McNally World History Series. The map of the world in 1900, edited by R. R. Palmer and Charles E. Nowell, denotes the British empire in a shade somewhere between red and hot pink.
10 Known in British imperial history as the Second Sikh War, the conquest of the Punjab extended the British Indian empire to the borders of Afghanistan. See Farwell, 1972: 37–60.
11 The literature on Russian–British rivalry in Asia is extensive. The classic articulation of the British position can be found in Rawlinson (1875) and

Boulger (1879 and 1885). The most recent study is Hopkirk (1992). Less studied has been Russian–Chinese rivalries in Central Asia; see Clubb, 1971.

12 Edwardes (1975: vii) attributes Arthur Conolly, who was himself killed in Afghanistan, with coining the term.

13 Geographically, the territory comprising the 'Eastern Question' seems to have extended from the Balkans to Japan. Anderson (1966) provides a useful overview. In 1939, Kerner published a two-volume bibliography of works on eastern Asia alone.

14 1982: 70, 83. For a summary of forms of knowledge diffusion in eighteenth-century England and the organization of knowledge about China in the same period, see pp. 45–61 and 78–98.

15 For some examples see Hevia, 1995, n 6.

16 *The Chinese Repository*, 1.1 (May 1832): 1–5. The *Repository* was published from 1832 to 1851; it included articles on the geography of the Qing empire, Chinese human and natural history, language and literature, trade and commerce, foreign relations, and beliefs. In addition, the monthly published a steady stream of articles on Chinese character and behaviour, and on the opium trade and the effects of opium consumption.

17 Extraterritoriality meant that no matter what crimes Englishmen might commit in China, they and other Westerners could not be tried in a Chinese court of law. Prior to the first Anglo-Chinese war, European traders and diplomats were only allowed to reside at the Portuguese colony of Macao. The treaties allowed European residence in five ports and eventually expanded to over twenty.

18 For an overview of the library and additional details on the form of Wade's reports see Hevia, 1995: 7–8 and 13–14. After he retired from the diplomatic corps and took a chair in Chinese studies at Cambridge University, Wade's books became the backbone of the Chinese language collection in the University's library.

19 The original was published in London in 1867 under the title *Wenjian zier ji* [Series of Papers selected as Specimens of Documentary Chinese]. It was reprinted in shorter form by Kelly & Walsh of Shanghai, a publisher which from the late nineteenth century on acted as a distributer of new China-based knowledge.

20 Wade–Giles is still used as a standard for library card catalogues in the United States. Recently, the British Library converted to the romanization system invented in the People's Republic of China known as Hanyu pinyin.

21 The reports began to be produced on an annual basis in 1860, and carried a standard set of categories by 1870. See *British Parliamentary Papers*, various years.

22 The *Statutes*, a standard official handbook of institutions, titles and dynastic codes, was edited and revised in successive reigns of the Qing emperors. It is unclear which edition Mayers relied upon.

23 I doubt if there are many libraries or research universities in the United States or Europe that do not contain a set of these invaluable books.

24 See Fairbank *et al.*, 1995: 224, 226. This is a collective biography of Morse's life and includes material on his retirement years in England (discussed below).
25 The quotation comes from Sir Henry Rawlinson (1875: 203).
26 Occasionally, like Colquhoun, they journeyed from western Russia to Peking, providing eyewitness accounts of developments in the region. See Colquhoun, 1898.
27 For a history of the beginnings of this peculiar institution see Fairbank, 1953.
28 Known in Chinese as the *Tongwen guan*, the translation school was run by the American missionary W. A. P. Martin between 1869 and 1900. See Covell (1978: 170–86) for an overview.
29 For a map of the treaty ports in China, see Fairbank, 1992: 202.
30 Diversity of filing systems is quite evident today in the remnants of the now defunct British imperial archive. Any perusal of records in, for instance, the Public Records Office indicates the replacement over time of one indexing system with another. If my own archival burrowing efforts are any indication, when systemic changes were introduced, some files were 'lost' – not necessarily in a physical sense, but because they were not properly recoded, and so could not be retrieved.
31 The final shot in *Raiders of the Lost Ark* captured this point quite well. Warehousing continues to be a feature of institutions such as the Victoria & Albert and British Museums in London, while the British Library has numerous satellite storage facilities for its collection. Occasionally, items just go missing.
32 Wade is a case in point; he often ran well ahead of the more cautious imperial centre in imagining and fashioning policy, and was eventually recalled as a result. On Wade's recall and conflicts with the Foreign office see Cooley,1981: 135, and Hevia, 1995. Other examples relevant to this study include the situation involving British India, Russia and Afghanistan in the 1870s discussed by Eldridge, 1973: 200–5.
33 On hybridity, see Young, 1995, especially pp. 1–28.
34 On the trade in Chinese labour, see Campbell, 1923. Snow recounts a panic that ensued in South Africa when Chinese labourers mixed with Africans, raising fears of a super race; see 1988: 45–55. On Yellow Peril anxieties in the American context, see Isaacs, 1958 and McClellen, 1971: 235–6.
35 This literature began as early as 1864 with the publication of Alexander Michie's *The Siberian Overland Route from Peking to Petersburg*. Thirty years later, Michie would still be writing about Russian threats in the pages of *Blackwood's Edinburgh Magazine* (1893a and b). Michie's observations were updated by, among others, Colquhoun, who made the trip from the opposite direction, but this time by train (1900). See also the bibliography under Boulger and Krausse.
36 In a section appended to the American edition of D. C. Boulger's *China* (1893), Hazeltine argued that Russians were at bottom more than half Asiatic and concluded that they were reversing the conquests of the Mongols with the goal of making the Tzar emperor of China (1893: 534, 540). Michie made similar

observations, while warning about a link between despotism and technology (1893a: 633–4).

37 The phrase is used on the back cover of the 1975 Pyramid reprint of the first novel, *The Insidious Dr. Fu-Manchu*.

38 See Rohmer (1916: 62) for a particularly distasteful description of a multi-ethnic London. A comparison between rats from merchant vessels docked in London and humans from Africa and Asia is drawn in Rohmer (1917: 99–103).

39 See Isaacs (1980, especially pp. 86, 116–22) and Moy (1993) on Fu-Manchu's staying power.

40 I take up British characterizations of China's ruling elite in Hevia, 1995.

41 These seem to include Daoist alchemy and Lamaist sorcery. On the latter, see Rohmer, 1917: 130–8.

42 This and the next quote are in Rohmer 1917: 8 and 19.

43 By 1930, the Si-Fan is said to control the global underworld; see Rohmer, 1930: 88–9.

44 All the novels considered here are rich in description of such states, but the general pattern is nicely laid out in the first one; see Rohmer, 1913: 82–92.

45 See Rohmer, 1913: 140, 154, 168. In the second novel, Fu-Manchu nearly succeeds in spiriting off Dr Petrie, Nayland Smith's Watson; see Rohmer, 1916: 106–10.

46 See the exchange with Petrie about opium in Rohmer, 1913: 87–8; see also 1936: 113.

47 Si-Fan is one among other Chinese words for Tibet.

48 In addition to locating the headquarters of the Si-Fan in Tibet, there are other references that make Great Game links. In the third novel, for instance, Fu-Manchu's daughter appears. She is the child of a Russian mother and has designs on uniting China and Russia; see Rohmer, 1930: 104, 189.

49 Rohmer's novels remain in publication to the present. In the 1920s and 1930s, new ones were serialized in *Collier's* magazine.

50 This particular variation was so powerful that it was honoured on a United States commemorative postage stamp in 1995. Quite appropriately, Ming the Merciless occupies the entire foreground of the design.

51 John F. Kennedy, it will be recalled, loved James Bond. See Nadel, 1995: 157. Like thousands of other teenage boys in the early 1960s, I was part of the James Bond fad and saw each of the first three movies more than once when they were initially released.

52 British fears of underground invasions went back at least to discussions of a channel tunnel in the 1880s; see Pick, 1993.

53 In the film, Yen Lo, the psychologist, brags about his power over the American mind, while Major Marco makes the link to Fu-Manchu and unspeakable acts. Richard Condon's 1959 novel also has certain similarities to Rohmer (1936).

54 Parenthetically, Khigh Dhiegh, who played the parts of the oriental mastermind in *The Manchurian Candidate* and *Hawaii Five-O*, seems to have obtained

little work following diplomatic recognition between the United States and the People's Republic of China in 1978. However, he re-emerged briefly after the 4 June 1989 Beijing massacre as the heartless party secretary in the made-for-television version of the Liang Heng-Judith Shapiro romance, *China Nights*.

55　See Caniff, 1987: 118, 127; *Hearings before the Subcommittee on the Improvements in the Federal Criminal Code of the Committee in the Judiciary, U.S. Senate, 84th Congress*, 1955, especially v. 3: 739 and v. 8: 3894–9; Anslinger and Tompkins, 1953: 10–11; and Deverall, 1954. In his masterful study of the heroin trade, McCoy demolishes the allegations made in these works. They were not simply anti-communist propaganda, but more than likely part of CIA disinformation campaigns designed to protect its network of agents, some of whom happened to be engaged in the drug trade. See McCoy, 1973, especially pp. 145–7.

56　They were *The Face of Fu-Manchu* (1965), *The Brides of Fu-Manchu* (1966), *The Vengeance of Fu-Manchu* (1968), *The Blood of Fu-Manchu* (1968), and *The Castle of Fu-Manchu* (1968).

57　In the original piece that eventually resulted in a book, Huntington placed a question mark in his title (1993). By 1996, whatever doubts he may have had seem to have disappeared.

58　Actually, Rohmer more or less did put it this way; see 1913: 86. It is also fairly clear that the contest is about ethical and moral values. In the end, however, Fu-Manchu fails because in spite of his superior brain power and an ability to mimic certain virtues of the British homosocial world (he is brave and keeps his word), he underestimates British masculinity and the loyalties and ethics of that world.

59　The quotation is from James R. Lilley, former CIA chief in Beijing and US ambassador to China from 1989–91, in a piece entitled 'The "Fu-Manchu" problem', see *Newsweek*, 24 February 1997: 36. At the same time, Lilley has endorsed *Pax Pacifica*, arguing that few have 'dramatized the protracted struggle between East and West' as well as Pieczenik.

References

Anderson, Matthew (1966) *The Eastern Question, 1174–1923*, New York: Macmillan & Co.

Anslinger, H. J. and Tompkins, W. F. (1953) *The Traffic in Narcotics*, New York: Funk & Wagnalls.

Bernstein, Richard and Munro, Ross (1997) *The Coming Conflict with China*, New York: Alfred A. Knopf.

Berridge, Virginia and Edwards, Griffith (1981) *Opium and the People*, New York: St Martin's Press.

Boulger, D. C. (1879) *England and Russia in Central Asia*, London: W. H. Allen & Co.

—— (1885) *Central Asian Questions: Essays on Afghanistan, China, and Central Asia*, London: T. F. Unwin.

—— (1893) *China*, New York: Peter Fenelon Collier & Son, 1900.

British Parliamentary Papers; House of Commons, Sessional Papers (1971) Reprinted in Irish University Press Area Studies Series, China, 22 vols, Shannon: Irish University Press.

Campbell, Persia (1923) *Chinese Coolie Emigration to Countries within the British Empire*, reprinted New York: Negro University Press (1969).

Caniff, Milt (1987) *Steve Canyon: May 15, 1953–April 30, 1954*, Princeton, NJ: Kitchen Sink Press.

Clubb, O. Edmund (1971) *China & Russia: The 'Great Game'*, New York: Columbia University Press.

Cohn, Bernard (1987) *An Anthropologist among the Historians and Other Essays*, Delhi: Oxford University Press.

—— (1996) *Colonialism and Its Forms of Knowledge*, Princeton, NJ: Princeton University Press.

Colquhoun, Archibald R. (1898) *China in Transformation*, New York and London: Harper.

—— (1900) *Overland to China*, New York and London: Harper.

Cooley, James (1981) *T. F. Wade in China: Pioneer in Global Diplomacy, 1842–1882*, Leiden: E. J. Brill.

Cordier, Henri (1876) 'A classified index to the articles printed in the journal of the North-China Branch of the Royal Asiatic Society', *Journal of the North China Branch of the Royal Asiatic Society*, 9: 201–15.

—— (1904–8) *Bibliotheca sinica, dictionnaire bibliographique des ouvrages relitifs a l'Empire Chinois*, Paris: E. Guilmoto.

—— (1912) *Bibliotecha indosinica, dictionnaire bibliographique des ouvrages relatifs a la Peninsule Indochinoise*, Paris: E. Guilmoto.

Covell, Ralph (1978) *W. A. P. Martin, Pioneer of Progress in China*, Washington, DC: Christian University Press.

De Lauretis, Theresa (1984) *Alice Doesn't: Feminism Semiotics Cinema*, Bloomington: Indiana University Press.

Deleuze, Gilles and Guattari, Félix (1977) *Anti-Oedipus: Capitalism and Schizophrenia*, trans. Robert Hurley, Mark Seem and Helen Lane (1983), Minneapolis: University of Minnesota Press.

—— (1988) *A Thousand Plateaus: Capitalism and Schizophrenia*, trans. Brian Massumi, London: Athlone.

Deverall, Richard (1954) *Mao Tze-Tung: Stop This Dirty Opium Business! How Red China is Selling Opium and Heroin to Produce Revenue for China's War Machine*, Tokyo: Toyoh Printing and Book-Binding Co.

Edwardes, Michael (1975) *Playing the Great Game: A Victorian Cold War*, London: Hamilton.

Eldridge, C. C. (1973) *England's Mission*, Chapel Hill: University of North Carolina Press.

Fairbank, John K. (1953) *Trade and Diplomacy on the China Coast: The Opening of the Treaty Ports, 1842–1854*, reprinted Stanford: Stanford University Press (1969).

—— (1992) *China, A New History*, Cambridge, MA: Belknap Press.

Fairbank, J. K., Coolidge, M. H. and Smith, R. J. (1995) *H. B. Morse: Customs Commissioner and Historian of China*, Lexington: University of Kentucky Press.

Farwell, Byron (1972) *Queen Victoria's Little Wars*, New York: W. W. Norton & Co.

Greenhalgh, Paul (1988) *Ephemeral Vistas*, Manchester: Manchester University Press.

Guha, Ranajit (1963) *A Rule of Property for Bengal,* Durham: Duke University Press (1996).

Hevia, James L. (1995) 'An imperial nomad and the Great Game: Thomas Francis Wade in China', *Late Imperial China*, 16(2): 1–22.

Hopkirk, Peter (1992) *The Great Game*, New York: Kodansha International.

—— (1995) *On Secret Service East of Constantinople*, Oxford: Oxford University Press.

Huntington, Samuel P. (1993) 'The clash of civilizations?', *Foreign Affairs*, 72(3): 22–49.

—— (1996) *The Clash of Civilizations and the Remaking of World Order*, New York: Simon & Schuster.

Issacs, Harold (1958) *Scratches on Our Minds*, New York: M. E. Sharpe (1980).

Kerner, Robert (1939) *Northeast Asia, A Selected Bibliography*, Berkeley: University of California Press, 2 vols.

Kohn, Marek (1994) *Dope Girls: The Birth of the British Drug Underground*, London: Lawrence & Wishart.

Krausse, Alexis (1900a) *China in Decay*, London: Chapman & Hall, 3rd edn.

—— (1900b) *Russia in Asia: A Record and a Study, 1558–1899*, London: G. Richards.

—— (1903) *The Far East, Its History and its Question*, London: G. Richards.

Latour, Bruno (1990) 'Drawing things together', in Michael Lynch and Steve Woolgar (eds) *Representations in Scientific Practice*, Cambridge, MA: MIT Press, pp. 19–68.

—— (1993) *We Have Never Been Modern*, Cambridge, MA: Harvard University Press.

McClellan, Robert (1971) *The Heathen Chinese: A Study of American Attitudes towards China, 1890–1905*, Columbus: Ohio State University Press.

McCoy, Alfred W. (1973) *The Politics of Heroin in Southeast Asia*, New York: Harper & Row.

Mani, Lata (1985) 'The production of an official discourse on *Sati* in early nineteenth-century Bengal', in Francis Barker, Peter Hulme, Margaret Iverson and Diana Loxley (eds) *Europe and Its Others* (vol. 1), Colchester: Essex University Press, pp. 107–127.

Marshall, Peter and Williams, G. (1982) *The Great Map of Mankind*, London: J. M. Dent.

Matsuda, Matt (1996) *The Memory of the Modern*, New York: Oxford University Press.

Mayers, William F. (1877) *The Chinese Government: A Manual of Chinese Titles, Categorically Arranged and Explained*, 3rd edn revised by G. M. H. Playfair, Shanghai: Kelly & Walsh (1897).

Michie, Alexander (1864) *The Siberian Overland Route from Peking to Petersburg*, London: John Murray.

—— (1893a) 'The Russian acquisition of Manchuria', *Blackwood's Edinburgh Magazine*, 153 (May): 631–46.

—— (1893b) 'Balance of power in Eastern Asia', *Blackwood's Edinburgh Magazine*, 154 (September): 397–415.

Milligan, Barry (1995) *Pleasures and Pains*, Charlotteville: University Press of Virginia.

Morse, H. B. (1906–7) 'Currency in China', *Journal of the North China Branch of the Royal Asiatic Society*, 38. Reprinted as a pamphlet, Shanghai: Kelly & Walsh (1907).

—— (1907) *Currency, Weights, and Measures*, Shanghai: Kelly & Walsh.

—— (1908) *The Trade and Administration of the Chinese Empire*, London: Longmans, Green.

—— (1909) *The Gilds of China*, London: Longmans, Green.

—— (1910–18) *The International Relations of the Chinese Empire, 1834–1911*, 3 vols, London: Longmans, Green.

—— (1926) *Chronicles of the East India Company Trading to China, 1615–1834*, 5 vols, Oxford: Oxford University Press.

Moy, James S. (1993) *Marginal Sights: Staging the Chinese in America*, Iowa City: University of Iowa Press.

Nadel, Alan (1995) *Containment Culture*, Durham: Duke University Press.

Parssinen, Terry (1983) *Secret Passions, Secret Remedies*, Philadelphia: Institute for the Study of Human Issues.

Pick, Daniel (1993) *War Machine*, New Haven: Yale University Press.

Pieczenik, Steve (1995) *Pax Pacifica*, New York: Warner Books.

Playfair, G. M. H. (1879) *The Cities and Towns of China*, 2nd edn, Shanghai: Kelly & Walsh (1910).

Rawlinson, Henry (1875) *England and Russia in the East*, London: John Murray.

Richards, Thomas (1993) *The Imperial Archive*, London: Routledge.

Rohmer, Sax (Arthur Ward) (1913) *The Insidious Dr. Fu-Manchu*, New York: Pyramid Books (1975).

—— (1915) *The Yellow Claw*, New York: Pyramid Books (1966).

—— (1916) *The Return of Dr. Fu-Manchu*, New York: Pyramid Books (1975).

—— (1917) *The Hand of Fu-Manchu*, New York: Pyramid Books (1976).

—— (1919) *Dope*, New York: A. L. Burt Co.

—— (1930) *The Daughter of Fu-Manchu*, New York: Pyramid Books (1976).

—— (1936) *President Fu-Manchu*, New York: Pyramid Books (1976).

Smith, Arthur H. (1894) *Chinese Characteristics*, reprinted Port Washington, NY and London: Kennikat Press (1970).

—— (1899) *Village Life in China*, New York: Fleming H. Revell Co.

Smith, D. Warres (1900) *European Settlements in the Far East*, New York: Charles Scribner's Sons.

Smith-Rosenberg, Carroll (1985) *Disorderly Conduct*, New York: Oxford University Press.

Snow, Philip (1988) *Star Raft: China's Encounter with Africa*, Ithaca: Cornell University Press.

Spivak, Gayatri (1985) 'The Rani of Surmur', in Francis Barker, Peter Hulme, Margaret Iverson and Diana Loxley, *Europe and Its Others*, Vol. 1, Colchester: University of Essex Press, pp. 128–51.

Stoler, Ann (1989) 'Making empire respectable: the politics of race and sexual moral-
 ity in 20th-century colonial cultures', *American Ethnologist*, 16(4): 634–60.
Tietjen, Arthur (1956) *Soho: London's Vicious Circle*, London: Allan Wingate.
White, Hayden (1978) *Tropics of Discourse*, Baltimore: Johns Hopkins University
 Press.
Young, Robert (1995) *Colonial Desire: Hybridity in Theory, Culture and Race*, London:
 Routledge.

Zlatko Skrbiš

MAKING IT TRADEABLE: VIDEOTAPES, CULTURAL TECHNOLOGIES AND DIASPORAS

Abstract

In this commentary I address some of the key ideas presented in Kolar-Panov's paper titled 'Video as the diasporic imagination of selfhood: a case study of the Croatians in Australia' which was published in *Cultural Studies* 10: 2, 1996. My own research, conducted during the same period, on the same group of migrants and in the same country, found very little evidence to support some of the assertions made in the paper. I therefore challenge the author's main assumptions about the impact of video technology on the formation of diaspora identities and address some of the theoretical issues behind the notion that video technology is the first widespread post-modern communication medium. I highlight the intrinsic similarities between telecast and video technologies and show how Kolar-Panov's argument tends to slide into both technological and social determinism.

Keywords diaspora; video technology; identity; technological/social determinism; atrocities

Introduction

THE RELATIONSHIP BETWEEN technological advancement and theoretical reflexivity has always been an uneasy one. It is quite common to see new technologies being happily and uncritically embraced and theorized as if representing a radical break with all previous forms of technocultural appropriation. The fascination with such 'radical breaks' can easily become self-perpetuating, however. Furthermore, this perspective encourages the interpretation of social facts as befitting the type of theoretical discourse which nurtures and invites that very fascination. In this commentary, I wish to challenge some of the assumptions

made in the paper 'Video as the diasporic imagination of selfhood: a case study of the Croatians in Australia', published in this journal by Dona Kolar-Panov (1996). Kolar-Panov's paper is concerned with the 'role and effects of video on cultural technology in the Croatian diaspora in Australia in the light of the war in the former Yugoslavia' (ibid.: 288). It is informed by research among Croatians and Macedonians in Perth, conducted between 1989 and 1994. The theme and historical context make Kolar-Panov's article extremely valuable and timely for two main reasons. First, the media and communication technologies are of central importance to late modernity. Second, the prominence of political conflicts and the diminishing importance of geographical distance require theoretical reflection. The study of Croatian diaspora in Australia by its very nature deals with the multidimensionality of modern social complexities as it addresses the intersection of globalization, transnationalism, the long-distance regulation of identities and the management of cultural and ethnic pluralities.

Kolar-Panov's paper explores the impact of VCR and other means of modern communication upon Croatian migrants and their children in Perth. Video technology was attributed with the ability to be used for 'maintenance and repair of the cultural identities' of migrants (ibid.: 289). The author presents production, viewing and distribution of videos in a diaspora context as one of the very important regulatory mechanisms of diaspora identification. This assertion is not only perfectly compatible with the technological trends of the modern age but also fits neatly into the 'emerging postmodern culture of hybridity' (ibid.: 288).

Video technology and its use in a diaspora context is a prime concern of the author. It arises in two contexts. First, it appears in the form of an ethno-specific genre of 'video-letters'. These video-letters usually assume the form of 'a video-tape which is a mixture of a personal letter and snapshots with the added effect of an oral communication' (ibid.: 311n). In practice, these video-letters represent a video recording put together by family members and/or friends in Australia and/or Croatia and exchanged via mail. They may either contain various family-related occasions (holidays, graduations, birthdays, funerals, etc.), or they may have a clearly distinguishable political and historical content. Usually, they combine both. The wide acceptance and popularity of video-letters may not necessarily originate in people's fondness for the new technology. I believe there are two reasons for their relatively widespread appropriation in a diaspora context. First, they are both comparatively cheaper than international phone calls (Margolis, 1995). Second, they can successfully compensate for any possible lack of proficiency in written expression among migrants. The question of video technology is addressed in the context of the emergence of 'new videos', which have started to circulate among Western Australian Croatians – they 'featured graphic images of atrocities'. As Kolar-Panov (1996: 290) puts it:

> The images we were watching on the videotapes were brutal and unedited images of death, images largely kept out of the mainstream media. These

videos, translated from many realities and fragments of personal experience, conveyed portraits of men, women and children along the long path to exile and death. Displayed alongside this was a disjoined and spurious glorification of such death as being for the homeland.

I will discuss this type of particularly symptomatic 'atrocity tape' towards the end of this paper.

Videos and diasporic identification

Between 1991 and 1994 I conducted research into the persistence of ethnonationalism among Croatian migrants in Australia and their children (Skrbiš, 1994a). Focusing on Croatians living in Adelaide, Melbourne and Sydney, it was found that ethno-nationalist sentiments persist in a new environment despite the physical distance between the homeland and diasporic settings.[1] I found that not only do they exist, but they also condition – mostly indirectly but certainly to a considerable extent – the nature and intensity of ethno-national sentiments in the homeland. This finding did not come as a surprise, considering the arbitrariness and relativity of physical distance in the contemporary world (Robertson, 1992; Schiller et al., 1992; Anderson, 1994).

The research required the detailed exploration of interactive processes between the Australian–Croatian diaspora and the Croatian homeland. It included the print media, ethnic broadcast, ethnic community influence, the presence and activities of Croatian political parties in Australia, etc. The issue central to these interactive processes was the somewhat troublesome and not at all taken-for-granted construction of the Croatian homeland. Despite the difficulty of the diaspora population to clearly delineate between the political, ethnic and geographical dimensions characterizing their homeland, Croatia commonly assumed the existence of a fetishist construct.

When analysing the main sources of identity regulation for first and second generation Croatians living in Australia I found that the transmission of both nationalist feelings and other identity components of these individuals were predominantly conditioned and mediated through the ethnic community (Skrbiš, 1994a, 1994b) and parental influence (Pallotta-Chiarolli and Skrbiš, 1994). The intergenerational aspect of these identity formation processes was found to be extremely relevant. The first generation migrants (and to a very limited extent second generation) were assuming the central position as ethno-cultural subject-agencies. The second generation individuals were more likely to be subjected to expressions of symbolic ethnicity (Gans, 1979) and highly mediated and channelled messages and images. In another paper (Skrbiš, 1996) I have tried to explain the complex nature of arrangements regulating the formation and transmission of ethno-national identities in the diaspora settings.

The media did play an important but not crucial role in the identity for-
mation process among the respondents. The role of ethnic community organiz-
ations – which have developed their own distinct and often mutually antagonistic
profiles (an aspect completely unproblematized by Kolar-Panov) – was much
greater than that of the media. While the first generation immigrants resorted to
all possible sources of information (ethnic press, ethnic radio programmes, the
Croatian homeland press and the Australian media), the second generation
largely relied on the Australian media and information mediated through their
parents or Croatian ethnic community organizations.

So where does VCR technology fit? My research showed that videotapes
were predominantly used to record the news in anticipation of coverage of events
in the Balkans. However, as the war progressed, this news videotaping enthusi-
asm diminished rapidly among the second generation, yet persisted at a substan-
tial level among the first generation. Any other use of video technologies was
never disclosed by my informants unless they were specifically asked about their
use of videos. This included 'video-letters' and videos designed by the Croatian
homeland political establishment to reassure the Croatian diaspora population of
the country's unfailing and unchallenged national unity and that the path taken
by the Croatian government was the right one. Rather, a combination of factors
featured very prominently in these identity formation processes: from the influ-
ence of ethnic community organizations, ethnic press and radio programmes, to
the influence of the first generation over the second generation. In other words,
diasporic identities were continuously being formed in the shadow of the tragic
events overseas but this was not so because of the existence, availability or uti-
lization of videotapes, as Kolar-Panov would have us believe. After all, ethno-
specific videos do not necessarily make one more ethnic.[2]

VCR and the reality of the hyperreal

Kolar-Panov (1994b: 151) explicitly describes the VCR as the 'first widespread
post-modern communication medium' and, following Jameson (1984), 'as being
poststructuralist in essence, since the apparatus allows the production and repro-
duction of nostalgia and provides for the creation of personal pastiche of images
and sounds as no other medium has done so far' (Kolar-Panov, 1996: 292).

How do we understand the functioning and existence of video technologies
in this context? Undoubtedly, their technical characteristics such as the ability to
record programmes *in absentia* and the possibility of post-event viewing of images
encourages the view that one is confronted by a technical invention which rep-
resents and encourages a radically new way of imagining the real. Despite the
global scope of VCR marketability and consumption of video images *en masse*, I
feel tempted to express some doubt in relation to claims that video technology
represents something radically different. Instead, I argue that what appears to be

emerging in a theoretical field is – to echo Žižek (1995: 77) – a theoretical and ideological institutionalization of the promiscuous 'play of difference' and 'hyper-reality'. In other words, an emphasis on the otherness of video presentation may better fit the dominating theoretical discourse than the empirical reality.

The illusionary construction of video as a novelty completely overshadows an important emphasis on the mechanical reproducibility of texts, voices and images by Walter Benjamin (1970). It is exactly this reproductive capacity which makes home video technology possible. The main and truly novel characteristic of videos is their liberating potential from the external constraints of time and space. Indeed, '[t]he spectator may decide what to watch, when to watch it, and how to watch it. He has the option to fast forward, pause or move backwards in slow, fast or normal speeds. . . . Like memory, the traces of video are available for the video spectator to reinspect' (Berko, 1989: 293). The final effect of such manipulation of imagery is its denarrativization, decontextualization and exposure to voyeuristic fetishization (e.g. Naficy, 1991a).

The assumed 'liberating potential' of video technologies also needs to be qualified, however. Video technologies differ from the television telecast insofar as they exploit the implicit *post-festum* effect of their visual presentation. The interpretations which define videos as a poststructuralist media *par excellence* perceive video technologies as a radical break with the whole modernist tradition based on what Benjamin called 'homogenous and empty' time (cf. Anderson, 1993: 22–36). Furthermore, they not only see video as being invested with post-structuralist qualities of fragmented and liminal experience/presentation of reality but also portray the presentations of reality as simply serving the demand for simultaneity. Again, I feel tempted to argue against such a dichotomizing. The question is: Is it possible that the productions and utilizations of different kinds of temporarity, as produced by telecast and video technologies, aren't all that radically different after all?

I wish to argue that video accentuatedly embodies what has always been inherently inscribed in a telecast – *the lag*. Just remember the Gulf War and its coverage by CNN, which 'entertained' the viewer with what was described as 'a simultaneous' or 'live' experience of the Gulf War. The well-designed timing between bombardment and the length of commercials, however, was so incred-ibly exact and 'coincidental' that it was hard to resist the idea that the label of simultaneity was either a fake or a trading manoeuvre. The idea of 'live' television is becoming increasingly difficult to defend without an acknowledgement of the perplexing nature of the telecast. The complex relationship which binds video technology to television – the medium which rendered the existence of video technology imaginable and possible – often tends to be all too easily overlooked (cf. Berko, 1989; Goodall, 1995).

The boundaries delineating the divergent utilization of temporality via tele-cast and video technology are breaking down, only to reveal that this distinction happens to be a heuristic device. To put it in the form of a paradox: not only does

the video develop to an extreme the quality which has always been inherently inscribed in a telecast – the possibility of manipulating the lag – but the television apparatus itself assumes the nature of a videotic instrument which can play with perceptions and constructions of time.

This uneasiness permeating the debate about the relationship between television and video technologies is symptomatic of a conception of video as a postmodernist technological artefact *par excellence*. Kolar-Panov (1996: 291) argues that 'the VCR is still the most accessible and therefore most popular means of communication, second perhaps only to the telephone.' She grounds the assumption of the primacy of video technology over television by pointing to the availability of videotapes on the market which are 'distributed or sold in corner shops, pharmacies, libraries and even vending machines, side by side with Coca-Cola and condoms' (ibid.: 292). There is something puzzling about the failure to differentiate between the cause and the effect or between the technological media and disposable videotapes. To put it simply, videotapes are widely available because they are cheap and consumable goods – neither television sets nor VCRs can pride themselves on having these qualities.

Another question is whether or not new cultural technologies necessarily contribute to a new cultural impact. The above reflections allow us to return to the original question about the extent to which video technology can impact upon the development of diasporic identities. In an earlier essay, Kolar-Panov (1994b: 171) wrote: 'Ethnic video as cultural technology, and as cultural practice involving a detachment from its original place and time, creates and extends new cultural patterns and give rise to new shapes of collective consciousness which in turn give rise to new common identities and new cultures.' This statement contains a considerable degree of technological determinism. Ethnic video as cultural technology is expected to make an impact across a supposedly wide range of sociocultural positions. In any event, Kolar-Panov unquestionably expects this new technology to change the existing cultural patterns, failing to acknowledge that this novelty may indeed have a selective impact. Unfortunately, she makes no positive statement as to what the new forms of consciousness and identities are, so that the reader is confronted with an omnipotent signifier which can 'give rise to new identities and cultures' on the one hand and an empty signified on the other. Clearly, the media and video technologies do play an important role in these processes but their relative recency in itself does not make them a radical novelty.[3] It is hard to justify why their recency should have to imply any radically new and specific form of cultural appropriation.

The loss of innocence and the gaze of perversion

At this point let us return to the notion of the 'atrocity videos'. As I have already noted in relation to video as a poststructural medium, the chief advantage of

video over television is that the viewer is given an almost limitless capability of making informed choices not only as to 'when' and 'where' but also in terms of 'what' he or she is going to watch. In other words, video technology positions us as preselectors of images which are 'called into' the field of vision. What surprises me in the case of the paper under present critical scrutiny is the author's indication that, with concern for the war-torn homeland among the Croatian diaspora 'came *a demand* for timely information that the existing mainstream media simply could not provide. . . . These new videos – some of which featured graphic images of atrocities – had a considerable impact upon those who viewed them, including myself' (Kolar-Panov, 1996: 289–90; my emphasis).

Kolar-Panov here slides from technological determinism to social determinism. The viewing of these atrocity videos is described as a type of social gathering which included a particular ritual. People watching such videos were:

> frequently getting up and leaving the room 'to get a drink', 'to go to the bathroom', 'to check on the baby', until finally the video would be stopped, usually with an excuse that there was another one 'which is really more interesting, and we should watch it since it has to be returned' or 'it is time for the news', which would be taped otherwise if we were watching a videotape. No one, including myself, was ready to admit that we were sickened by such tapes, that they disturbed us.
>
> (Ibid.: 309)

Let us for a moment accept without question the existence and indiscriminate effectiveness of 'atrocity videos'. Simultaneously, let us also recall the above stated designation of a video as a 'poststructuralist' medium with its inherently ascribed function of technically limitless reproducibility of atrocity images. It is precisely this crossing of the two which reveals the very problematic nature of Kolar-Panov's argumentative endeavour. The desire and/or willingness of the viewers to bring the images of the victimized bodies into the comfort of their living rooms in the diaspora is never questioned by the author.

Diaspora entertainment which resorts to images of destruction and death is nothing typically Croatian. Naficy (1991a: 108) explains something similar when describing the televisual fetishization of American-Iranian television (*sic*!): 'By fetishizing and continually *repeating* these tortured images, exile TV invites identification and pleasure in the return to loss, and, thereby feeds into the masochistic economy of desire' (ibid.: 108; cf. also Naficy, 1991b). The existence and assumed centrality of such atrocity videos is therefore a symptom of an era which can comfortably live up to Baudrillard's (1988: 21–2) definition of obscenity which 'begins when there is no more spectacle, no more stage, no more theatre, no more illusion, when everything becomes immediately transparent, visible, exposed in the raw and inexorable light of information and

communication.' And repetition, one feels tempted to add in this context. There seems to be nothing innocent in the gaze of the atrocity videotape viewers.

Conclusion

This critique of the literature on video technology and diaspora identification is based on my own research and analysis of the Australian Croatian diaspora. I argued on the basis of the outcome of my own research among the members of the Australian Croatian diaspora that videos of both 'atrocity' and 'video-letter' nature play a marginal role in diaspora identity formation. In short, there was nothing in my own research that could empirically support assertions by Kolar-Panov about the significance of video technology on the formation of diaspora identities.

Kolar-Panov failed to adequately address the linkage between video technology and its designation as a poststructuralist medium. As a supposedly poststructuralist medium, video technology is *per definitionem* directed towards the dissolution of boundaries. It dehistoricizes and decontextualizes information, and for that reason fits quite problematically into the explanatory paradigm which Kolar-Panov uses to elucidate the diasporic identity formation.

In any event, a more concerted effort to reconcile empirical evidence with fashionable modes of theoretical discursivity is needed to prove the hypothesized link between video technology and its impact upon the formation of diaspora identities.

Notes

1 For the purposes of the study, thirty-two second generation and thirty first generation Croatians were interviewed. These interviews were combined with participant observation.
2 Interestingly, a similar study conducted in the same period among Canadian Croatians by Daphne Winland (1995) also failed to recognize videos as playing any detectable role in the constitution of Canadian Croatian identities. In other words, despite the overlap of the topics and times of our three individual enquiries (1989 to 1994), there exists a fundamental discrepancy in our assessment of the importance of video technologies.
3 Benjamin Barber (1995: 73) similarly reminds us how the walkman is – despite its recent appearance – nothing new. It's simply a phonograph repackaged for a new type of consumer.

References

Anderson, B. (1993) *Imagined Communities*, London and New York: Verso. Revised edn.

—— (1994) 'Exodus', *Critical Inquiry*, 20 (Winter): 314–27.

Barber, B. (1995) *Jihad vs. McWorld*, New York: Random House.

Baudrillard, J. (1988) *The Ecstasy of Communication*, New York: Semiotext(e) Foreign Agents Series.

Benjamin, W. (1970) *Illuminations*, London: Jonathan Cape.

Berko, L. (1989) 'Video: in search of a discourse', *Quarterly Review of Film Studies*, 10: 289–307.

Gans, H. J. (1979) 'Symbolic ethnicity: the future of ethnic groups and cultures in America', *Ethnic and Racial Studies*, 2(1): 1–20.

Goodall, P. (1995) *High Culture, Popular Culture: The Long Debate*, Sydney: Allen & Unwin.

Jameson, F. (1984) 'Postmodernism, or the cultural logic of late capitalism', *New Left Review*, 146: 53–93.

Kolar-Panov, D. (1994a) 'Ethnic-cleansing, plastic bags and throw-away people', *Continuum*, 8(2): 159–87.

—— (1994b) 'Video as a cultural technology: the Macedonian experience in Australia'. *Macedonian Review*, 24(2): 147–73.

—— (1996) 'Video as the diasporic imagination of selfhood: a case study of the Croatians in Australia', *Cultural Studies*, 10(2): 288–314.

Margolis, M. L. (1995) 'Transnationalism and popular culture: the case of Brazilian immigrants in the United states', *Journal of Popular Culture*, 29(1): 29–41.

Naficy, H. (1991a) 'Exile discourse and televisual fetishization', *Quarterly Review of Film and Video*, 13(1–3): 85–116.

—— (1991b) 'The poetics and practice of Iranian nostalgia in exile', *Diaspora*, 1(3): 285–302.

Pallotta-Chiarolli, M. and Skrbiš, Z. (1994) 'Authority, compliance and rebellion in second generation cultural minorities', *Australian and New Zealand Journal of Sociology*, 30(3): 259–72.

Robertson, R. (1992) *Globalization: Social Theory and Global Culture*, London: Sage.

Schiller, N. G. et al. (eds) (1992) *Towards a Transnational Perspective on Migration*, New York: The New York Academy of Sciences.

Skrbiš, Z. (1994a) *Ethno-nationalism, Immigration and Globalism, with Particular Reference to Second Generation Croatians and Slovenians in Australia*. Unpublished Ph.D. thesis, Adelaide: Flinders University of South Australia.

—— (1994b) 'On ethnic "communities" in non-native environments', *Two Homelands/Dve Domovini*, 5: 137–49.

—— (1996) *Migrants, Heimat and the Global Condition*. Paper presented at the RC05 Meeting of the International Sociological Association, Manila.

Winland, D. N. (1995) '"We are now an actual nation": the impact of national independence on the Croatian diaspora in Canada', *Diaspora*, 4(1): 3–29.

Žižek, S. (1995) 'Guilty pleasures', *World Art*, 2: 76–81.

Lez Cooke

DRAMATIC DISCOURSES

Robin Nelson, *TV Drama In Transition* (Basingstoke and London: Macmillan, 1997) 277 pp., ISBN: 0 333 67753 6 Hbk, £47.50, ISBN 0 333 67754 4 Pbk, £14.99.

Given the paucity of critical studies on television drama it is perhaps understandable that Robin Nelson's dense but stimulating book is bubbling over with ideas, allusions and theoretical references. In fact the structure of the argument echoes the style of a 'flexi-narrative' drama as it flits enthusiastically from one idea to another as Nelson seeks to explain the forces at play in a range of recent British and American television dramas.

Flexi-narrative and *flexiad* drama are terms which Nelson introduces to describe those forms of popular television drama (*Hill Street Blues, Casualty*) which meet the distracted attention span of the new 'postmodern' audience. One might question if these 'new' narrative forms are really that new, or whether they are that different from the multi-narratives of television soap operas, the most popular form of television drama, to which little attention is paid in the book. One might also question whether this 'new' form has indeed emerged as a consequence of a perceived shift towards a 'three-minute culture', as Nelson asserts, or whether the economics of television drama production have more to do with it, with shorter scenes requiring less rehearsal and production time and less attention to a more elaborate (and therefore more expensive) *mise-en-scène*.

According to Nelson, television drama is in transition as a result of the social, cultural and economic changes of the last two decades and these changes have had considerable impact on the tastes and habits of the television audience, and on television companies. In this respect, Chapter 3, 'Dislocations of postmodernity: transition in the political economy of culture' is a key chapter. The social and economic changes since 1972 are read through the prisms of postmodernist discourse to account for a shift in class allegiances and values, resulting in a newly emergent postmodern television audience.

The Introduction sets out Nelson's 'post-culturalist' theoretical framework. (For a book which is sceptical about postmodernism, it is ironic that such a 'postmodern' approach should be adopted.) He discusses both British and American dramas, critical realist and formulaic dramas, critical postmodern and popular postmodern dramas, and concludes by advocating diversity, arguing that there is space for both critical realist/postmodern drama and popular/formulaic drama in the television schedules.

Nelson makes clear his intention to juxtapose 'theoretical' chapters with chapters which focus on critical readings, and it is in the former that the full panoply of academics and philosophers, postmodernist or otherwise, is mobilized in dense, sometimes abstract arguments.

Each of the theoretical chapters engages with a key perspective: technology and televisual form, political economy of culture, realism, pleasure and the audience, and

problems of value and evaluation. However, the analytical chapters do not fully illustrate the theories which precede them, often focusing on a particular aspect of the complex arguments in the theoretical chapters, for example, the discussion of *Oranges Are Not The Only Fruit*, *Middlemarch* and *The X-Files* as 'critical realist' dramas in Chapter 6, when Chapter 5 has discussed a whole range of different realisms, not just critical realism.

Perhaps the most important chapter is the final one, 'For what it's worth: problematics of value and evaluation'. Here Nelson is concerned with the need to make critical/aesthetic value judgements in the face of the abandonment of evaluation within postmodernist critical discourse. Nelson reiterates the need to defend public service broadcasting against the tide of commercialism:

> A public service ethos is necessary to sustain diversity in TV drama. Wholly commercial strategies tend, as demonstrated, either to formulaic realism or to a dehistoricized postmodern bricolage dispersing critical potential. Notwithstanding the fact that some viewers will re-work the materials in a process of symbolic play, such provision sells people short.
>
> (pp. 231–2)

Nelson clearly values critical realist and critical postmodern dramas like *Between The Lines* and *Twin Peaks* over formulaic drama like *Heartbeat* and *Baywatch*. However, he tends to undervalue the potential of popular multi-narrative or 'flexi-narrative' dramas, like *Eastenders*, to tell 'usable stories', which enable viewers actively to engage with social issues and identifiable situations.

TV Drama In Transition is ultimately ambivalent in its attitude towards postmodernity and the new 'affective order'. The cultural shift of the last two decades has seen the emergence not only of a postmodern television audience and the production of bland market-researched dramas like *Heartbeat*, but also of 'critical postmodern' dramas like *Twin Peaks*, dramas with the potential to 'de-centre the subjectivity of viewers' and open up the possibility of 'all kinds of liberations' (p. 237). Nelson's book aims to encourage resistance to 'the desire-producing logic of consumer capitalism' (p. 9) and, while welcoming *Twin Peaks* as a critical rather than formulaic postmodern television drama, he also remakes the case for realism as a popular form, one which, especially in its more progressive 'critical realist' manifestations (epitomized by 'quality' dramas like *Our Friends In The North*), can 'change hearts and minds'. As Nelson characteristically puts it:

> In its accessibility, critical realism may yet be more productive of a dialogic exchange with potential for cognitive reorientation than critical postmodern discourses whose disjunctions and refusal of the audience's need for answers may still lead viewers literally to switch off.
>
> (p. 248)

TV Drama In Transition is a welcome addition to an under-represented field, but for all its postmodern ambiguities, Nelson's rallying cry in defence of realism is remarkably reminiscent of Colin McArthur's case for *Days Of Hope* as a progressive realist text, made in the face of the anti-realist vanguardism of the journal *Screen* more than twenty years

ago. Television drama may be in transition (when hasn't it?), but realism just won't go away.

References

Tulloch, John (1990) *Television Drama: Agency, Audience and Myth*, London: Routledge.

Peter Beilharz
Alain Touraine, *Critique of Modernity* (Oxford, Basil Blackwell 1995) $39.95.

Who is Alain Touraine? For many years Director of CADIS, the Centre d'Analyse et d'Intervention Sociologiques in Paris, Touraine is widely associated with the close analysis of social movements. His intellectual output has been extraordinary – *The May Movement*, *The Worker's Movement*, *The Post-Industrial Society*, *The Self-Production of Society*, *The Voice and the Eye*, a study of the Polish *Solidarity* alongside *Anti-Nuclear Protest*, *The Return of the Actor*, now *Critique of Modernity*.

Why read Touraine? The work of Alain Touraine is of major significance in French sociology, through its impact in other realms, such as English-speaking cultural studies, is relatively minor. Bourdieu rules. While the English seem able to enthuse endlessly about Giddens, Beck and Lash, Touraine's work remains overlooked and underused. So whose fault is this? That of the consumers or the producers, or the media, like reviewers? Bourdieu's appeal is, I believe, caught up partly with his style, sort-of-Marxist or Marxisant, coolly crossing over sociology, culture and anthropology. The risk with Bourdieu's work is that it reassures us, rather than pushes us. Touraine's work may well be more challenging – readers of *Critique of Modernity* may well feel challenged. For this is a kind of summary of a life's work and it is a book conducted at a fairly abstract level. It is arguably longer than it needs to be. Those new to Touraine may well prefer *What is Democracy?*, published in English in 1997, or those entrapped with English could wait for the translation of his new 1997 French work, *Can We Live Together?*

Touraine is of course known as a social movement theorist, though this doesn't quite capture the significance or nature of his project. It would be more accurate to describe his as a sociology of action, where social movements manifest action in modernity. Touraine here seeks to strike out an alternative path between modernism and postmodernism, across reason and subject. Touraine's sociology maintains the key strength of French sociology since Durkheim – it focuses on the way economy threatens to eat society up. Modern societies come increasingly to resemble firms fighting for survival, on an international market, where identity can no longer be defined in social terms. In poor countries identity takes the form of a new communitarianism; in rich countries, that of narcissistic individualism. Modernity, however, continues to move, because it is not based on one single principle such as rationalization or commodification. Modernity is the result of the dialogue or contest between reason and subject.

Touraine restates this dualism of reason and subject variously across 400 pages. I am not sure I'm convinced, though the struggle for balance is admirable. Touraine's

characterization of modernity is powerful, although I find the nature of the narrative in this book less compelling than his case studies of the French workers' movement, though this latter work like his enthusiasm for Latin American is also probably close to my own curiosities (reviewer's rule number one: don't project. Start from presences, not absences). Plainly, Touraine's purpose in *Critique of Modernity* is retrospective, big picture stuff. What is surprising in this analysis, perhaps, is that Touraine's drift from the shadow Marxism of social movements takes him in effect into the arms of liberalism, not without a struggle, but to liberalism nevertheless. Not that this should be cause for utter dismay in the context of a French or Parisian intellectual culture that is always somehow closer to Jacobinism than to liberalism; but all the same it is surprising that Touraine's main sense of the enemy, at century's turn, is still totalitarianism rather than the creative destruction which we call capitalism. Touraine's sensitivity to the dualization of the world and especially Latin America is high; only his own sense of autobiography seems here to be more ghosted by the spectre of communism as antimodernising (Maoism) or, alternatively, as hypermodernism (Trotskyism). Modernity remains problematical, for it can offer us only four possibilities, none of which is particularly edifying – sexuality, consumption, the company or the nation as icons. Modernity reduces, ultimately, to modernism. Totalitarianism is nevertheless for Touraine the century's most serious pathology. That is why the contemporary appeal to the subject is so powerful today. Only the subject must, for Touraine, be a social movement, not just the self. This means seeking to strengthen society and not the state. Democracy matters, still, because it involves social conflict between actors who, while they are in conflict, refer to the same values, and seek to give them different forms. Democracy matters, further, because it is by definition processual, and oppositional, for democracy can never represent a final or settled state of affairs.

The modernist obsession with revolution is ultimately disabling. Yet modernity itself *is* in a sense revolution, and that revolution continues to sweep us along every day of our lives, damaging some more than others. The real achievement of *Critique of Modernity* is to reframe so many of these kinds of debates and issues which have both held the twentieth century up and torn it down. Bedside reading this ain't; but then if we need to be stretched, we need also to avoid relying only on those works which repeat and reassure. Touraine's life work has its own familiar themes and recurring patterns, but the object of his project is that older, early modern one, which dares you to think for yourself.

Notes on Contributors

Peter Beilharz teaches sociology at La Trobe University in Melbourne. He is the founding editor of *Thesis 11* and the author of a number of books; *Labour's Utopia*, published in 1992, *Transforming Labour* in 1994, *Post Modern Socialism* in 1994; and *Imagining the antipodes* in 1997.

Lisa Cartwright is Associate Professor of English and of visual and cultural studies at the University of Rochester. She is the author of *Screening the Body: Tracing Medicine's Visual Culture* (Minnesota, 1995) and co-editor with Paula A. Treichler and Constance Penley of *The Visible Woman: Imaging Technologies, Science, and Gender* (NYU, 1998).

Lez Cooke is Principal Lecturer in Media Studies at Staffordshire University where he teaches courses in alternative practices in film and broadcasting, British cinema, and British television drama. He has written widely on British cinema and television and is currently researching a history of British television drama.

James L. Hevia is Assistant Professor of history at North Carolina A&T State University. He has published numerous articles on Anglo–Chinese relations in the eighteenth and nineteenth centuries. His book *Cherishing Men From Afar: Qing Guest Ritual and the Macartney Embassy of 1793* (Duke University Press, 1995) received the Joseph R. Levenson Prize of the Association for Asian Studies in 1997.

Lianne McTavish is an assistant professor of art history at the University of New Brunswick. She recently completed her dissertation on gender and seventeenth-century French visual culture. Her current work is on early modern French midwifery.

Daniel Mato is Professor of social sciences and the Director of the Program on Globalization, Cultural Processes and Sociopolitical Change at Universidad Central de Venezuela. He has also been a visiting professor at several universities in Latin America and the United States.

Viktor Mazin is critic, translator from French and English, editor-in-chief of the art and science journal *Kabinet: Pictures of the World*, co-editor of the psychiatric journal *Acta Psychiatrica*, and a member of the Crimean Association of Psychiatrists, Psychoanalysts, and Ethologists. He works in the East European Institute of Psychoanalysis (St Petersburg). He is the author of '*Necrorealism and*

 © *Routledge 1998*

Jufit' (INA Press, St Petersburg, 1997). From the late 1980s he has given papers on the theory of visuals in St Petersburg, Moscow, Berlin, Karlsruhe and Vienna.

Zlatko Skrbiš teaches sociology at Queensland University of Technology, Brisbane, Australia. The main theme of his research is long-distance nationalism. Later this year his book titled *Long-Distance Nationalism: Homelands, Migrants and Identities* will be published by Ashgate.

Michelle A. Stephens is a Ph.D. candidate in American Studies at Yale University. Her dissertation is entitled *Imperial Fictions and International Romances: West Indian Intellectuals in the United States, 1914–1962*.

Olessia Tourkina is critic, curator of numerous art exhibitions, and senior research fellow in the Department of Contemporary Art at the State Russian Museum. His essays on contemporary art have been published in different magazines and catalogues in Russia, Germany, Finland, USA, etc. From the late 1980s he has given papers and lectured at conferences in St Petersburg, Moscow, Sverdlovsk, Amsterdam, Hamburg, Berlin, Helsinki, Erfurt, Baltimore, Karlsruhe, New York and Vilnius. He is the author of *St. Petersburg Alter* (Ed. d'En Haut, Switzerland, 1993, with V. Mazin), *Timur* (Avant-Garde, Moscow, 1993, with V. Mazin and T. Novikov), *Necrorealismus* (Berlin, 1993, with V. Mazin and V. Kustov), and *Rebus* (Avant-Garde, Moscow, 1994, with V. Mazin and S. Bugaev).

Notes for Contributors

Submission

Authors should submit **three** complete copies of their paper, including any original illustrations. Send articles to the Editors:

Professors Lawrence Grossberg and Della Pollock
Editors, *Cultural Studies*
Department of Communication Studies
CB#3285, 115 Bingham Hall
University of North Carolina at Chapel Hill
Chapel Hill, NC 27599-3285
USA
Email address: cs-journ@email.unc.edu

It will be assumed that the author has retained a copy of his or her paper. Submission of a paper to *Cultural Studies* will be taken to imply that it presents original, unpublished work not under consideration for publication elsewhere. In submitting a manuscript the authors agree that the exclusive rights to reproduce and distribute the article have been given to the Publishers. This includes reprints, photographic reproductions, microfilm, or any other reproduction of similar nature and translations, though copyright is retained by the author.

Manuscript Format

All submissions should be in English, typed or computer printed in double spacing on one side of the paper only, preferably $8\frac{1}{2}$" × 11". Please include an abstract of up to 300 words (including 6 keywords) for purposes of review. For both articles and reviews, the author's name should not appear anywhere on the manuscript except on a detachable cover page along with an address, short biographical note, and the title of the piece. E-mail addresses are appreciated.

Photographs, tables and figures

Photographs should be high contrast black and white glossy prints. Tables and figures need not be rendered professionally but should be neatly drawn in black ink.

CULTURAL STUDIES 12(2) 1998, 280–284

Copyright-protected material

Written permission to reproduce photographs, tables, figures, song lyrics, or any other copyright-protected material *must* be obtained by authors from the copyright-holders before submission.

Citation style

Manuscripts must conform to the Harvard reference style. The Harvard system uses the name of the author and the date of publication as a key to the full bibliographic details which are set out in a reference list at the end of the article. When the author's name is mentioned in the text itself, the date alone is inserted in parentheses immediately after the name, as in 'Smith (1970).' When a less direct reference is made to one or more authors, name and date are given together, with different references separated by a semicolon, as in, 'several authors have noted this trend (Smith, 1970; Mbene, 1984; Sánchez, 1991).'

When the reference is to a work of dual or multiple authorship, use only the surnames or the abbreviated form: 'Smith and McLeod (1982)' or 'Smith et al (1982).'

If two authors cited have the same surname, include their initials in the reference to distinguish them: 'Zukovic, C. (1993) and Zukovic, R. L. (1991).'

If two or more works by the same author are cited, add lower case letters after the date to distinguish them: 'Parenti (1973a, 1973b).'

The date of publication used is the date of the source to which you have referred. However, when using a republished book, a translation, or a modern edition of an older book, give the date of original publication as well: 'Lacan (1966/77).' When using a reprinted article, cite the date of the original publication only. (See 'Reference list' below for proper reference list formats.)

Page numbers in citations are indicated by inserting the relevant numbers after the date, separated from the date by a colon: 'Hani (1980: 56) or Leibowitz and Mohammed (1993: 23–4).'

When referring to mass media materials, include relevant information within parentheses: '(Women's Weekly, 16 July 1983: 32).'

Treat recorded music as a book: the musician or group is considered the author, the title is underlined, and the distributor is listed as publisher. Treat television serials (as opposed to episodes) and films similarly. Treat television episodes, poems, songs and short stories (i.e. works that are usually not published separately) as articles, placing the title in single quotation marks.

Reference list

Submissions should include a reference list conforming to the style shown in the following examples. Note: elements of information in each reference are

separated by a period or full stop; lines after the first line in the reference are indented; authors' names are given in full; page numbers are required for articles published in readers, journals, or magazines; where relevant, translator, date of first publication of a book, and original date of a reprinted article are noted; when referring to a revised or second edition, cite only the edition used. Examples:

Book
Leach, Edmund (1976) Culture and Communication. Cambridge: Cambridge University Press.

Two or more references to same author
Leach, Edmund (1976) Culture and communication. Cambridge: Cambridge University Press.
—— (1974) Levi-Strauss. London, Fontana.

Multiple authors
Ogden, C. G. and Richards, I. A. (1949) The Meaning of Meaning (2nd edn.). London: Routledge & Kegan Paul.

Two references published in same year; translated text; two places of publication
Lacan, Jacques (1977a) Ecrits: A Selection. Trans. Alan Sheridan. New York and London: Norton. (Originally published 1966).

Article in reader not already cited; multi-volume work; article in book by same author
Leavis, F. R. (1945) ' "Thought" and Emotional Quality'. In his (ed.) (1968) A Selection from Scrutiny (vol. 1). Cambridge: Cambridge University Press, 211–30.

Article in journal
Macherey, Pierre and Balibar, Etienne (1978) 'Literature as an ideological form: Some Marxist propositions'. Oxford Literary Review, 3(1) 4–12.

Article in magazine or newspaper
Burstall, Tim (1977) 'Triumph and disaster for Australian films'. The Bulletin, 24 September 1977: 45–54.

Film or TV programme
The War Game (1966). Dir. Peter Watkins, BBC.

Proofs

Page proofs will be sent for correction to the author whose name appears first on the title page of the article unless otherwise requested. The difficulty and expense involved in making amendments at the page-proof stage of publication make it essential for authors to prepare their typescripts carefully: any alteration to the original text is strongly discouraged. Our aim is rapid and accurate publication. Authors can help us by providing good, clear copy, following the

above instructions and examples, and returning their page proofs as quickly as possible.

Offprints

25 offprints and a copy of the issue in which the article appears will be supplied free of charge to the author. There is no other remuneration for publication in *Cultural Studies*.

Guidelines for Book Reviews

Our goal is to provide information on and analysis of books of potential interest to the readership of *Cultural Studies*, which maintains an international readership. Because the field of cultural studies is/can be defined broadly and often draws on the work and literature of other fields, reviews should focus on the book's relevance to cultural studies. Our ideal book review is a 475–950 word, succinct and incisively critical review. Longer reviews and essays will be the exception. Submissions for longer reviews and review essays will undergo the journal's blind review process and should only be submitted after consultation with a book review editor. Also, please contact a book review editor for details on reviewing films, conferences, and other events of significance to the readership of *Cultural Studies*.

All submissions should be in English, typed or computer printed in double spacing on one side of the paper only, preferably 8½" × 11". The author's name should not appear anywhere on the manuscript except on a detachable cover page. E-mail addresses are appreciated.

All reviews should include the following:
Heading information:

1. Your name and title for the book review (short, preferably 5–6 words maximum)
2. Title and author of the book reviewed
3. Publication information: city, publisher, date, page length, ISBN number and price for cloth/Hbk, ISBN number and price for paper.

Body of review:

1. Brief description or explanation of contents of book
2. Consideration of its relevance to cultural studies
3. A critical engagement with the contents of the book

Ending Information (on attached, separate page):

1. Word count
2. Brief biographical note of the author of the review (2–3 lines)
3. Address of book review author

Book reviews should be submitted to one of our book review editors:

Tim O'Sullivan
School of Arts & Humanities
De Montfort University
The Gateway
Leicester LE1 9BH
United Kingdom

Jennifer Daryl Slack
College of Arts & Sciences
Department of Humanities
Michigan Technological Univ.
1400 Townsend Drive
Houghton, MI 49931-1295
United States

Graeme Turner
Department of English
University of Queensland
Brisbane, Qld 4072
Australia

Education and Cultural Studies

Toward a Performative Practice

Edited by **Henry A. Giroux**, and
Patrick Shannon, both at
Pennsylvania State University, USA

Although the disciplines of critical
education and cultural studies have
traditionally occupied separate spaces
as they have addressed different
audiences, their concerns as well as
the political and pedagogical nature of their work overlap.
Education and Cultural Studies brings members of these two
groups together to demonstrate how a critical understanding
of culture and education can implement broad political
change. Writing from within this framework of cultural studies
and critical pedagogy, the contributors illuminate the possibili-
ties and opportunities open to practicing educators.

Contributors include Carol Becker, Harvey J. Kaye, David Theo
Goldberg, Jeffrey Williams, Sharon Todd, Douglas Kellner,
Deborah Britzman, Jacqueline Reid-Walsh, Claudia Mitchell,
Cameron McCarthy, Mike Hill, Susan Searls, Stanley Aronowitz,
Douglas Noble, Kakie Urch, Henry Giroux, David Trend, and
Robert Mikilitsch.

November 1997: 229x153: 256pp
Hb: 0-415-91913-4: **£45.00** Pb: 0-415-91914-2: **£13.99**

Routledge books are available from all good bookshops, or can be ordered
direct by any of the following methods:

• Written orders to: Tracy Perry, Routledge,
 , Andover, Hants SP10 5BR
• Telephone our **Customer Hotline** on **01264 342939** or **Fax 01264 343005**
• Access our Internet site. Full details of all Routledge titles are available on the
 Internet by accessing **www.routledge.com**

Bringing It All Back Home
Essays on Cultural Studies
Lawrence Grossberg
"These essays represent an original contribution to and sustained reflection on the central debates in critical cultural theory by one of its leading practitioners and most engaged and distinctive voices."
—Stuart Hall
456 pp, £17.95 pb

Dancing in Spite of Myself
Essays on Popular Culture
Lawrence Grossberg
In this volume Grossberg has collected essays written over the past twenty years that have also established him as one of the leading theorists of popular culture and, specifically, of rock music.
328 pp, £15.95 pb

Cultural Marxism in Postwar Britain
History, the New Left, and the Origins of Cultural Studies
Dennis Dworkin
In this intellectual history of British cultural Marxism, Dennis Dworkin explores one of the most influential bodies of contemporary thought.
Post-Contemporary Interventions
328 pp, £15.95 pb

Nations, Identities, Cultures
V. Y. Mudimbe, editor
This volume investigates the concepts of nation, identity, and culture as they have evolved within the context of exile and as a result of the consolidation of the ethnic and political.
240 pp, £14.95 pb

The Politics of Culture in the Shadow of Capital
Lisa Lowe and David Lloyd, editors
The essays in this volume demonstrate how localized and resistant social practices challenge contemporary capitalism as a highly differentiated mode of production.
Post-Contemporary Interventions
608 pp, £22.95 pb

High Contrast
Race and Gender in Contemporary Hollywood Film
Sharon Willis
Willis examines the dynamic relationship between racial and sexual difference in Hollywood film from the 1980s and 1990s.
304 pp, £15.95 pb

Displacing Whiteness
Essays in Social and Cultural Criticism
Ruth Frankenberg, editor
Approaching whiteness as a plural rather than a singular concept, *Displacing Whiteness* makes a unique contribution to the study of race dominance.
352 pp, £16.95 pb

Meaning in Motion
New Cultural Studies of Dance
Jane C. Desmond, editor
Meaning in Motion brings together the work of critics who have ventured into the boundaries between dance and cultural studies, and thus maps a little known and rarely explored critical site.
Post-Contemporary Interventions
392 pp, 37 b&w photos, £17.95 pb

Disappearing Acts

Spectacles of Gender and
Nationalism in Argentina's
"Dirty War"
Diana Taylor
Diana Taylor looks at how national
identity is shaped, gendered, and
contested through spectacle and
spectatorship.
328 pp, 50 b&w photos, £17.95 pb

Listening Subjects

Music, Psychoanalysis, Culture
David Schwarz
Schwarz uses psychoanalytic
techniques to probe the visceral
experiences of music listeners and
shows how the historical conditions
under which music is created affect
the listening experience.
248 pp, 65 musical examples, £16.95 pb

Race and the Subject of Masculinities

*Harry Stecopoulos and Michael Uebel,
editors*
Race and the Subject of Masculinities
offers an important challenge to the
new studies of masculinity by focusing
on the ways in which the social
construction of masculinity intersects
with other categories of identity,
particularly those of race and ethnicity.
New Americanists
448 pp, 23 b&w photos, £17.95 pb

Gilles Deleuze's Time Machine

D. N. Rodowick
Rodowick presents the first
comprehensive study, in any language,
of Deleuze's work on film and images.
Post-Contemporary Interventions
280 pp, 41 b&w photos, £15.95 pb

Refiguring Spain

Cinema/Media/Representation
Marsha Kinder, editor
Marsha Kinder has gathered a
collection of new essays that explore
the central role played by film,
television, newspapers, and art
museums in redefining Spain's
national/cultural identity and its
position in the world economy during
the post-Franco era.
352 pp, 58 b&w photos, £15.95 pb

Culture, Power, Place

Explorations in Critical
Anthropology
*Akhil Gupta and James Ferguson,
editors*
In light of increasing mass migration
and the transnational cultural flows of
a late capitalist, postcolonial world, the
contributors to this volume examine
shifts in anthropological thought
regarding issues of identity, place,
power, and resistance.
360 pp, £17.95 pb

Mathematics, Science, and Postclassical Theory

*Barbara Hernstein Smith and
Arkady Plotnitsky*
This unique collection of essays deals
with the intersections between science
and mathematics and the radical
reconceptions of knowledge, language,
proof, truth, and reality currently
emerging from post-structuralist
literary theory, constructivist history,
sociology of science, and related work
in contemporary philosophy.
336 pp, £15.95 pb

AUPG, 1 Gower Street, London WC1E 6HA, Tel/Fax: (0171) 580 3994/5

For Product Safety Concerns and Information please contact our EU
representative GPSR@taylorandfrancis.com
Taylor & Francis Verlag GmbH, Kaufingerstraße 24, 80331 München, Germany

www.ingramcontent.com/pod-product-compliance
Ingram Content Group UK Ltd.
Pitfield, Milton Keynes, MK11 3LW, UK
UKHW021439080625
459435UK00011B/303